World of Art

Charlotte Cotton is a curator and writer. She has held positions including Head of the Wallis Annenberg Department at Los Angeles County Museum of Art and of Photography at the Victoria and Albert Museum. She has curated exhibitions on contemporary photography worldwide. Her publications include *Photography is Magic* (2015), *Public, Private, Secret: On Photography & the Configuration of Self* (2018) and *Fashion Image Revolution* (2018).

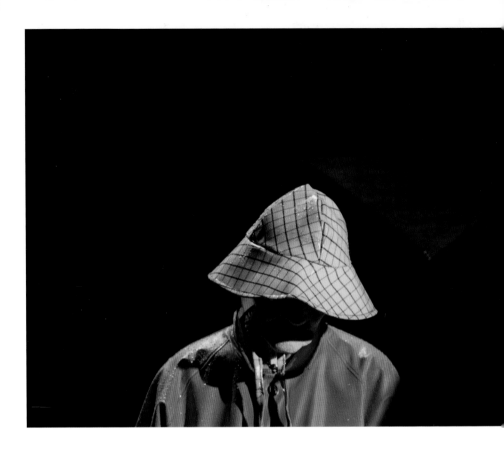

1 Philip-Lorca diCorcia, *Head #7*, 2000. DiCorcia's *Head* series was made by
placing flash lighting on construction scaffolding above a busy New York street,
out of sight of the passers-by below. The movements of the pedestrians prompted
diCorcia to activate the flash, at which moment he photographed the illuminated
stranger with a long-lens camera. The resulting images show people who do not
know that they are being photographed and so do not compose themselves for
their 'portraits'.

World of Art

The Photograph as Contemporary Art
Charlotte Cotton

Fourth edition

For Issi and Jacob

First published in 2004 in the United Kingdom
by Thames & Hudson Ltd, 181A High Holborn,
London WC1V 7QX

www.thamesandhudson.com

First published in 2004 in the United States
of America by Thames & Hudson Inc.,
500 Fifth Avenue, New York, New York 10110

www.thamesandhudsonusa.com

This new edition 2020

The Photograph as Contemporary Art © 2004,
2009, 2014 and 2020 Thames & Hudson Ltd,
London

Text by Charlotte Cotton

Art direction and series design: Kummer & Herrman
Layout: Adam Hay Studio

British Library Cataloguing-in-Publication Data
A catalogue record for this book is available from
the British Library

Library of Congress Control Number 2019940742

ISBN 978-0-500-20448-1

Printed in Hong Kong through Asia Pacific
Offset Ltd

Contents

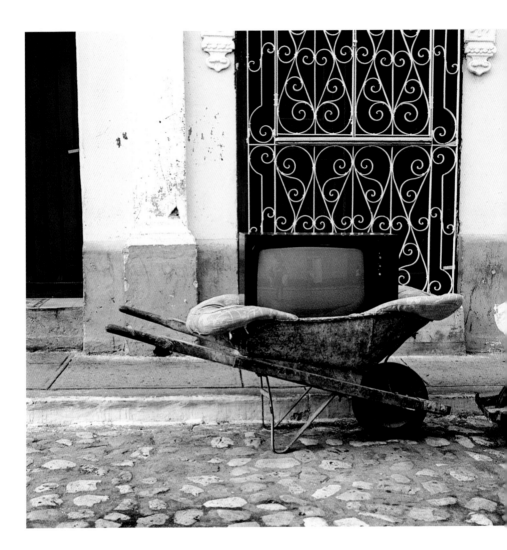

2 Zoe Leonard, *TV Wheelbarrow*, from the series *Analogue*, 2001/2016. Leonard's pointedly titled series *Analogue* consists of street photographs made in various cities around the world which she has either lived in or visited. The series captures the enduring possibilities of the camera to reflect and document what surrounds us and the still-relevant language of pre-digital photography.

Introduction

If there is a single, overarching idea of contemporary photography in *The Photograph as Contemporary Art*, it is the wonderful pluralism of this creative field. The selection of over 350 photographers whose work is illustrated and cited in these pages aims to convey a sense of the broad and intelligent scope of contemporary photography. While it includes some well-known photographers who hold established residence in the pantheon of contemporary art, it treats contemporary art photography as fundamentally diverse in both form and intent, involving the cumulative efforts of many independent practitioners. Every photographer whose work is summoned here shares a commitment to making their own contribution to the physical and intellectual space of culture. In its most literal interpretation, this means that all of the photographers in this book create work for viewership, predominantly through display on gallery walls and in the pages of art books, with the intention of elaborating, pinpointing and making departures from resonant cultural ideas. It is important to bear in mind that most of the photographers are represented here by a single image, invariably selected to stand for their entire body of work. The selection of one project from a photographer's oeuvre belies the full range of their expressions and underplays the plural possibilities that photography offers its makers, but is a necessary simplification in the context of this book.

The majority of contemporary art photographers working today have undertaken some form of undergraduate and graduate art-school education and, like other fine artists, are crafting work primarily for an audience of art viewers, structured into an international web of commercial and non-profit galleries, museums, publishing houses and imprints, festivals, fairs and biennials. In the wake of this increase in

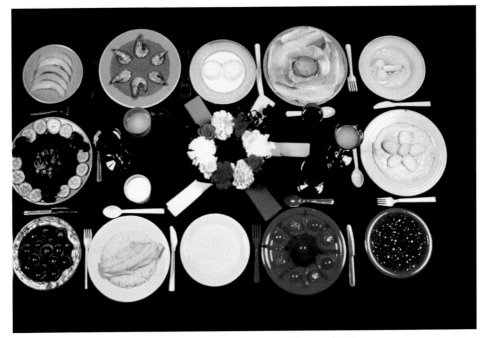

3 Sophie Calle, *The Chromatic Diet*, 1998. For six days, the French artist Sophie Calle ate a diet of food of a single colour, invented for her by the novelist Paul Auster. This combination of artistic strategy and daily life is the hallmark of Calle's imaginative work.

professional infrastructure that champions and commodifies photography as contemporary art in the twenty-first century, there is perhaps a tendency to position photographic practices as the consolidation and qualification of the field, rather than as its conceptual rethinking. Photography's place as a necessary and expected aspect of contemporary art practice has strengthened significantly in the new millennium, underpinned by the homage that continues to be paid to the medium's groundbreaking photographers and the ongoing appraisal of the roles that photography has played in our cultural and social histories since the early nineteenth century. While the re-animation of photography's own histories is a substantive part of the story of art photography in the twenty-first century, it is done with artists' full cognizance of the climate within which photography's meaning is constructed. Even when we see historic photographic techniques and practices at play, they are being activated within the climate of our contemporary image-making environment. The militating factors that shape our image world – of which photography

as contemporary art is a component – include the ways in which we use purely image-based communication in our daily interactions, on social media and image-sharing platforms, for instance; the opportunities for self-publishing photobooks following the revolution in digital printing in the early twenty-first century and the concurrent growth of small-press independent artist book publishing; new camera technologies such as the ability to fuse still- and moving-image capture; the evolution and application of imaging and 3D printing software; and the spectres of state surveillance and corporate data-mining that now constitute the motherlode of unauthored machine-made (and read) images. These new facets of image-making impact not only on the visual languages and modes of dissemination for photography as contemporary art, but also push us to become more specific about what qualifies as artistic photographic practice in light of the ubiquity of photography in everyday life. In this context, it becomes increasingly evident that contemporary art photography is

4 Yinka Shonibare, *Diary of a Victorian Dandy 19:00 hours*, 1998. Nigerian-born British artist Yinka Shonibare's *Diary of a Victorian Dandy* features five moments in the day in the life of a dandy, performed by the artist. One of the obvious references is to *The Rake's Progress*, William Hogarth's (1697–1764) painted morality tale of the young cad Tom Rockwell.

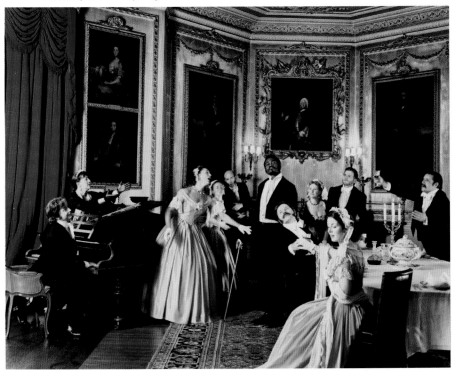

5 Andreas Gursky, *Prada I*, 1996. Gursky's signature vantage point is a viewing platform looking out over distant landscapes or sites of industry, leisure and commerce such as factories, stock exchanges, hotels and, here, a luxurious Prada store. He often places us so far away from his subjects that we are not part of the action at all but detached, critical viewers.

6 Catherine Opie, *Flipper, Tanya, Chloe, & Harriet, San Francisco, California,* 1995. Since the mid 1990s, Opie has created subtly radical depictions of queer households that serve to visually naturalize the domesticity and everyday existence of non-heteronormative couples and families. The capacity of traditional versions of photography to visualize people and places who are markedly absent from mainstream visual media, and to make their presence known, has been an important artistic strategy in chronicling and calling for social change.

driven by the astute and active choices of its makers, whose works maintain the brilliantly dialogical nature of an art form within the ever-shifting wider photographic landscape. More than this, we perhaps see more clearly the extent to which artist–photographers make their work in conscious resistance to and questioning of the mainstream ideas and uses of photography, and collectively protect at least one arena where the basic democracy of photography preserves the right to observe and to be seen, and to articulate personal narratives and human stories.

The chapters of the book divide contemporary art photography into nine categories. These categories, or themes, were chosen to avoid giving the impression that it is either style or choice

of subject matter that predominantly determines the salient characteristics of current art photography. Naturally, there are stylistic aspects that connect some of the works shown in this book, and there are subjects that have been especially prevalent in the photography of recent years – but the themes of these chapters are more concerned with constellating photographers who share common ground in their motivations and working practices. During the now four-edition lifetime of *The Photograph as Contemporary Art*, the parameters of contemporary art photography have grown wider, not least because the idea of photography as art is essentially artist-led, determined more by the actions of artists both collectively and individually than by institutional or market-led distinctions and hierarchies. This book celebrates the fact that the selection of artists shown here is a sampling of an active field of creative photographic expression.

Chapter 1, 'If This Is Art', considers how photographers have devised strategies, performances and happenings especially for the camera. It is situated at the beginning of the book because it challenges a traditional stereotype of photography: the idea of the lone photographer searching for and framing the ebb and flow of daily life, looking for a moment of great visual charge or intrigue. This chapter pays attention to the degree to which an image's focus has been preconceived by the photographer – a strategy designed not only to alter the way we think about our physical and social world, but also to take that world into extraordinary dimensions. This area of contemporary photography grew, in part, out of the documentary photographs of conceptual art performances in the 1960s and 1970s, but with an important difference. Although some of the photographs that appear in this chapter play off their potential status as casual records of temporary artistic acts, they are, crucially, destined to be the final outcome of these events. They are not merely a document, trace or by-product of an action that has now passed, but the object produced, chosen and presented as the work of art.

Chapter 2, 'Once Upon a Time', concentrates on storytelling in art photography. It looks at the prevalence of 'tableau' photography in contemporary practice: work in which narrative has been distilled into a single image. Its characteristics relate directly to the pre-photographic era of eighteenth- and nineteenth-century Western figurative painting. This is not because of any nostalgic revivalism on the part of the photographer, but because an established and effective way of creating narrative content through the composition of props, gestures and the style of the work of art can be found in such

painting. Tableau photography is sometimes also described as 'constructed' or 'staged' photography, because the elements depicted and even the precise camera angle are worked out in advance and drawn together to articulate a preconceived idea. By constructing narratives within the compositional frame of historical tableau paintings, contemporary artists give definite, storied narrative form to contemporary experiences and the redressing and revising of human society and history. 'Once Upon a Time' also highlights photography's capacity to reveal the uncanny theatricality of environments that are purposely made to simulate real-life scenarios, including the staging of military training sites and television and film sets. Collectively, they speak to strategies within contemporary art photography for articulating the typically unseen forces that influence and control the ordering of society.

7 Larry Sultan, *Argument at the Kitchen Table*, 1986. Sultan's *Pictures from Home* project draws together posed and casual images of his parents with family photographs and film footage to create an eloquent portrayal of familial bonds. The project includes delicate observations of the interaction between the two parents.

8 Zoe Strauss, *Billboard 18 – Room Where Bessie Smith Died, Clarksdale, Mississipi.*
From the series *Ten Years*, 2001–10. For close to twenty years, Zoe Strauss has
used photography as a device for social interaction and consciousness raising,
focusing on portrayals of America. Strauss's intention for all of her photographic
activism is to acknowledge and situate both the beauty and conflict of everyday
life as a public and shared experience.

Chapter 3, 'Deadpan', gives the greatest consideration to the
idea of a photographic aesthetic. The term 'deadpan' relates to a
type of art photography that has a distinct lack of visual drama
or hyperbole. In their formal quietude, these images seem to be
products of an impartial gaze, silently witnessed by the camera.
The theatricality of human action, staged environments and
dramatic light qualities seen in many of the works in Chapter
2 are markedly absent here; instead, these photographs have a
visual command that comes from their clarity and scale – all of
the photographs are made with either medium- or large-format
cameras and, often, displayed in large print sizes. 'Deadpan'
considers the work of photographers who provide vantage
points onto the manmade and natural world, and depict our
collective human behaviours; the layers of history in a site; and
the conflation and gradual passing of time. It also spans into
portraiture and the capacity of photography to scrutinize and
hold the agency of a living subject. Photographers represented

in this chapter use conspicuous and slow cameras, and ask their human subjects to briefly hold their position (and even their breath) as the camera captures the momentary encounter. The works represented in this chapter are those that suffer the most from a reduction in size and print quality when presented as book illustrations; it is, in part, in their dazzling clarity that their impact is felt.

While Chapter 3 engages with a 'neutral' aesthetic in photography, Chapter 4 concentrates on subject matter at its most oblique. 'Something and Nothing' looks at how contemporary photographers have pushed the boundaries of what might be considered a credible visual subject, including objects and spaces that we might ordinarily ignore or pass by. What is significant in this chapter is photography's propensity for transforming even the slightest subject into an imaginative trigger of great import – a re-casting, perhaps, of the enduring idea of photography as a medium that subtly frames and eloquently observes. The photographs shown in this chapter maintain the 'thing-ness' of whatever they describe, whether street litter or the debris of everyday domestic life, but also explore how they are conceptually altered through the visual charge of being photographed and presented as art. In this respect, contemporary artists have determined that through a sensitized and subjective point of view, everything in the real world is a potential subject, and every unconscious human action has meaning.

Chapter 5, 'Intimate Life', concentrates on emotional and personal relationships as a collective diary of human intimacy. Some of the photographs have a distinctly casual and amateur style, many resembling family snaps taken with Instamatic cameras or the uneven flash of a cameraphone. But this chapter primarily considers what contemporary photographers add to this vernacular style – such as a focus on less-documented, pungently specific moments in everyday life, events that are distinctly different from the tropes adopted in familial and social image-making. 'Intimate life' also looks at other seemingly less casual and more considered approaches to representing the most emotionally resonant of subjects for a photographer, and photography's role in holding on to memories, relationships, intimacies and the meaning that they represent.

9 OPPOSITE Gillian Wearing, *Self-Portrait as my Father Brian Wearing*, 2003. For her *Album* series, Wearing has restaged photographs from her family albums. She wears prosthetic masks, the edges of which are intentionally left visible around her eyes. The uncanny sense of her trying on the photographic identities of her family and friends and moments of their histories is brilliantly realized.

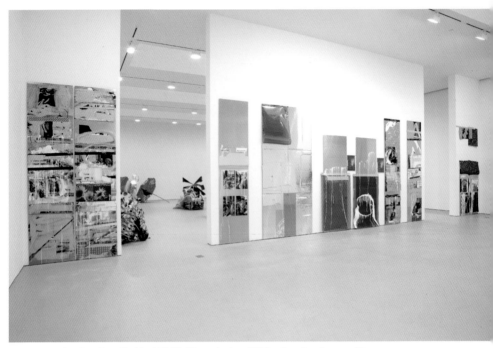

10 Isa Genzken, *Untitled*, 2006. Since the late 1990s, Genzken has used her own and found photographs as a dynamic element within her sculptural installations, with no special privilege accorded to the photographic medium, nor, significantly, any barriers to its equal place within the scheme of her art.

Chapter 6, 'Moments in History', covers a large amount of ground in order to highlight the ways in which photography's documentary capacity might be traced within the arena of contemporary art. It starts with what is arguably the most counter-photojournalistic approach, loosely termed 'aftermath photography' – work by photographers who arrive at sites of social and ecological disaster after they have been decimated. In the literal scarification of the places depicted, contemporary art photography presents allegories of the consequences of political and individual upheaval. 'Moments in History' also highlights the work of artists who are showing us both how photography is implicated in the mechanics of capitalism, state and military surveillance and penal and border systems, and how it can be turned around to counteract and reveal the impact, oppressions and biases of governance. This chapter also represents other photographic strategies that aim to bypass the act of 'othering' human photographic subjects, including long-term collaboration between photographers

and communities that are isolated by geography, excluded from media representation and socially persecuted.

Chapter 7, 'Revived and Remade', explores a range of recent photographic practice that centres on and exploits our pre-existing knowledge of imagery. This includes the remaking of well-known photographs and mimicking of generic types of imagery such as advertising, film stills or vernacular photography. In recognizing these familiar forms of imagery, we are made conscious of what we see, how we see and how images trigger our emotions and shape our understanding of the world. The implicit critique of originality, authorship and photographic veracity that this brings to the fore has been a perennial discourse in photographic practice, and has come to especial prominence in photography of the last forty years. This chapter also looks at instances in which photographers have revived, reinterpreted or created archives of photographs. These examples invigorate our understanding of past events or cultures, as well as enriching our sense of parallels, shifts and continuities between contemporary and historical ways of seeing.

Chapter 8, 'Physical and Material', focuses on photography in which the very nature of the medium is part of the narrative of the work. With digital photography now a ubiquitous aspect of daily experience and communication, a number of contemporary art photographers have made conscious decisions to highlight the physical and material properties of photography and how they currently operate within the rarefied spaces of galleries and museums. The photographs illustrated in this chapter draw attention to the many choices that a photographer must make when creating an artwork, set within our contemporary image environment in which rendering a photograph as a material form is an exception rather than the rule of the medium at large. For some, the explicit choice has been to use analogue technologies (that is, older film-based and light-sensitive chemical processes) rather than the digital image-capture and post-production techniques that are now the standard, default image-making processes. Of all the chapters in this book, 'Physical and Material' makes manifest the ways in which the meaning of analogue materials and thinking – the alchemy of photographic processes – has been recast with renewed cultural relevance and unexpected vitality in the twenty-first century.

The final chapter, 'Photographicness', considers the innovative ways in which contemporary artists are creating image-based works rooted in the stories of photography, but drawing upon sculptural and painterly ideas simultaneously.

11 Barbara Kasten, *Construct, NYC*, 1984. Over the past five decades Kasten's investigations of what photographic materials can do – how they can be manipulated, but also their inherent capacities to automatically render an indexical image – have marked her out as a precedent-setter and honourary peer for Postinternet image-makers who are redefining the idea of photography.

By flattening the hierarchy of what used to be the separate disciplines of sculpture, painting and photography, the artists represented here are expanding rather than concretizing the idea of photography. In so doing, they further open up the character of contemporary art photography as multiform; a space where all possibilities are at play, and cultural changes in the ways that we make, disseminate and consume photography are creatively taken into account.

While the expanding and rethinking of the history of photography continues to influence contemporary art photography, the second decade of the twenty-first century has ushered in an era of incredible confidence and experimentation within this field of artistic practice. It is distinctly different from the late twentieth-century process of validating photography as either a widely recognized, independent art form through stylistic and critical alignment with traditional art forms, or as the continual and unchanged thread of a close-to two-hundred-year separatist history of photography. Now that photography's identity as contemporary art has been accepted as fact, the stage is set for further diverse and multivalent turns in its creative journey.

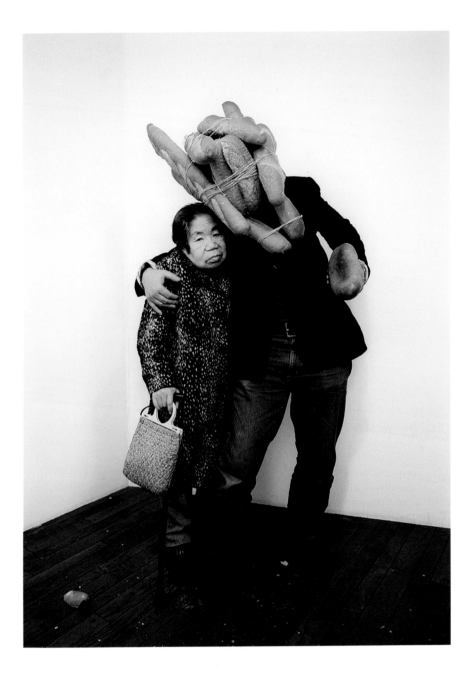

12 Tatsumi Orimoto, *Bread Man Son and Alzheimer Mama,Tokyo*, 1996

Chapter 1
If This is Art

The photographers in this chapter collectively make one of the most confident declarations about how central photography has become within contemporary art practice, and how far removed it has become from traditional notions of the way a photographer creates their work. All of the photographs here evolve from a strategy, performance or happening orchestrated by the photographers for the purpose of creating an image. Although making an observation and framing a moment from an unfolding sequence of events remains part of the process for many here, the central artistic gesture is one in which an event is directed especially for the camera. Artistic creation begins long before the camera is actually held in position and an image fixed, starting instead with the planning of the idea. Many of the works here share the corporeal nature of performance and body art, but the viewer experiences the physical actions indirectly. We comprehend these works' meanings not just *through* an image but *as* photographic acts.

The roots of this approach lie in the conceptual art of the mid-1960s and 1970s, when photography became central to the wider dissemination and communication of artists' performances and other temporary works of art. The motivations and style of such photography within conceptual art practice was markedly different from the established modes used in fine art photography of the time. Rather than offering an appreciation of virtuosic photographic practice or distinguishing key individuals as 'masters' of photography, conceptual art played down the importance of craft and authorship. It made an asset of photography's unshakable and everyday capacity to depict things; it took on a distinctly 'non-art' and 'unauthored' look and emphasized that it was the act depicted in the photograph that was of artistic

importance. Conceptual art used photography as a means of conveying ephemeral artistic ideas or actions, standing in for the art object in the gallery or on the pages of artists' books and magazines. This versatility – photography's status as both document and evidence of art – retained an intellectual vitality and ambiguity that has been well used in contemporary art photography, especially in practices that shift artistic actions into the context of the ordinary and everyday, and engage with the fallible and political corporality of the human body.

To cite this historical moment in art practice is not to say that the same dynamic between avant-garde art and photography is still at play today. Rather, it is to suggest that the ambiguity with which photography has positioned itself within art, as both a document of an artistic gesture and a work of art, is a heritage that is used imaginatively by many contemporary practitioners. French artist Sophie Calle's (b. 1953) blending of artistic strategy with daily life is one of the most compelling realizations of conceptually led photography. In *The Hotel* (1981), Calle took a job as a chambermaid in a hotel in Venice. During her daily cleaning of the bedrooms, she photographed the personal items of their temporary inhabitants, discovering and imagining who they might be. She opened suitcases, read diaries and paperwork, inspected laundry and rubbish bins, systematically photographing each intrusion and making notes that were then published and exhibited. Calle's artworks conflate fact and fiction, exhibitionism and voyeurism, performance and spectatorship. She creates scenarios that consume her, border on running out of control, fail, remain unfinished or take unexpected turns. The importance of a script for her art was highlighted in her collaboration with the writer Paul Auster (b. 1947), who, in his novel *Leviathan* (1992), created a character based on Calle, called Maria. Calle intertwined the novel's character with her artistic persona by correcting passages in the book that referred to Maria. She also invited Auster to invent activities for her, while undertaking the activities he had invented for Maria in the novel. These included a week-long chromatic diet that consisted of eating food of a single colour. On the final day, Calle added a further twist by inviting dinner guests to choose one of the meals from the diet.

Performance played a major role in Chinese art in the 1980s and 1990s. In a political climate in which avant-garde artistic practice was outlawed, the temporary theatricality of performance-based art that could be staged from under the institutional radar provided an opportunity and outlet for dissident expression. The corporeal nature of performance also

13 Zhang Huan, *To Raise the Water in a Fishpond*, 1997. This group performance was staged to be photographed, the still image being the final outcome of the artistic gesture. Along with Ma Liuming and Rong Rong, Zhang Huan was a member of the Beijing East Village community. The group always used photography as an integral part of their performance pieces.
14 Rong Rong, *Number 46: Fen-Ma Liuming's Lunch, East Village Beijing*, 1994

intrinsically challenged the cultural subordination of the self in China, and hence became a critical dramatization of Chinese politics. One of the best-known artists' groups was the short-lived and politically persecuted Beijing East Village, which began in 1993. Most of its members had trained as painters, and used performances that blurred life and theatre to present disturbing manifestations that questioned, countered and responded to the violent shifts in Chinese culture. These were staged to small audiences in houses or out-of-the-way places. In the extreme performances of Zhang Huan (b. 1965), Ma Liuming (b. 1969) and Rong Rong (Lii Zhirong, b. 1968), the human body was tested to its limits, the artists enduring physical pain and psychological discomfort. Photography was always part of the performance, whether through its interpretation by art photographers or as a final work of art born out of the performance.

In a parallel practice, the Ukrainian artist Oleg Kulik (b. 1961) stages performances with a direct, politically confrontational element. These have included acting like a savage dog, attacking the police and representatives of institutionalized power. His concept of the 'artist–animal' is not just a persona he adopts for the length of his performances, but is also presented as a way of life: he has even formed his own Animal Party, to give his ideas a political platform. The influence of earlier conceptually

15 Joseph Beuys, *I Like America and America Likes Me*, 1974
16 OPPOSITE Oleg Kulik, *Family of the Future*, 1992–7

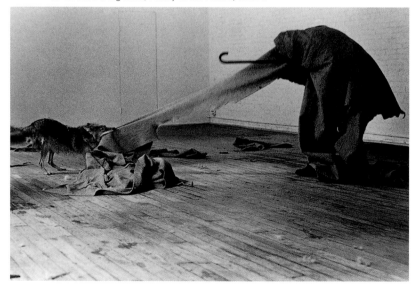

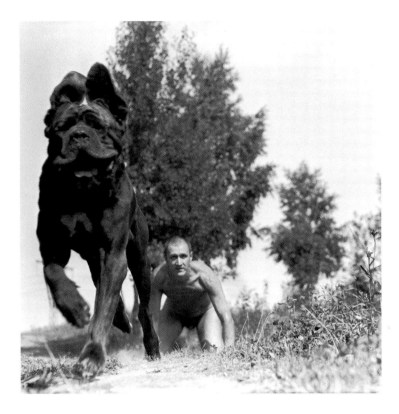

minded artists is especially apparent in Kulik's work. One New York performance, in which he lived as a dog for two weeks, was entitled *I Bite America and America Bites Me* in homage to the heritage of performance as a politicized photo opportunity. It references German artist Joseph Beuys's (1921–1986) protest against the Vietnam War, *I Like America and America Likes Me*, in which Beuys lived locked up with a coyote in a New York gallery and their strange cohabitation was photographed. Kulik's *Family of the Future* is made up of photographs and drawings that ruminate on what the relationship between man and animals could be if the behaviour and attitudes of both were combined in one lifestyle.

The inscribing of cultural and political meaning onto the human body is a dynamic component of contemporary art photography. Chinese artist Ni Haifeng (b. 1964) paints his own torso with motifs from eighteenth-century Chinese porcelain, designed by Dutch traders catering to the Western market for 'china'. The words on his body are written in the style of a museum label or a catalogue entry, suggestive of the language

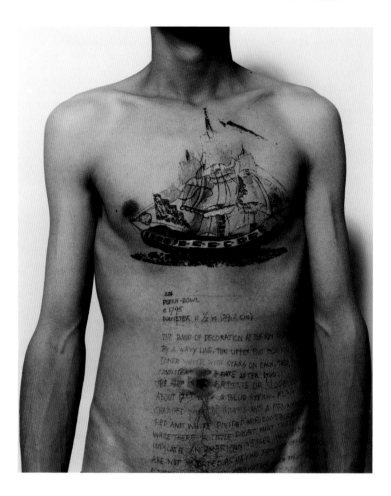

of the collector. Haifeng succinctly and materially delineates the social trauma of global trade and colonialism, and the commodification and exploitation of human beings.

The equal prominence given to text and image in Kenneth Lum's (b. 1956) work investigates the role of the caption in enabling a photograph to elaborate its ideas or subtext fully. The image alone, even carefully staged by the artist, is shown to be problematic and mute without the addition of text to fully unpack the meaning of the interaction between the performed characters. In *Don't Be Silly, You're Not Ugly*, Lum uses the words of the Caucasian woman's ostensibly well-intentioned entreaty to her friend to highlight the complex but utterly pedestrian nature of micro-aggressions, and the ways in which social values of beauty, gender and race play out in daily life.

18

The bringing together of textual fragments and photographic images to confront the racial biases of representation and language, calls to mind the critically acclaimed and highly influential works in the 1990s and early 2000s by American artist Lorna Simpson (b. 1960).

Australian artist Tony Albert's (b. 1981) *Brothers (Our Past, Our Present, Our Future)* has multiple iterations, scales and media, including video projection installations, mosaic-style groups of portraits and, as shown here, human-scale photographic prints. A descendent of Girramay, Kuku-Yalanji and Yidinji language groups, Albert portrays Aboriginal men facing the camera with confidence and prepossession, each with a red target motif painted on their bare torso. Through a Western lens, the photographs represent the individual impact and implications of state violence and racial profiling of Indigenous people. In Aboriginal iconography, the red circles represent the emanation of water ripples or sound waves – a depiction of a quality of the men's inner, human spirit. The target motif is used by Albert across different bodies of work and mediums as a form of mark-making that also serves to counter Western ideas of Aboriginal art as exclusively made with dot paint marks, which is not the dominant technique of traditional Indigenous art practice in the Queensland area, from where Albert directly descends.

17 OPPOSITE Ni Haifeng, *Self-Portrait as a Part of Porcelain Export History (no. 1)*, 1999–2001
18 Kenneth Lum, *Don't Be Silly, You're Not Ugly*, 1993

Don't be silly
you're not ugly
You're not ugly
You're not ugly at all
You're being silly
You're just being silly
You're not
You're not ugly at all

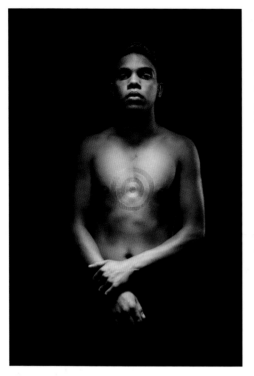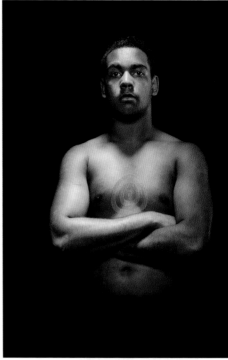

9, 20

The capacity of photoconceptualism to dislodge the surface of everyday life through simple acts is evident in British artist Gillian Wearing's (b. 1963) *Signs that say what you want them to say and not signs that say what someone else wants you to say*. For this work, Wearing approached strangers on the streets of London and asked them to write something about themselves on a piece of white card; she then photographed them holding their texts, which range from playful, obfuscating wordplay to startlingly direct and desperate entreaties. The resulting photographs reveal the emotional states, social anxieties and personal issues that were occupying the minds of those portrayed. By making the inner thoughts of her subjects the externalized narrative of their portraits, Wearing captures something of the profundity and psychological experience of everyday life and human interaction

19 Tony Albert, *Brothers (Our Past, Our Present, Our Future)*, 2013. Albert portrays Aboriginal men facing the camera with a red target motif painted on each of their bare torsos, appearing both confident and vulnerable. The targets speak to the racial targeting and profiling of Indigenous people in Australia, but also to Aboriginal iconography, in which the symbol represents a quality of the men's inner, human spirit.

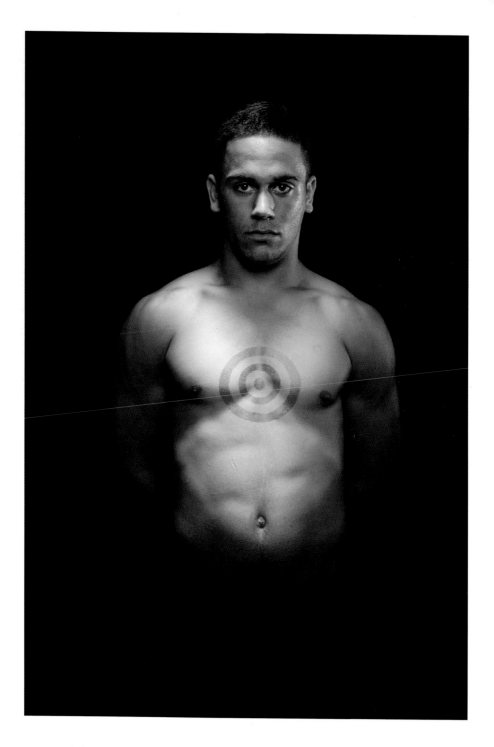

through artistic intervention combined with a straightforward photographic approach.

A similarly astounding use of public space as a site for performative art strategy is present in Nona Faustine's (b. 1977) photographic series, *White Shoes*, begun in 2012. Faustine powerfully visualizes the legacy of oppression and violence against people of colour, with its roots in the structural debasement and dehumanization that underpin slavery. She bares her body, and, wearing only a pair of white, heeled shoes, stands resolutely and faces the camera, standing on a wooden box that infers both a stage or plinth for her objectified body, and a platform – a soap box – for her visual declaration to us. She stands in the middle of Manhattan's Wall Street, on the site of one of the prominent slave markets in the eighteenth century, positioned close to the docks to receive Africans who had survived their sea journey and imprisonment. Faustine's choice to produce her photograph on the literal site of a historical slave market also draws our attention to the affluent architecture of New York's financial district – which, in turn,

20 Gillian Wearing, *Signs that say what you want them to say and not signs that say what someone else wants you to say*, 1992–93. The signs, written by Wearing's subjects on the spot, reveal something of the emotional state or personal issues that were occupying the minds of those portrayed. They add an extra dimension to Wearing's front-facing, seemingly straightforward portraits.

21 Nona Faustine, *From Her Body Sprang Their Greatest Wealth*, 2013. Site of colonial slave market, Wall Street, New York. Faustine powerfully visualizes the legacy of oppression and violence against people of colour by baring her body and standing resolutely, facing the camera, in solidarity with African women (including Faustine's ancestors) who were paraded and photographed as chattels and property in colonial and American slave auctions in the seventeenth, eighteenth and nineteenth centuries.

reminds us that this commercial centre is built upon the exploitation of enslaved Africans and African Americans.

22 Talia Chetrit's (b. 1982) recent performances for the camera intentionally confront the representational tropes and visual consumption of women's bodies in the context of both art and social media. She stages self-portraits that are purposely impolite, manifesting a strategy of exhibitionism that pushes back against social and cultural expectations of how young women (including artists) 'should' present themselves. Chetrit calls forth her artistic forebears, including VALIE EXPORT (b. 1940), Carolee Schneemann (1939–2019) and Hanna Wilke (1940–1981), as well as complicating the script for female self-representation in the present moment. The pushback that Chetrit orchestrates and performs is also directed towards the viewer of her images, asking us to confront our own culpability in consuming and naturalizing repressive constructs of femininity and rejecting less 'palatable' performances of self, gender and sexuality.

23 In her ongoing series *Experimental Relationship*, begun in 2007, Pixy Liao (b. 1979) scripts scenarios that she and her

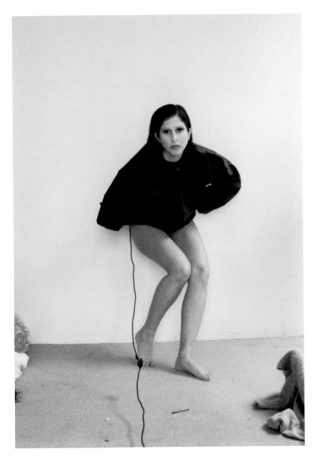

22 Talia Chetrit, *Self-Portrait (Corey Tippin make-up #2)*, 2017

photographic collaborator and boyfriend, Moro, perform for her camera. There are multiple layers of narrative bound up in her succinct, playful and often humorous photographs. *Experimental Relationship* subverts ingrained, binary gender distinctions within art and visual culture, countering and amplifying the subtexts of domesticity. Liao intentionally upends the patriarchal gendering of photographer and subject, with Liao performing the 'masculine' roles of photographer and director and Moro, feminized by his compliance, as both performer and prop in the photographs they create together. *Experimental Relationship* also wittily calls out national and racial stereotypes, with Liao (who was born and raised in China) both culturally appropriating from her boyfriend's homeland of Japan, and confounding the stereotypical Western characterization of an Asian woman as

essentially docile and submissive through her forthright control of both the scenarios and their articulation with her camera.

Whitney Hubbs's (b. 1977) recent photographs have explored both the visual language of portraiture and the directorial role of photographers who represent women's bodies. Hubbs's photographs of her own body and performances, and the photographs she has made with female subjects, who she describes as 'surrogates' for her own gestures and physical form, are purposeful but evade easy reading. In *Pleasure Possibilities #1, 2019*, Hubbs pushes her body into an edge of her studio, with shards of glass taped to the skin of her torso

the upside-down self-portrait. The image is without obvious script, and refuses to adhere to the legible conventions of self-portraiture as defined by our social media image environment. Hubbs consciously creates a fragmented and uncertain version of self-representation that contradicts photographic tropes, in order to perhaps present a more truthful document of corporeality and visual presence.

At this juncture in history, in which self-representation is a naturalized act that constantly drives the behaviours of social media platforms, many artists use the everyday currency of images as a pivot and a point of disputation in their artistic practice. In photography, artists including Arvida Bystrom

23 Pixy Liao, *Homemade Sushi*, 2010. From the series *Experimental Relationship*

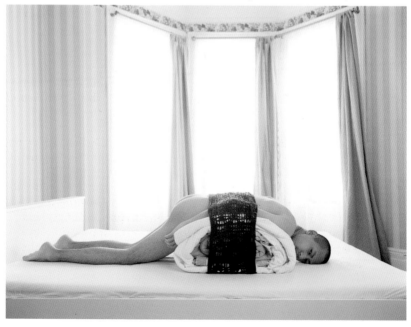

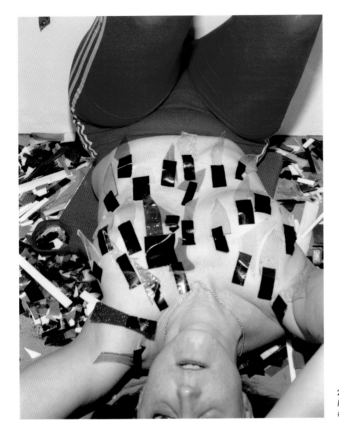

(b. 1991), Maisie Cousins (b. 1992), Josephine Kuuire (b. 1987), Sarah Maple (b. 1985), Laurence Philomène (b. 1993), Signe Pierce (b. 1988), and Molly Soda (b. 1989) are showing us how the performance of selfhood still holds real agency, despite the strictures and biases that drive social media.

25 Paul Mpagi Sepuya's (b. 1982) photographic practice conflates and purposely confuses the traditional separations between the observer and the observed in photographic portraiture. Ranging from simple studio-environment portraits to the spatial collaging of forms and vantage points using photographic fragments and studio materials such as mirrors and velvet backdrop cloths, Sepuya calls forth the multi-layering of relationality and representation that underpins all portrait-making encounters. The artist's studio is framed as a physical and psychological space of reciprocity, into which Sepuya brings a lexicon of bodily gestures including those drawn from paintings, late twentieth-century pornography and social

media, in which to enact (and improvise upon) the intersections of photography with desire, intimacy, race and objectification. Throughout the span of Sepuya's practice, photography is shown to be a dynamic and social action that can prompt, reveal and give form to human bonds.

The performance of human relationality and bodily presence, and photography's capacity to envisage the sub-textual and visual nature of our relationships, is present in the work of artists including Jen Davis (b. 1978), Joanna Piotrowska (b. 1985), Karen Miranda Rivadeneira (b. 1983), Shen Wei (b. 1977) and D'Angelo Lovell Williams (b. 1992). In Swedish artist Annika von Hausswolff's (b. 1967) *Everything is connected, he, he, he,* the photographer plays with depictions of the sexualized body. This photograph, of a basin of soaking laundry, can also be read as a diagram of heterosexual sex organs: the phallic tap and the coiled washing in the shape of a uterus and fallopian

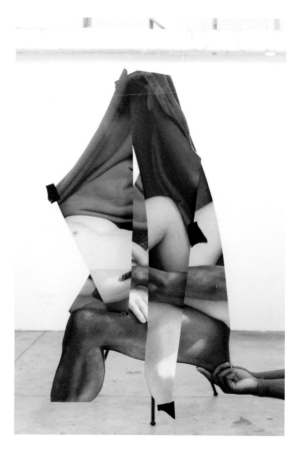

25 Paul Mpagi Sepuya,
Mirror Study (0X5A6571),
2018

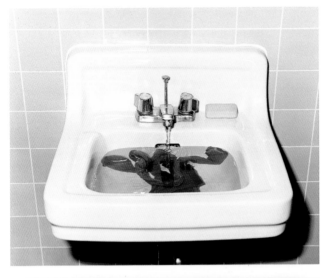

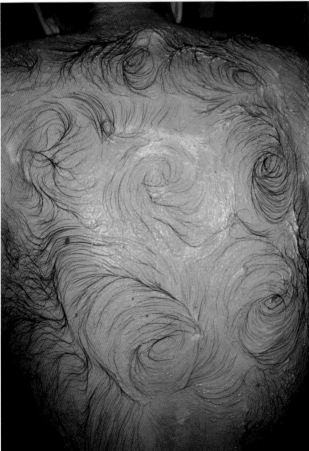

26 Annika von Hausswolff,
*Everything is connected,
he, he, he,* 1999
27 Mona Hatoum,
Van Gogh's Back, 1995
28 OPPOSITE Sarah Lucas,
*Get Off Your Horse and Drink
Your Milk,* 1994

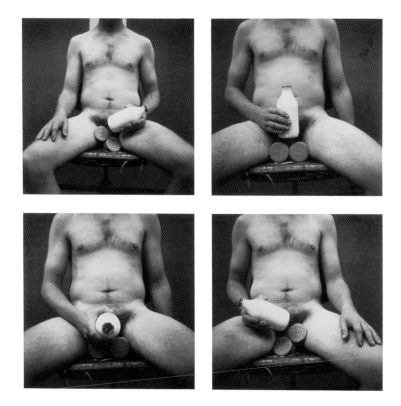

tubes. Von Hausswolff creates a visual game in which we see both the actual subject of the bathroom sink and the conceptualized subject of heteronormative sex. This interplay between two pictorial registers highlights the hovering status of contemporary art photography, discussed earlier in the chapter, as both a device for documenting a performance, strategy or happening and a legible work of art in its own right.

Photography is a practical way to fix such an observation, but also the means by which that play between visual registers comes into force. Such is the visual currency of Mona Hatoum's (b. 1952) *Van Gogh's Back*, where we jump mentally from the swirls of hair on the man's wet back to the starry skies of van Gogh's swirling paintwork. The enjoyment of such a photograph is based on our shift from registering a photographic image as a three-dimensional scene (something we respond to because of its presentation of a sculptural object or event that we trust once existed in the real world) and that of a two-dimensional, graphic representation of the swirls of wet hair that we connect, via van Gogh, to a patterned sky.

27

This wry, visceral playfulness has also been apparent in the
work of British artist Sarah Lucas (b. 1962). *Get Off Your Horse
and Drink Your Milk* has a blunt, funny rudeness that, in its ad
hoc staging, brings together the popular cartoon language of
tabloid newspaper photo-stories with the use of performance
and the photographic grid in avant-garde art practice. Whereas,
earlier in this chapter, we have seen the naked body used as
a means of reaching and signalling sensitized experience, in
Lucas's work it is the way the body is conventionally represented
in the everyday imagery of magazines and newspapers that
is important. In the work shown here, she enacts a reversal
and subversion of received sexual roles and imagery, the body
becoming more travesty than desirable symbol.

28

An engaging corporeality is also evident in Jeanne Dunning's
(b. 1960) photographs, showing an organic mass dramatically
abstracted to the point that the actual subject is lost in favour
of its reference to bodily organs, both exterior and interior.
In *The Blob 4*, a sack with the look of a huge silicon implant
covers a woman's torso, the bulk sliding like swollen flesh
towards the camera, an embodiment of the embarrassment and
vulnerability of human physicality. In an accompanying video
piece, a woman is shown trying to dress it in women's clothing,
struggling as if with an unwieldy, bloated body. In both pieces,
the 'blob' carries psychological connotations of the human body
as irrational and uncontrolled.

29

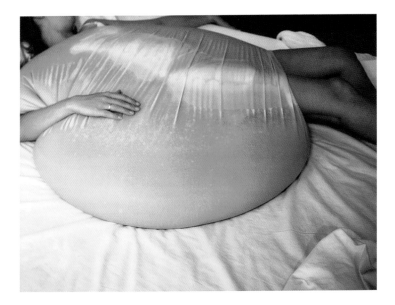

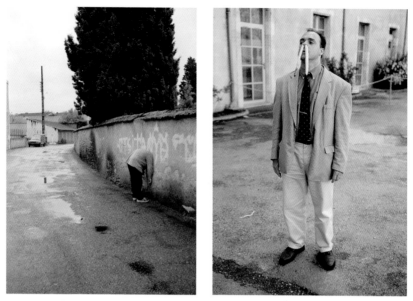

29 OPPOSITE Jeanne Dunning, *The Blob 4*, 1999
30 Erwin Wurm, *Outdoor Sculpture*, 1999
31 Erwin Wurm, *The bank manager in front of his bank*, 1999. Wurm photographs himself and the people who agree to collaborate with him in absurd sculptural poses, sometimes with the aid of props made from everyday objects. No special physical skills or equipment are required for these 'one-minute sculptures', which encourage people to turn themselves into works of art in their daily lives.

'Bread Man' is the performance persona of the Japanese artist Tatsumi Orimoto (b. 1946), who hides his face under a sculptural mass of bread and then performs normal everyday activities. His performances as this cartoonish character are not particularly dramatic. As he walks or cycles around town, his strange but non-threatening appearance is usually politely ignored by passers-by; occasionally it engenders amused curiosity. But the photographs representing these absurdist interventions are dependent on people's willingness and resistance to break with their daily routines in order to interact and be photographed with the artist. Orimoto has also used his bread guise for double portraits of himself and his mother, who has Alzheimer's disease – a visual merging of her changed mental reality with his performance of physical difference.

A similar kind of seemingly banal disruption of daily life is present in the incongruent physical acts that Erwin Wurm (b. 1954) stages and then photographs. In his *One Minute Sculptures*, Wurm provides a manual of sketches, instructions and descriptions of potential performances that require no

12

30, 31

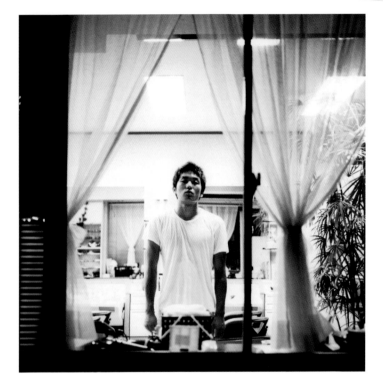

specialized physical skills, props or locations – such as wearing all your clothes at once, and putting a bucket on your head while standing in another bucket. By extending the invitation to anyone willing to undertake these acts, Wurm suggests that the work of art is the idea; the artist's own physical manifestation of it is more of an encouragement to others to participate than an act only he can perform. Models for Wurm's photographs include friends, visitors to his exhibitions and people who respond to the adverts he places in newspapers.

32 Japanese artist Shizuka Yokomizo's (b. 1966) *Strangers* (1998–2000) is a body of work premised on inviting her photographic subjects to follow simple instructions that intentionally disarm

32 Shizuka Yokomizo, *Stranger 10*, 1999. Yokomizo sent letters to the inhabitants of houses into which she could photograph from street level. She asked the strangers to stand in front of their windows at a certain time in the evening with the lights on and the curtains open. The photographs show the people who followed the directions posed in anticipation of being photographed by an unknown photographer.
33 OPPOSITE Bettina von Zwehl, *Meditations in an Emergency #14*, 2018. Von Zwehl's series of seventeen haunting, silhouetted portraits of New York high school students, photographed lying on the floor, reference the 'die-in' pose adopted in public demonstrations against gun violence in America.

them and prompt less self-conscious gestures for the camera. *Strangers* consists of nineteen portraits of single figures photographed through the downstairs windows of houses at night. Yokomizo selected windows that she had observed at street level, and sent letters to the inhabitants of the houses asking if they would stand facing the window with the curtains open at a designated time. In these photographs we are looking at the strangers looking at themselves; the windows act as mirrors as they anticipate the moment they will be photographed, partially duplicated in the viewer's experience of seeing their own reflection in the glazing of Yokomizo's framed photographs. The title of the series refers not only to the status of the sitters as strangers to the artist and to us, but also to the photographing of that curious self-recognition, or misrecognition, we experience when we catch a glance of ourselves unexpectedly.

33 For over twenty years, German artist Bettina von Zwehl (b. 1971) has created photographic portraits with an underlying structure that means that her subjects' appearance, how they present themselves and the photographic outcome of their collaboration with von Zwehl is not entirely controlled by them. She has created bodies of work where, for example, her

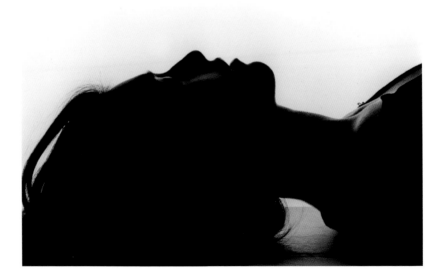

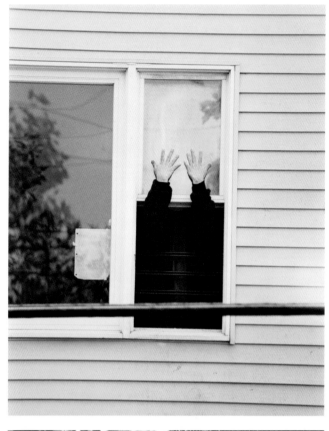

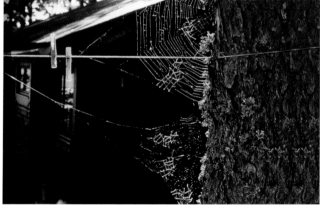

34 TOP Rachel Harrison, *Untitled (Perth Amboy)* 2001
35 Nina Katchadourian, *Mended Spiderweb #19 (Laundry Line)*, 1998

36 David Spero,
*Lafayette Street,
New York*, 2003

subjects went to sleep wearing white clothes, were woken and then photographed with the vestiges of slumber still clear on their faces. In 2018, Bettina von Zwehl created a remarkably haunting series of silhouetted portraits of New York high school students, each photographed lying on the floor. Taking her cue from the protests across America in the wake of the mass shooting at Marjory Stoneman Douglas High School on 14 February 2018, von Zwehl collaborated with the teenagers to stage their portraits in direct reference to the 'die-in' pose adopted in public demonstrations against gun violence.

34 In *Untitled (Perth Amboy)*, American artist Rachel Harrison (b. 1966) observes a strange and obscure form of human gesture; a 'found' performance. The photographs show the window of a house in New Jersey where, it was claimed, there had been a visitation from the Virgin Mary on the windowpane. Guests to the house place their hands on either side of the window in an attempt to comprehend the phenomenon through the sensory experience of touch. Harrison's *Perth Amboy* is a contemplation of human attitudes to the paranormal. The image is fittingly elliptical; the repeated gesture remains visually unfathomable to us, mirroring the pilgrims' desire for tangible comprehension of the intangible.

The customization of the natural world has been the playful signature of projects by the American artist Nina
35 Katchadourian (b. 1968) since the mid-1990s. In her *Renovated Mushroom (Tip-Top Tire Rubber Patch Kit)* (1998), she repaired cracks in mushroom caps with brightly coloured bicycle-tyre patches and photographed them. In the *Mended Spiderweb*

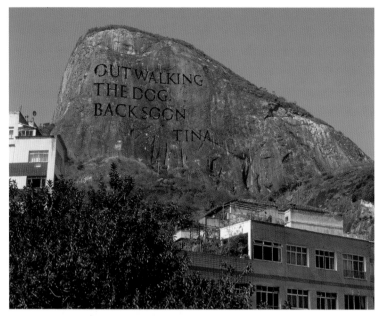

37 Wim Delvoye, *Out Walking The Dog*, 2000
38 OPPOSITE David Shrigley, *Ignore This Building*, 1998

series, she patched up spiders' webs with starched, coloured thread. In an unplanned twist to her acts of handiwork, overnight, spiders would attempt to remove and rework her 'repairs'. In the context of art, Katchadourian's small and consciously clumsy interventions into nature are also a wry, feminized retort to the much grander engagements with nature made in land art of the 1960s and 1970s.

The interplay of two- and three-dimensional spaces is one of the great pleasures of looking at photographs. The ability of the medium to depict solid plastic forms, fleeting events and combinations, and graphically reduce them to two dimensions, has been an enduring fascination and challenge to photographers throughout its history. In contemporary art photography, such questions about the essential nature of the medium not only have a bearing on the techniques employed by artists but can also often be the *subject* of entire bodies of work. British artist David Spero's (b. 1963) *Ball Photographs* (2001–4) depict modest locations into which he has placed colourful rubber balls, which, when photographed, make for comical but beautiful punctuations of the spaces. They form homemade celestial planes, tilted through the floors, sills and surfaces of each scene. They draw our attention to the many still lifes

36

within each photograph and the transformations of their contents into photographic subjects.

Wim Delvoye's (b. 1965) sculptures and photographs are driven by their unsettling humour and visual punchlines. Like his finely crafted, rococo-style wooden cement mixers and intricate mosaics of sliced salami and sausages, his photographs offer an irreverent joining of the mundane and functional with the grand and decorative. Delvoye uses this device to create experiences that are aesthetically pleasurable and psychologically aberrant. He mixes civic typographies normally used for inscriptions on monuments and gravestones with the language of the quickly scribbled, casual note left on a doorstep or kitchen table. This combination of the grandiloquent and the ordinary, public and private, carries a serious comment on our wasteful abuse of natural resources and the nature of communications in contemporary life. Similarly, British artist David Shrigley's (b. 1968) photographs and sketches use the formulas of shock and visual puns, with a special nod towards Surrealism, to debunk art's pretentiousness in an absurdist, schoolboyish way. Shrigley's consciously unsophisticated style of sketching and perfunctory, 'unauthored' photographic aesthetic is crucial in our immediate enjoyment of the work, inviting a reaction with more in common with our daily experiences of toilet-wall jokes and schoolroom doodles. As we have seen throughout this chapter, photography situated as a conceptual art medium performs and reveals the paradoxes, dark underbelly and sub-textual realities of being human.

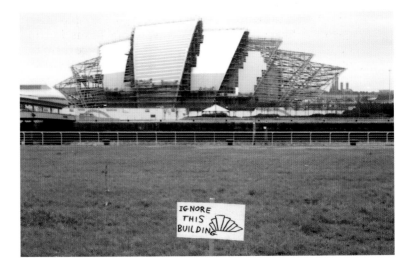

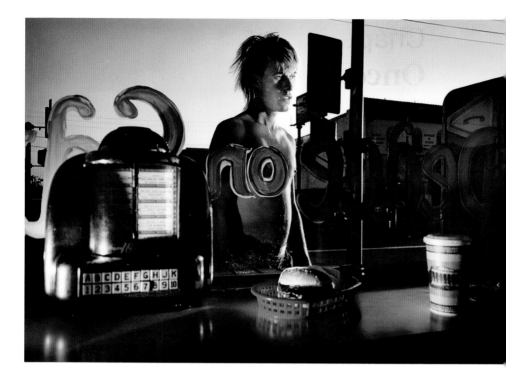

39 Philip-Lorca diCorcia, *Eddie Anderson; 21 years old; Houston,TX; $20*, 1990–92. Tableau photography often alludes to the lighting used on a film set, with lights spotted in a number of places to create a simulated naturalism and in anticipation of actors moving through the scene. A theatrical and psychological charge is also added by working at particular times of day, such as sunset, where combining natural and artificial lights leads to a dramatic sense of place and narrative.

Chapter 2
Once Upon a Time

This chapter considers the dramatic use of storytelling in contemporary art photography. Some of the photographs shown here make obvious references to fables, fairy tales, apocryphal events and modern myths that are already part of our collective consciousness.

This area of photographic practice is often described as tableau or tableau-vivant photography: a stand-alone picture with a resolved pictorial narrative loaded into a single frame. Tableau photography has its precedents in pre-photographic art and figurative painting of the eighteenth and nineteenth centuries, and we rely on the same cultural ability to recognize a combination of characters and props as a pronounced moment in a story. It is important not to think of contemporary photography's affinity to figurative painting as simply one of mimicry or revivalism; instead, it demonstrates a shared understanding of how a scene can be choreographed and the audience invited to pay attention to the story being told.

1, 39 Philip-Lorca diCorcia's (b. 1951) *Hollywood* (1990–92) is a series of portraits of men whom diCorcia met in and around Santa Monica Boulevard, Hollywood, and asked to pose for him. The title of each photograph details the name of the man, his age, where he was born and how much diCorcia paid him to pose. In *Eddie Anderson; 21 years old; Houston, Texas; $20*, a young man, naked from the waist up, is shown through the window of a diner. The photograph places the viewer as though sitting inside the diner, watching the approach of the young man – already a kind of storytelling is encouraged in the viewer's mind. One wonders what high hopes brought each man to Tinseltown; what route led to his being down on his luck, charging for his photograph (the associations with the sex industry are clear). His youthful physique is powerful and

available but, at the same time, he is literally without a shirt on his back. The image is set at twilight – a turning point between day and night, and a time of day with especially dramatic casts of light. It is often described as 'cinematic', and in reference to diCorcia's work, which often combines photographic and ambient light, resembles the lighting of a theatre stage or film set in which actors move and perform. Alongside figurative painting, novels and folktales, cinema acts as a reference point that creates the maximum contingent meaning, further imbuing diCorcia's image with an imaginative blend of fact, fiction and enactment.

40 One of the leading practitioners of the staged tableau photograph is the Canadian artist Jeff Wall (b. 1946), who came to critical prominence in the late 1980s. His art practice developed in the late 1970s, after time as a postgraduate student of art history. Although his photographs are more than mere illustrations of his academic study, they display a detailed comprehension of how pictures work and are constructed that underpinsmuch of the best tableau photography. Wall describes his oeuvre as having two broad areas. One is an ornate style, in which the artifice of the photograph is made obvious by the fantastic nature of the stories; since the mid-1980s he has often utilized digital manipulation to create this effect. The other is a much slighter (though still staged) event that resembles a casually glanced-at scene. *Insomnia* is made in Wall's 'ornate' style, with compositional devices similar to a Renaissance painting. The angles and objects of a kitchen scene direct us through the picture and lead our understanding of the action and narrative, the interior layout acting as a set of clues to the events that could have led up to this moment. We see traces of the man's movements around the sparse kitchen in his restless state, unsatisfied, resigned to crumpling on the floor in a desperate attempt to achieve sleep. The lack of homely detail in this kitchen is perhaps a reflection of the character's lifestyle, but also implies the sparseness of a theatre set viewed from onstage. Wall displays many of his tableau works on large lightboxes, which, because of their spatial and luminescent qualities, amplifies the drama of his photographs. Not quite a photograph, nor a painting, nor a wholesale adoption of the production values of backlit billboard advertising, the lightbox nonetheless suggests the experience of each visual form and language.

The labour and skill involved in reconstructing such a scene is arguably equivalent to the time and dexterity expended by a painter in their studio. What is also brought into question by such elaborate production values, where everything is gathered

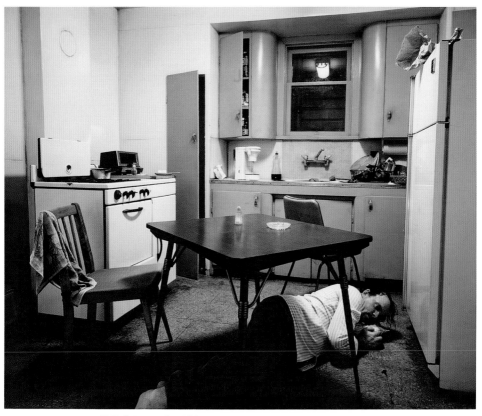

40 Jeff Wall, *Insomnia*, 1994

together expressly for the realization of a photograph, is
the idea of the photographer working alone. The use of actors,
assistants and technicians needed to create a photographic
tableau redefines the photographer as the orchestrator of
a cast and crew, the key rather than sole producer, akin to a
film director who imaginatively harnesses collective fantasies
and realities.

Such a characterization has been at the centre of the
expansive practices of the Canadian artist Stan Douglas
(b. 1960) over the past three decades. Douglas creates
heavily researched, interconnected projects that manifest
as multiscreen films, augmented reality, live performance
and photographs that interweave stories and perspectives.
In *Midcentury Studio* (2012), Douglas focuses on his ongoing
exploration of modernity and post-Second World War trauma,
discrimination and race. His artistic strategy is to combine his

research with re-enactments of mid-century film noir and visual storytelling styles that draw out and reanimate history, inserting the possibilities of retrospective looking at the legacy of modern history into our present day. For *Suspect, 1950*, Douglas takes on the persona of a press photographer – a character partially based on Canadian military veteran Raymond Munro, a self-taught photographer who in 1945–50, ahead of the post-war professionalization of photojournalism, began to document the trails of violence and criminality in Vancouver. Douglas draws on the formal structure of mid-century photography, with its unprecedented close proximity to the contemporary surges of lawlessness, to enact stories of societal failure and position contemporary viewers in the amplified historical roots of our own, current social *mise-en-scene*.

42 Teresa Hubbard (b. 1965) and Alexander Birchler (b. 1962) construct photographs that are intentionally ambiguous in their symbolism, but no less emphatic in their narrative charge. They build sets, direct and act alongside their selected cast of professional actors. For *Untitled*, they positioned the camera as though splicing through the floors and walls of a house, creating curiosity and dread around what might lie beyond the frame, left and right, above and below. The

41 Stan Douglas, *Suspect, 1950*, 2010

42 Teresa Hubbard and Alexander Birchler, *Untitled*, 1998

composition also resembles a strip of film caught between two frames, suggestive of the conflation of time that is possible in tableau photography. It makes reference to a sequential past, present and future, or to another moment/frame that is only partly visible. Such a division of space, and the simultaneous representation of different times, are similar to the use of different moments in the same image in Renaissance altarpieces.

In *Soliloquy I*, British artist and filmmaker Sam Taylor-Johnson (b. 1967) shows the figure of a beautiful young man, expired on a sofa, his right arm hanging lifelessly to the floor. His pose, the light source positioned behind him, emulates a popular work by the Victorian painter Henry Wallis (1830–1916), *The Death Of Chatterton* (1856). The painting shows the shamed seventeen-year-old poet Thomas Chatterton committing suicide in 1740, after his poetry, which he had presented as the found writings of a fifteenth-century monk, was exposed as his own work. In the mid-nineteenth century, Chatterton represented the idealized character of the young, misunderstood artist whose spirit is smothered by bourgeois disapproval, and his suicide was seen as his last act of self-determination. In her

43

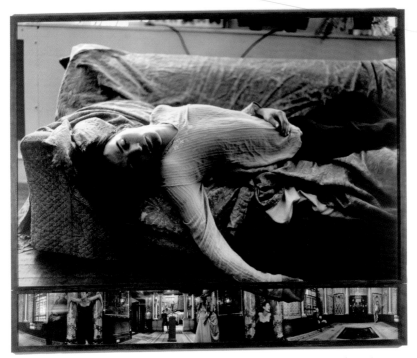

43 Sam Taylor-Johnson, *Soliloquy I*, 1998. This image has the rich colour, size and combination of a Pietà-like figure study and frieze of animated action of Renaissance religious paintings and altarpieces. The frieze that runs along the lower edge of the image was made with a 360-degree panning camera.

photograph, Taylor-Johnson not only remakes a tableau from a period in art history when it was a prevalent and popular form of picture-making, but also consciously revives the idealism bound up in Wallis's painting.

Nigerian-born British artist Yinka Shonibare's (b. 1962) *Diary of a Victorian Dandy* features five moments in the day in the life of a dandy, performed by the artist. One of the obvious references is to *The Rake's Progress* (1732–34), William Hogarth's (1697–1764) painted morality tale of the young cad Tom Rockwell. Hogarth depicted seven episodes in Rockwell's life, each vivid with the pleasure and consequences of the character's debauchery. For his contemporary series, Shonibare constructed scenes representing different moments in the day, all set in historical interiors, with the cast and artist wearing Victorian-style costume. The Caucasians are shown to be 'colour-blind' to the artist and his skin colour. His place within Victorian society appears to be protected by his guise as a dandy, his declaration of self-fashioning and authenticity

assured through the pronounced artifice of his manner and dress. Hogarth's satire on the state of contemporary society was engraved and widely published as a series of prints in 1735, an eighteenth-century form of mass media. Interestingly, Shonibare's *Victorian Dandy* series was initially commissioned for display as posters on the London Underground system, intended to function within today's sites of popular and commercial imagery.

British artist Tom Hunter's (b. 1965) tableau photographs of the early 2000s also present contemporary reworkings of Victorian paintings, specifically those of the Pre-Raphaelite Brotherhood. *The Way Home* is a direct compositional and narrative reference to John Everett Millais's (1829–1896) *Ophelia* (1851–52), a Victorian recasting of William Shakespeare's (1564–1616) tragic character from *Hamlet*. The contemporary stimulus for *The Way Home* was the death of a young woman who had drowned on her walk home from a party. The work shows this modern-day Ophelia succumbing to the water and metamorphosing into nature, an allegory that has held potency for visual artists for centuries. Hunter's luscious, large-scale colour photography parallels the luminous clarity

44 Tom Hunter, *The Way Home*, 2000

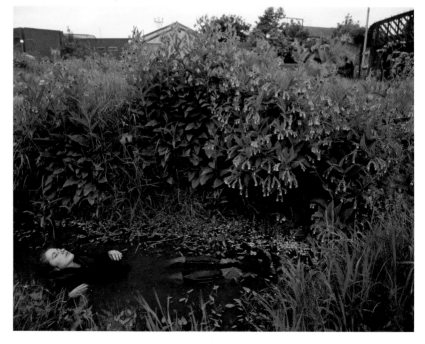

of Millais's painting. When historical visual motifs are used to depict a contemporary photographic subject in this way, they act as a confirmation that contemporary life carries symbolism and cultural preoccupations parallel with other periods in history. Art's position as chronicler of contemporary fables is reasserted.

45 Apsáalooke (Crow) artist Wendy Red Star (b.1981) works with humour and dramatic effect in her redressing of historical representations of Indigenous people and culture. In her *Four Seasons* series, Red Star purposely and astutely re-appropriates the objectification of Native American people and culture deployed in nineteenth- and twentieth-century photographic surveys and in museum and exhibition displays in the service of colonial agendas. Red Star presents herself, wearing a traditional elk-tooth dress that identifies her Apsáalooke (Crow) ancestry, within clearly fabricated, synthetic environments that reference the scenographic simulation of a "natural habitat" in a traditional world's fair enclosure or natural history museum diorama. In so doing, she simultaneously shows the history of representation of Native American women to be an Imperialist construct, and counters and critiques its meaning by reclaiming its visual conventions into her own artistic actions, asserting the agency with which she represents herself.

45 Wendy Red Star, *Four Seasons – Winter*, 2006
46 OPPOSITE Hank Willis Thomas, *The Cotton Bowl*, 2011

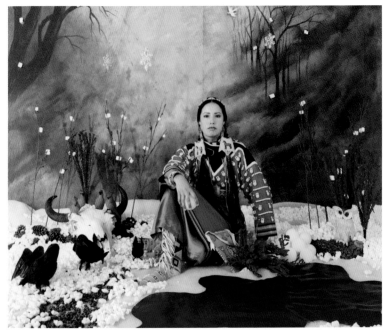

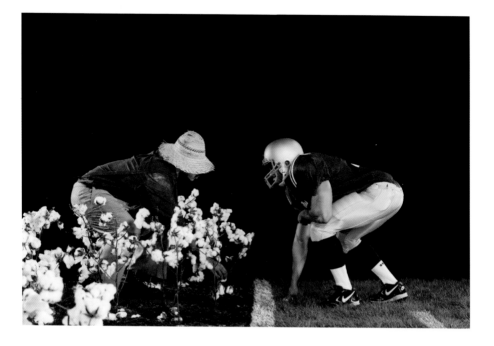

Tableau photography's aptitude for distilling multivalent references from the histories of art, photography and material culture makes it a powerful aspect of contemporary art photography. The construction, celebration and calling-out of representations of human identity and culture is used in the photographs and installations of artists including Juno Calypso (1989), Kudzanai Chiurai (b. 1981), Xaviera Simmons (b. 1974), and Lina Iris Viktor (b. 1987). Hank Willis Thomas's (b. 1976) *The Cotton Bowl* brings two iconic representations of African American men together for striking and immediate comparison. One black male figure is bent over in the backbreaking gesture of hand-picking a cotton crop, face hidden by a wide-brimmed straw hat. Cotton picking is a symbol of the exploitation of African slaves in nineteenth-century America, and of America's oppressive legacy of sharecropping after the abolition of slavery. Cotton was its dominant mass-consumer product and export until the 1930s. This characterization of enslavement faces his contemporary equivalent, represented as an American football player crouching on a football pitch. In *Cotton Bowl* (and within Thomas's wider project *Strange Fruit*, of which this is a component part), the contemporary sports entertainment industry is presented as today's version of a multi-billion-dollar

Once Upon a Time

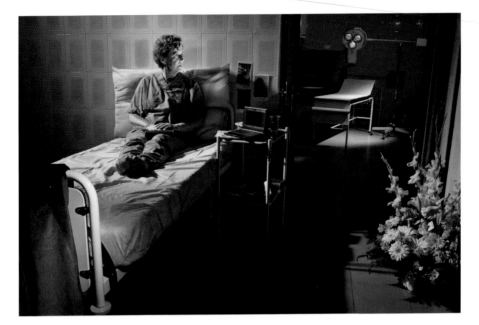

De: susan-morrisonexcite.com
Asunto: Re: Greetings
Fecha: 10 de septiembre de 2006 03:33:57 GMT+02:00
Para: infolademiddel.com

Hello,

You may be surprised to receive this mail, as you read this, don't feel so sorry for me because I know everyone will die someday. My name is Mrs. Susan Morrison, a business woman in London. I have been diagnosed with esophageal cancer which was discovered very late due to my laxity in caring for my health. It has defiled all forms of medication right now and I have only few hours left to live, according to medical experts...

47 Cristina de Middel, *Susan Morrison*, 2009
48 OPPOSITE Diana Markosian, *First Night in America*, 2018. From the series *Santa Barbara*.

industry that is systemically racist and highly exploitative of a predominantly black labour force. *Cotton Bowl* eloquently brings these historical and contemporary points in a centuries-long trajectory of exploitation and violence against African American men together into the same frame.

47 In her 2009 series *Poly Spam*, Spanish artist Cristina de Middel (b. 1975) orchestrated a series of tableau photographs, in which she visualized the 'authors' of the compelling scripts of spam emails that de Middel was receiving, and the desperate situations of their supposed senders. At times, de Middel would enter into correspondence with the scammers to learn more about their apparent situation, from which she staged her photographic interpretations of the fictional protagonists in these email scams. For some of the photographs, de Middel found locations in Spain and cast local actors; she also travelled to Senegal and portrayed actual lawyers in their offices, highlighting the degree of credibility and identity theft embedded within the most plausible scam attempts. In this photograph, she envisages an elderly woman who is about to have surgery for advanced esophageal cancer, who entreats de Middel in her email to distribute her multi-million-dollar wealth on her behalf in the absence of trustworthy family members, for a handsome fee.

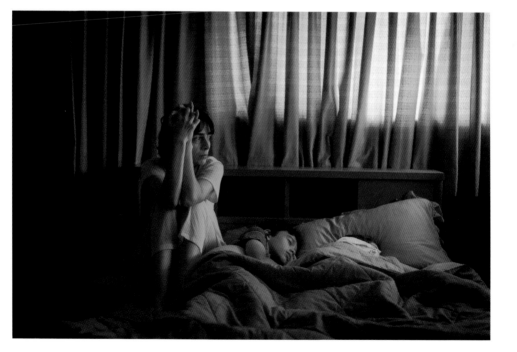

Diana Markosian's (b. 1989) *Santa Barbara* is a multi-form video and photography project that centres on the artist's recounting and dramatizing of her and her family's story. As a young child of Armenian descent, living in Moscow with her mother and brother, the American soap opera *Santa Barbara*, broadcast on Russian terrestrial television, offered an aspirational – albeit fictionalized – window onto life in America for many viewers. With hopes of a better future for her family, Markosian's mother started the process of becoming a mail-order bride, which eventually led to her arriving in California with her two young children and marrying an older man who lived in the fabled Santa Barbara. Markosian's film and photographic works melds the fictionalization of her family's story from each of their vantage points (in collaboration with the original script writers for the American soap opera *Santa Barbara*) with the realities of Markosian's process of casting actors to play the familial roles, and also her real mother's reactions and remembrances. In the photograph shown here,

49 Stefan Ruiz, *Baltazar Oviedo as Juan Salvador, Amarte es mi Pecado (Loving You Is My Sin), Mexico City, Mexico, 2003*. From the series *Factory of Dreams*.
50 OPPOSITE Max Pinckers, *Supplementing the Pause with a Distraction, 2012*. From the series *The Fourth Wall*.

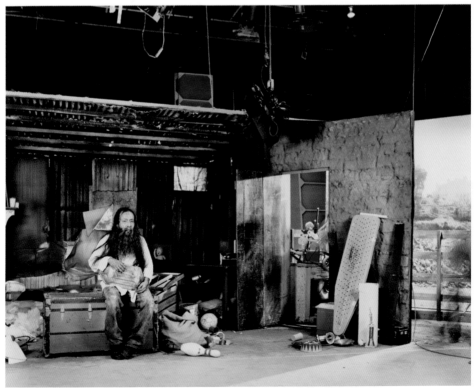

the actors playing Markosian, her mother and brother are shown on set in a scene scripted at night, shortly after their arrival in America, spotlighting the mother's narrative as she reflects on the complexity and reality of her circumstances. Iranian artist Azadeh Akhlaghi (b. 1978) has used a related strategy of re-enacting actual events as a starting point for her photographs. Using the death scenes of political and religious leaders, activists and cultural figures, Akhlaghi creates scripts for her cast of actors to enact, embody and reanimate turning points in twentieth-century Iranian history.

49 Over the course of eight years, Stefan Ruiz (b. 1966) took photographs at the Televisa TV studios in Mexico, where many of the most globally popular Spanish-language telenovelas (soap operas) are filmed. Ruiz created portraits of soap-star

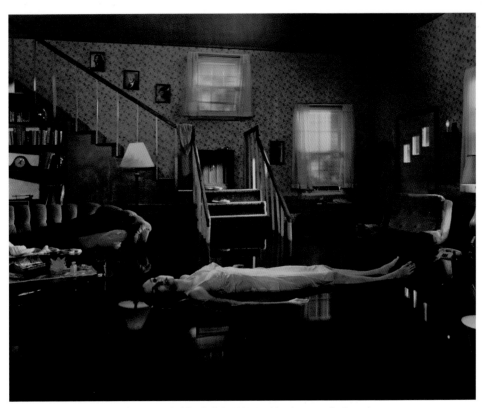

51 Gregory Crewdson, *Untitled (Ophelia)*, 2001. In this photograph, Crewdson recasts Shakespeare's Ophelia in post-war American suburbia. The *Twilight* series, of which this is part, brims with such elaborate scenes that reference sci-fi films, fables, modern myths and theatre.
52 OPPOSITE Charlie White, *Ken's Basement*, 2000. From the series *Understanding Joshua*.

actors and trainees in character both on and off set, before and after filming their scenes. His use of a large-format camera quietly captures the illusory drama, production design and visual contradictions of the studio environment, and makes legible the reduction of stories and characters to social, racial and gendered stereotypes. In Ruiz's photography, the epic escapism and hyperbolic stories of fortune, love and downfall that are the mainstays of daily telenovelas are staged day upon day on an industrial scale. Ruiz holds the viewer between the familiar seduction of the constructed fantasies played out in the TV studios, and the transience and fakery revealed to us by his behind-the-scenes images.

50 The subject of Belgian photographer Max Pinckers's (b.1988) *The Fourth Wall* project is the environment and wider cultural

influence of Bollywood filmmaking in Mumbai, India. In some respects, Pinckers's approach to this creative industry, which dramatizes and articulates cultural desires, fears and aspirations on a global scale, stems from documentary traditions. Among the many photographs in *The Fourth Wall* are relatively straightforward observational photographs in which Pinckers has subtly directed his photographic subjects to choreograph their actions for his camera and, in so doing, has revealed the ingrained, bodily effect of Bollywood films and their collective fantasies. Pinckers also harnessed the highly performative environment in which he was photographing – coincidentally, he later read a newspaper story about a robbery at a screen actress's home in which sleeping gas was pumped into her bedroom to keep her unaware of the robbery taking place, further affirming the inseparability of fact from fiction within and around his chosen subject.

51 American artist Gregory Crewdson (b. 1962) has said that his elaborately constructed melodramas are influenced by his memory of childhood. His psychoanalyst father's office was in the basement of their New York City home, and Crewdson would press his ear to the floorboards and try and imagine the stories being told in the therapy sessions. His mid-1990s tableau photographs are set in models of suburban backyards and undergrowth built in his studio. They are a mix of bizarre, disturbing and highly camp and entertaining. Stuffed animals and birds perform strange and ominous rituals, while plaster casts of Crewdson's body are shown being slowly devoured by insects, surrounded by lush foliage. Crewdson later shifted into

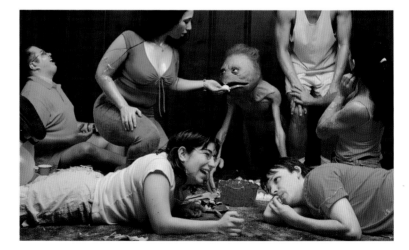

a more directorial mode. In his black and white series *Hover* (1996–7), he staged strange happenings in areas of suburban housing, photographing them from a crane above the rooftops. In his subsequent *Twilight* series, he worked with a cast and crew of the scale of a small, independent film set. Here it is not only the display of rituals and the paranormal, but also the construction of archetypal characters who carry out these acts that creates the psychological drama. Significantly, at the back of a book about *Twilight* is a 'documentary views' section that shows the entire production process, the crew members and the moments before and after a photograph is taken, confirming the degree to which Crewdson's tableau photography practice is akin to the production of a film or television show.

52 Fellow American Charlie White's (b. 1972) series of nine photographs *Understanding Joshua* implants the character of Joshua, a part-human, part-alien puppet crafted out of sci-fi references, into scenes of suburban American teen life. White's self-loathing protagonist has a fragile ego manifested in his physicality, seemingly a difference unnoticed by his friends and
53 family. In Japanese artist Mariko Mori's (b. 1967) installations
40 and photographs, which, like Jeff Wall's, are often displayed on light boxes, the production values are akin to those of luxury commercial image-making. They often resemble the architecture and point-of-sale design of contemporary fashion houses. The mixture of Far Eastern traditional arts and visual storytelling with contemporary consumer culture is part of Mori's trademark: she cherry-picks a range of styles and cultural

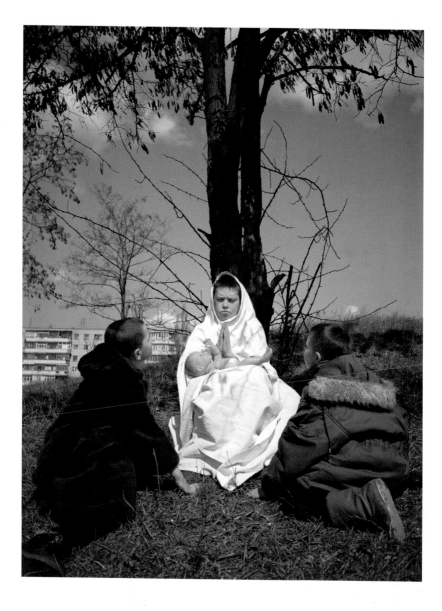

53 OPPOSITE Mariko Mori, *Burning Desire*, 1996–8
54 Sergey Bratkov, *#1*, 2001. As part of an artistic group in Kharkov in the Ukraine that also included Boris Mikhailov, Bratkov creates work in which there is a brutal clash between artistic performance and documentary photography. In the *Italian School* series, Bratkov photographed dress rehearsals of religious plays he had directed.

Once Upon a Time

references to bring the role of the photographer into close parallel with the visual inventiveness of a fashion stylist and art director. A regular theme in her work is the persona of the artist herself, who is often the central figure in her photographs.

Made in a reform school – a penal institution for children and young adults – in his hometown of Kharkov, Ukraine, Sergey Bratkov's (b. 1960) *Italian School* series directly references the iconography and perspectives of Italian Renaissance religious painting. Bratkov gained the local authorities' permission to photograph the children only by agreeing that the project would include religious instruction. Bratkov decided that he would direct the children in biblical plays within the fenced grounds of the school. He then photographed their performances.

Whereas the photographs previously discussed in this chapter draw on specific imagery and cultural genres for their narratives, many other photographers use the tableau formula

55 Wendy McMurdo, *Helen, Backstage, Merlin Theatre (the glance)*, 1996
56 OPPOSITE Liza May Post, *Shadow*, 1996

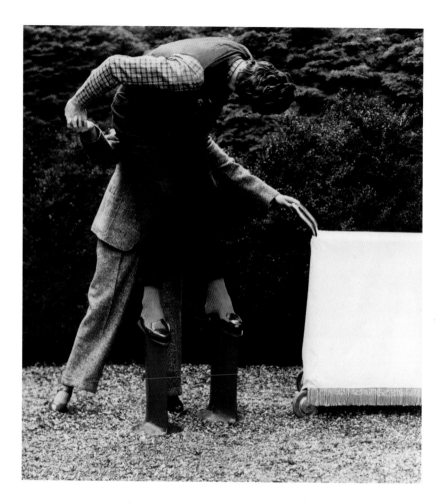

for more ambiguous, unreferenced narratives. By reducing the specificity of a place and culture, these tableau photographs often have the quality of a scene from a recurring, collective dream. The use of youthful protagonists is especially prevalent in tableau photography that has sought to visualize collective fears and fantasies, with an emphasis on the uncanny. Wendy McMurdo's (b. 1962) *Helen, Backstage, Merlin Theatre (the glance),* in which digital technology is used to represent a child and her doppelgänger, is an example of tableau photography in which the constructed nature of the image is foregrounded. The girls look quizzically at their doubles on a theatre stage, and the choice of setting alludes both to the staged photograph and the transformative space of the theatre.

55

Once Upon a Time

The magical, dream-like qualities of Dutch artist Liza May Post's (b. 1965) photographs and films are often created using custom-made clothing and props, which lift and contort the bodies of her performers into strange forms. In *Shadow*, both figures are dressed in androgynous clothes that hide their gender and age. The front figure wears stilted shoes that push the body into a precarious pose. The figure behind is more stable, but linked by a claw-like prop to a strange, wheeled object with a fringed cover, extending the sense of fragility in the scene. Post's details are hyper-real and, like a surreal dream, their combination and visual charge leaves the photographic narrative open to interpretation. As a format, tableau photography is able to carry intense-but-ambiguous dramas, left to be shaped by viewers' own trains of thought.

The psychological drama of Sarah Dobai's (b. 1965) *Red Room* is apparent, but left intentionally open-ended. Personal effects are starkly absent from the interior, and it is unclear whether this is a domestic or institutional space. The red blanket could be a sign of a character's taste or a prosaic way of disguising the roughness or dilapidation of the upholstery beneath it. The photograph was in fact taken in Dobai's living space, practical and familiar surroundings in which to stage her psychologically intense series while allowing some

material signs of her life to become part of the work. The pose of the figures hovers between the moment before or after a kiss or sexual act, their awkwardness and hidden faces filling the encounter with tension and uncertainty. The woman's white vest simultaneously denotes the unglamorous nature of domestic sex and a deep self-consciousness – coupled with the common anxiety dream of being seen semi-naked in public.

American photographer Sharon Lockhart (b. 1964) interweaves documentary photography, as a straightforward representation of a subject, with elements that disrupt the certainty of such a status. A series of photographs and accompanying short film, all depicting a Japanese female basketball team, demonstrates the balance between fact and fiction for which she is well known. Lockhart frames single figures and groups of players, cropping out enough of the indoor court to begin to abstract the nature of their movements and the game. In *Group #4: Ayaka Sano*, she has isolated the balletic pose of a single figure so that the girl's action,

57 OPPOSITE Sarah Dobai, *Red Room*, 2001
58 Sharon Lockhart, *Group #4: Ayako Sano*, 1997

understood as participation in a match, becomes tenuous, perhaps a posture that the photographer has orchestrated entirely. Doubt pervades the meaning of the image; the rules of the game played and the documentary function are both equally subverted.

Another pictorial device used in tableau photography to engender anxiety or uncertainty about the meaning of an image is to depict figures with their faces turned away from us, leaving their character unexplained. In Frances Kearney's (b. 1970) series *Five People Thinking the Same Thing*, five individuals are shown undertaking simple activities in sparse domestic interiors, all looking away. The thoughts preoccupying these unidentified figures are not revealed, leaving it up to the viewer's imagination to draw out potential explanations from the subtle and simplified depictions of a person's gestures and habitat.

Hannah Starkey's (b. 1971) *March 2002* uses this same device to give the figure of a woman sitting in a Japanese-styled canteen a surreal and mystical air. The possible readings of the

59 Frances Kearney, *Five People Thinking the Same Thing, III*, 1998

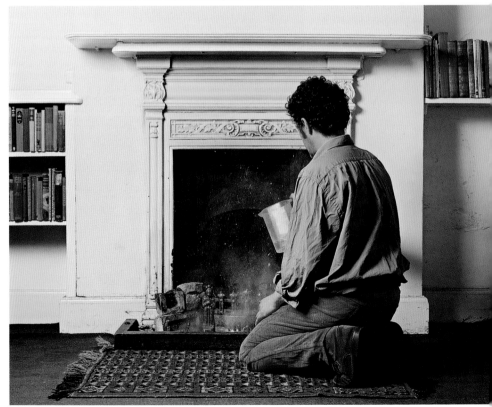

60 Hannah Starkey, *March 2002*, 2002. Starkey's tableau photographs are highly preconceived. Her working process starts with the building of a mental image of a scene. The search for a location, casting and choreographing of the photographs are a magical conflation of a preconceived idea and Starkey's acute awareness of how to observe the world around us.

woman's character are somewhere between a sophisticated urban dweller awaiting an assignation and an imaginary creature with long grey hair curling around her shoulders, like a mermaid from the watery scene on the canteen wall. Since the late 1990s, Starkey has shown the often-solitary female protagonists of her photographs caught in self-possessed reflection, visually connected with the world around them in ways that are transformed by Starkey into astute counter-arguments to prevailing, patriarchal media definitions of 'femininity'. There is a sense that Starkey's staged photographs elaborate on her real-life observations of strangers who trigger her curiosity and empathetic familiarity. Neither Kearney's nor Starkey's figures give enough visual information to make characterization the focal point of the image. Instead, the viewer is pushed to make meaning from the situation within which we encounter them; to make dynamic connections between interior space or objects and the possible characters of the people depicted. The spaces around the figures are much more than the confirmation of their identities; they

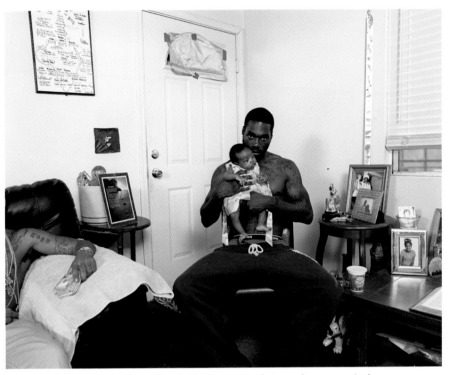

61 Deana Lawson, *Sons of Cush*, 2016. Lawson's photographs are a meticulous blend of the artist's intricate preconception with the physical presence and agency of her human subjects, dramatically articulating layered narratives of actual and symbolic experiences within the African diaspora, predominantly in America.
62 OPPOSITE Sarah Jones, *The Guest Room (bed) I*, 2003

offer clues to who and where they might be in relational and emotional terms.

American artist Deana Lawson's (b. 1979) photographs are a meticulous and amplifying blend of intricate preconceptions by the artist with the physical presence and agency of her human subjects. Lawson's body of work, which so far portrays mainly one or two sitters in each photograph, dramatically articulates layered narratives of actual and symbolic experiences within the African diaspora, predominantly in America. Lawson's approach is premeditated; she envisions her photographs and sources objects and props to be assembled in a multi-layered tableau, before finding and casting her subjects, often in the course of her daily life and interactions. She attempted an earlier iteration of *Sons of Cush* before meeting the father in this image, who holds the camera's gaze and carefully presents his baby girl (wearing a christening robe that Lawson had

picked out for the final photograph). Set within a modest domestic environment, the scene shows arrangements of objects and signs of real life, from the framed family photographs and the towel protecting the arm of the sofa to the foil taped to the door's window to gain some privacy. Other visual signs are emblematic on a deeper level, such as the partially shown man holding a stack of dollars and the writing on the whiteboard on the wall above him, which maps out the patrilineage of the biblical figure Cush, including his son, Nimrod, who is described in the Hebrew Bible's Table of Nations as 'a mighty one in the earth'.

62 British artist Sarah Jones's (b. 1959) portrayals of girls posed in interiors are consciously constructed out of the tension between the authentic and the projected, both in terms of imagery and experience. In *The Guest Room (bed) I*, a girl is shown lying on the bed in a faded and impersonal room. Because the indication is that she is not portrayed in her own room, the bed becomes a motif rather than a depiction of the subject's environment, its symbolism drawn from art history – Édouard Manet's (1832–1883) *Olympia* (1863) comes to mind. The horizon its bulk creates also triggers associations with the formal compositions of land- and seascapes. While the girl's long hair is naturalistic, it is not connected to any specific contemporary fashion, and her character retains its ambiguity as both archetypal and personal. Similarly, her

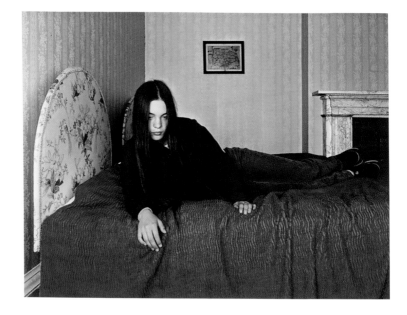

pose is in part a spontaneous response to the situation that
Jones has orchestrated for the photographic shoot, while at the
same time appearing to be drawn from the pre-photographic
gestures of reclining female figures in the histories of painting
and sculpture.

The otherworldliness to be found in contemporary life is
also a theme in the work of the Polish-American artist Justine
Kurland (b. 1969). The settings for her photographs of the late
1990s and early 2000s are the playgrounds and homesteads of
young women, often in remote places of natural beauty and
on the edges of urban environments (though older women
and men are also represented in her work). She stages these
contemporary idylls, with a hint of nostalgia for the back-to-
nature lifestyles of the 1960s, in remote, almost out-of-present-
time locations and situations that imaginatively propose a
matrilineal alternative to the strictures of patriarchal society.

The conscious adoption of established aesthetics and
formal conventions to amplify the drama of real-life scenarios
is brilliantly deployed by An-My Lê (b. 1960) in her *29 Palms*
series (2003–4). Lê's subject is an American Marines training
zone in the Mojave Desert, where soldiers have prepared for
combat in Iraq and Afghanistan. Her decision to photograph

63

64

63 Justine Kurland, *Buses on the Farm*, 2003

64 An-My Lê, *29 Palms: Infantry Platoon Retreat*, 2003–4

the behind-the-scenes 'rehearsals of war' that take place there in black and white, using a large-format camera, calls forth the history of war photography since the mid-nineteenth century. Additionally, she temporarily adopts the ambiguous 'camouflage' of a professional photographer, embedded within the day-to-day of the US military, ostensibly documenting training manoeuvres. Lê's subjects are not staged for her camera, but by adopting a laboured and archaic form of photography they speak of both contemporary and age-old enactments of imperial power, as well as the role that photography has played in such conflicts.

65 In Christopher Stewart's (b. 1966) *United States of America*, the blinds of a hotel room are shown closed in daytime; a man possibly of Middle Eastern origin is surreptitiously surveying the outdoors while waiting for the telephone to ring. It feels like a covert operation, but we are unsure if it is within or outside the boundaries of the law. Stewart photographs the actions of private security firms (made up of ex- or serving militia personnel), finding contemporary allegories for Western insecurity and paranoia. In so doing, his approach intentionally avoids taking a conventional documentary or photojournalistic

65 Christopher Stewart, *United States of America*, 2002. This photograph was taken while shadowing security professionals on training sessions. What is surprising, given the drama of the lighting and lack of distracting detail in the interior, is that Stewart did not choreograph the figure or alter the interior at all.

route to depict these security situations and, instead, he makes use of the formula of tableau photography to give a weighty drama to the real stakeouts he witnesses.

The final part of this chapter concentrates on tableau photography that is not reliant on human presence, but that finds drama and allegory in physical and architectural space. Finnish artist Katharina Bosse's (b. 1968) empty interiors are spaces designed for sexual play. These themed rooms in New York, San Francisco and Los Angeles are legally available for hire as venues for sex, and what is drawn out in Bosse's representations is the generic and clichéd nature of sexual fantasies, the crossover from intimate to institutional spaces. Bosse's photographs encode their poignant reading, in which architectural spaces contain the trace of an act that will generate its own stories.

Beginning in 2002, British artist Sarah Pickering (b. 1972) created a trilogy of photographic projects that explore environments and scenarios in which firefighters, police and

66

67

military forces are pre-emptively trained to control civil unrest and environmental disaster. She started her *Public Order* project ahead of undertaking graduate study, photographing at a training site for British Police Service specialist officers to practise maintaining public order in scenarios tellingly grouped together as related situations – including riots, public protests, anti-social behaviour and street violence. The training ground is a construction of streets, alleyways and building facades, with a train station, nightclub and a football stadium. Its simulation of an urban environment as a simplified network of buildings and streets, with signifiers of habitation such as graffiti, litter and (as shown here) signs of the aftermath of street violence, creates a scenography of social disorder and visualizes the ideological polarization of civilian unrest and resistance and the enforcement of governance and order.

Canadian Miles Coolidge's (b. 1963) *Safetyville* project, by contrast, is an uncanny depiction of an abandoned town, devoid of people, litter and personal details. Safetyville is a model town in California (one-third the scale of a real town)

66 Katharina Bosse, *Classroom*, 1998. Bosse photographs rooms that can be hired for sex, themed to cater for the most popular sexual fantasies. She depicts them while they are empty, like stage sets before or after a performance.

built in the 1980s to educate schoolchildren about road safety. In Coolidge's photographs, the commercial and federal signage that gives plausible detail to the town is prominent, highlighting the extent to which the structural organization of contemporary Western life by corporations and government pervades even this fake urban space.

German photographer Thomas Demand (b. 1964) deals with the obstinate presence of inanimate objects, mainly within architectural interiors. Demand starts his construction process with a photograph of an architectural place, sometimes a specific space such as Jackson Pollock's (1912–1956) studio barn or the underpass in Paris where Diana, Princess of Wales (1961–1997) was fatally injured. He then builds a simplified model of the scene in his studio, using Styrofoam, paper and card. At times, he leaves small signs of imperfection in his reconstruction, with tears or gaps in the paper as a way of signalling to the viewer that this is not a fully convincing reconstruction of a site. He then photographs the scene. Despite the lack of wear or dirt on the model and the recognition of its construction from flimsy materials – and hence of its non-functioning nature –

67 Sarah Pickering, *Farrance Street*, 2004. From the series *Public Order*.

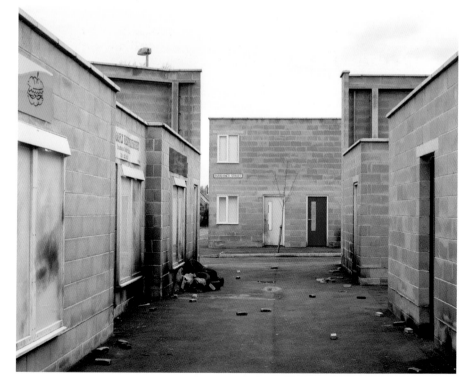

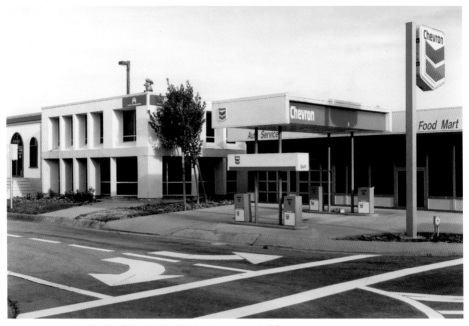

68 Miles Coolidge, *Police Station, Insurance Building, Gas Station*, 1996. From the series *Safetyville*.

the viewer is encouraged to decipher the significance of the space and the human acts that might have taken place there. It makes for a hyperconscious viewing experience, as we look hard for narrative form despite the inbuilt warning signs that this is a staged, therefore unreal, place. The close viewpoint and large scale of the works makes Demand's viewers less an audience looking onto an empty stage and more active investigators, asking how little of a physical subject and how much of the photographic approach we need in order to start the process of imagining meaning and finding familiar narrative.

70 British artist Anne Hardy's (b. 1970) photographs and installations are constructed interiors that appear abandoned, but are invariably filled with a host of clues and traces of human activity. Hardy constructs sets in her studio with a defined camera position in mind, building her scenery exclusively for this photographic vantage point. The skill of making a photograph such as this is to avoid overloading the image with obvious signs and allegory, while maintaining a sense – a carefully constructed and coded one – that we are observing a scene weighted in human action and experience.

Once Upon a Time

Hardy's photographs often start with her finding objects discarded on urban streets, that have lost their original place and function, around which she creates her sets. In this photograph, Hardy invites us into a DIY basement recording-studio environment, with sculptural stacks of speakers, four microphones carefully propped on the floor and ribbons of dark plastic film suggesting unwound reels of audio master tapes. The presence of human action – both the artist's actual labour in creating the scene, and the imagined activity of the absent fictional characters whose actions she has constructed – is coupled with an uncanny sense of approximation and simplification in the photograph's pseudo-Modernist, formal composition of lines and blocks of colour and shapes.

69 Thomas Demand, *Salon (Parlour)*, 1997

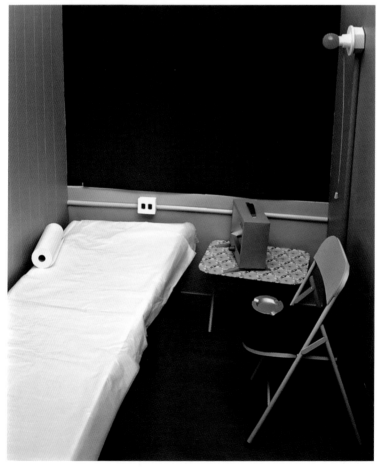

70　Anne Hardy, *Flutter*, 2017

71 Celine van Balen, *Muazez*, 1998. Van Balen's portraits of residents in temporary accommodation in Amsterdam include a series of head-and-shoulders portraits of Muslim girls. Her choice of the stark, deadpan aesthetic to represent the girls emphasizes the self-possession with which they confront her camera and their presence in contemporary society.

Chapter 3
Deadpan

The most prominent and probably most frequently used style of photography since the 1990s has been the deadpan aesthetic: a dispassionate, patient, keenly sharp version of photography that heralded the medium's status as a contemporary art form. The adoption of a deadpan aesthetic moves art photography outside the hyperbolic, sentimental and immediately subjective. Such pictures may engage their viewer with emotive subjects, but the sense of the photographer's emotional perspective is not an obvious guide to understanding their meaning. Deadpan photography offers an apparently measured way of seeing beyond the limitations of a subjective vantage point, pausing to contemplate and distil the flow of time; a way of mapping the extent of phenomena and forces that govern the man made and natural world and can be invisible from a physical and emotional human standpoint. Deadpan photography may be highly specific in its description of its subjects, but its seeming neutrality, specificity and totality of vision is of epic proportions.

The deadpan aesthetic became popular in the 1990s, especially with landscape and architectural subjects. Deadpan photographs, so technically well-done, so pristine in their presentation, rich with visual information and with a commanding presence, lent themselves well to the newly privileged site of the gallery as a place for seeing photography, moving the medium towards a central position in contemporary art. The impetus within art to define new trends to supersede established 'movements' played in deadpan photography's favour in the early part of the decade. Imagery that offered an objective and almost clinical mode had renewed freshness and desirability after a heavy concentration on painting and so-called neo-expressive, subjective art-making in the 1980s.

Although the art world's acknowledgment of the deadpan approach dates to the early 1990s, today's front-ranking practitioners had been working out of the limelight for at least half a decade before. Some of the principal figures in the establishment of photography within contemporary art were educated under Bernd Becher (1931–2007) and Hilla Becher (1934–2015), at the Kunstakademie in Düsseldorf, Germany. The school was instrumental in unshackling photography education from the teaching of vocational and professional skills such as photojournalism, instead encouraging its students to create independent, artistically led pictures. The 1920s and 1930s tradition in German photography known as New Objectivity (Neue Sachlichkeit), encapsulated in the photographs of Albert Renger-Patsch (1897–1966), August Sander (1876–1964) and Erwin Blumenfeld (1897–1969), are also considered part of the lineage of deadpan photography.

In 1957 the Bechers had begun collaborating on black and white photographs of pre-Nazi German industrial and vernacular architecture, such as water towers, gas tanks and mine heads, organized into series. Each building within a series is photographed from the same perspective, notes are taken on each and a typology is systematically created. The Bechers' work appeared in 'New Topographics: Photographs of Man-Altered Landscape', a touring exhibition that began in America in 1975 and is considered an important cultural marker of photography's recognition as an art form. The show was an early attempt to appraise European and North American photographers' reinvestment of topographical and architectural photography with the implications of contemporary urban generation and the ecological consequences of industry. What is significant is that these social and political issues were raised in the context of the art gallery and within the discourses of conceptual art, supported by the movement away from obviously subjective photographic styles.

One of the major figures of this earlier period was the American photographer Lewis Baltz (1945–2014), an influential instigator of the critical reworking of photography. His icy-cool, consciously minimalist black and white photographs map the uneasy encroachment of industrial and housing developments onto open landscapes. In their own way as significant as the Bechers' work, Baltz's photographs of the 1970s and 1980s harnessed the medium's documentary capacity to depict fast-changing social environments with a conceptual precision that gave it the right tenor for art-world status. After moving from America to Europe in the late 1980s, Baltz worked with colour photography to represent the new high-tech environments of

72

72 Lewis Baltz, *Power Supply No. 1*, 1989–92. Baltz's photographs depict rapidly changing social environments – such as high-tech research laboratories and associated industries in Europe – with a conceptual precision suited to the context of the art gallery.

research laboratories and industries, illustrated here with a photograph from his *Power Supply* series (1981–91). This shift to colour photography was necessary for Baltz to focus attention on the spectacle of 'clean' industries, and the codification and zones of data carried by these pristine spaces.

73 Taryn Simon's (b. 1975) *American Index of the Hidden and Unfamiliar*, published in its entirety as a book in 2007, remains one of the most singular photographic chronicles of American mythology and structural history of the twenty-first century. Simon took on the almost insurmountable challenge of photographing – and indexing – a spectrum of hard-to-access sites and scenarios throughout America. Her subjects range from a cryptopreservation facility and a junction where submarine transatlantic telecommunications cables surface into American terrain to the CIA's art collection, a hibernating bear, a braille edition of *Playboy* magazine and, shown here, an avian quarantine facility. Simon's photographs are dazzling in their envisioning of the hidden workings of American structures, procedures and phenomena – both in terms of the sustained

Avian Quarantine Facility, The New York Animal Import Center, Newburgh, New York

European Finches seized upon illegal importation into the U.S. and African Gray Parrots in quarantine.

All imported birds that are not of U.S. or Canadian origin must undergo a 30-day quarantine in a U.S. Department of Agriculture animal import quarantine facility. The quarantine is mandatory and at the owner's expense. Birds are immediately placed in incubators called isolettes that control the spread of disease and prevent cross-contamination by strategically placed High Efficiency Particulate Air (HEPA) filters. Before each quarantined bird is cleared for release, it is tested for Avian Influenza and Exotic Newcastle Disease.

Taryn Simon, from *An American Index of the Hidden and Unfamiliar* (2007)

73 Taryn Simon, *Avian Quarantine, The New York Animal Import Center, Newburgh, New York*, 2007

ideological narrative of American Exceptionalism that they collectively speak to, and in their strangely pedestrian and even banal material presence.

5, 74 The photographer Andreas Gursky (b. 1955) has become something of a figurehead for contemporary deadpan photography. He moved towards using large prints in the late 1980s, and through the 1990s pushed photography to new heights and widths. His works make for imposing objects – pictures to stop you in your tracks – and he has become synonymous with work on a monumental photographic scale. Gursky was one of the early adopters of digital imaging tools, and has brought traditional and new technologies together, using large-format cameras for maximum clarity and digital manipulation to refine and tile multiple image files into a single photograph. Significantly, his photographs are not primarily contingent on being viewed as part of a series. He shifts his photographic approach only gradually, more in the realms of his photographs' production values (such as size and framing) than in obvious changes in concept, tenor or subject matter. Instead, he operates like a painter might: each satisfyingly complete picture adds to his oeuvre and every photograph he releases has a good chance of contributing to the high reputation enjoyed by his work as a whole. Gursky has worked in connected themes throughout his practice, and his photographs stand as discrete but consistently recognizable visual experiences. His signature vantage point and, it is often claimed, his first critically acknowledged innovation is a viewing platform looking out over distant landscapes and sites of industry, leisure and commerce such as factories, stock exchanges, hotels and public arenas. He often places us so far away from his subjects that we are not part of the action at all but detached, critical viewers. From this position, we are shown a mapping of contemporary life governed by forces that are not possible to see from within the crowd or from a monocular perspective – the pseudo-simulation of human vision with which photography has traditionally been credited. Human figures are usually minute and densely packed in a mass; when individual actions or gestures can be picked out, they are like notes within chords of general activity. At their most vivid, these works give us a sense of omniscience: we see the scene as a whole made up of tiny constituent parts and feel akin to a conductor in front of an orchestra.

Although Gursky commands a dominant position in our understanding of the capacities of deadpan photography, he by no means holds the patent on either this style or its range of subjects. Many photographers have similarly been drawn to analyzing the world with the thoughtfulness and precision that

74 Andreas Gursky, *Chicago, Board of Trade II*, 1999

Deadpan

75 is possible in their medium. Sze Tsung Nicolás Leong's (b. 1970) *History Images* rely on considerate, slow photography to provide a stunning frame through which to meditate on the impact of accelerated change in contemporary China. Between 2000 and 2004 Leong photographed in China's rapidly developing cities, including Beijing, Guangzhou, Nanjing and Shanghai, with the purpose of recording, 'histories...in urban form.' Leong portrays not only the epic scale of structural transformation of China in the early twenty-first century, but the removal of the material remnants of the region's history, itself the logical conclusion of the eradicating ideology of China's 1966–76 Cultural Revolution. By visualizing the moments between

75 Sze Tsung Nicolás Leong, *Chunshu, Xuanwu District, Beijing*, 2004. In his *History Images* series, Leong visualizes the moments between the total erasure of China's Imperial architectural history and the inscription of its future history onto its urban fabric, photographically tracking the dynamics of history.
76 OPPOSITE Edward Burtynsky, *Oil Fields #13, Taft, California*, 2002

the erasure of these material, architectural remnants and the creation of a new urban future, Leong marks out the very concept and dynamics of history.

76 In Edward Burtynsky's (b. 1955) photographs of Californian oilfields, the landscape is shaped by industry, with oil pumps and telegraph poles weaving across its surface as far as the distant ridge of mountains in the background. While social, political and ecological issues are embedded in his subjects, they are visualized as objective evidence of the consequences of contemporary life and the exploitation of the earth. Polemical narratives are raised for the viewer, but this information appears to have been given impartially. Deadpan photography often acts in this quasi-factual mode: the personal politics of the photographers come into play in their selection of subject matter and their anticipation of the viewer's analysis, not in any explicit political statement through text or photographic style.

77 Jacqueline Hassink's (1966-2018) *Mindscapes* project, published as a book in 2003, links a number of investigations

of architectural spaces for both public and private use within transnational businesses. Hassink applied to photograph ten rooms in a hundred American and Japanese corporations (including the CEOs' home offices, archives, lobbies, boardrooms and dining rooms). The refusals and acceptances Hassink received feature on a graph that accompanies the photographs of the rooms to which she gained entrance. Does a board meet at a round or more hierarchically shaped table? Is the business traditional, its space decked out in wood panelling, or does it adopt a high-tech minimalist appearance, suggesting a forward-thinking and progressive mode of commerce? The results of Hassink's systematic approach spell out the generic links between corporations, regardless of the nature of their business, and the values that each corporation attaches to itself through the demarcation of space.

For over fifteen years, Candida Höfer (b. 1944) has made cultural institutions her subject, creating an archive of the spaces in which collections are stored and accessed. Höfer's approach was developed using a handheld medium-format camera, which allowed her to work unobserved and with a

77 Jacqueline Hassink, *Mr. Robert Benmosche, Chief Executive Officer, Metropolitan Life Insurance, New York, NY, April 20, 2000*, 2000

78 Candida Höfer, *Bibliotheca PHE Madrid I*, 2000

degree of intuition when looking for the viewpoint that best described what she found in these spaces. This approach has carried through into Höfer's work using a large-format camera, and has given her room for the inclusion of unexpected elements in the construction of her imagery. Her pictures' clear, lengthy gaze is prevented from being a deadening experience by her choice of a perspective that does not edit out the oddities and contradictions of the interior space. At times, this is done simply through the choice of a vantage point where we see the space sitting subtly out of kilter with the architectural symmetries of the site.

Deadpan photography has a great capacity for capturing the wonder of the manmade world in an elegiac manner. For over thirty years, Naoya Hatakeyama (b. 1958) has photographed cities and heavy-industrial spaces in his native Japan. His

79

79 Naoya Hatakeyama, *Untitled / Osaka*, 1999

Deadpan

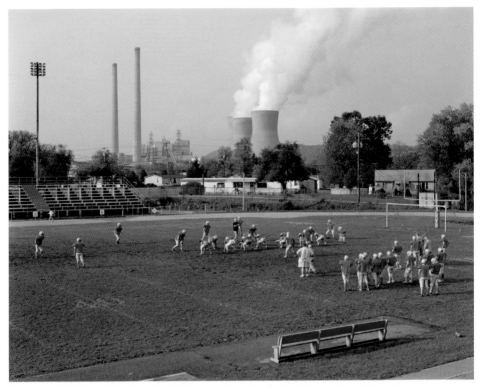

80 Mitch Epstein, *Poca High School and Amos Plant, West Virginia*, 2004. Epstein foregrounds the towers of a coal-fired power plant with the scene of a high school American football team in a practice session – dwarfed yet seemingly unconcerned by the industrial power on their horizon.
81 OPPOSITE Dan Holdsworth, *Untitled (A machine for living)*, 1999

ongoing *Untitled* series, begun in the late 1990s, features views over Tokyo exhibited in a grid of small photographs – an evocation of the infinite photographic views onto the chaotic, ever-changing and seemingly unnavigable layout of the city. Hatakeyama has also collaborated with the architect Toyo Ito (b. 1941), photographing Ito's buildings during construction and engaging with the conceptual thinking and structure that underpins the architectural process. *Untitled, Osaka* is an elevated view into a baseball stadium as it is converted into a show-home park. It is represented as a contemporary settlement, yet somehow similar to a classical ruin. There is a breathtaking magic in the photograph that suggests that something impossible to see either at close quarters or in the real-time motion of the busy city is contained in its awesome span.

Since the early 2000s, American photographer Mitch Epstein (b. 1952) has created extensive photographic surveys that stand as deep, compelling essays about the state and decline of individual lives, communities, resources and landscapes in America. From 2003 to 2005, Epstein travelled across America and photographed his series *American Power* with the overarching theme of investigating the privileging (and power) of corporate agendas over constitutional protection of American labour and the environment. He focused on small towns and suburbs in close proximity to the nuclear, fossil fuel, solar and wind power industries, as well as the destruction in the wake of environmental trauma – such as the devastation caused in the path of the Atlantic Hurricane Katrina in 2005. Each photograph in *American Power* articulates a different vantage point; the images collectively build into a narrative about the impact, divisiveness and consequences of power, and the vulnerability of both American ways of life and the resources on which civilization relies. In *Poca High School and Amos Coal Power Plant, West Virginia*, Epstein shows the towers of a coal-fired power plant, emanating smoke that contains airborne pollutants, behind a scene of a high-school American

football practice session. Such non-hyperbolic photography frames a wide and revealing record of human behaviours and cultures. Contemporary photographers who continue this long-held photographic tradition, taking the viewer into the specificities of places and quiet encounters with strangers, include Joshua Dudley Greer (b. 1980), Brian Schutmaat (b. 1983) and Max Sher (b. 1975).

Since the late 1990s, British artist Dan Holdsworth (b. 1974) has photographed transitional architectural spaces and remote landscapes where a human-scale sense of place is questioned and dislocated. His projects are linked together by an intensely investigative and analytical idea of photography and its capacity to capture the characteristics and phenomena of places, as defined by the energetic accumulation of glacial time or human intervention. In his photographs of the car parks of a newly built out-of-town shopping centre, Holdsworth uses nighttime as both the temporal equivalent of the auspicious spaces he depicts, and the best conditions with which to describe them. By setting up his camera for a long exposure, the lights of the car park and the traffic are made to radiate a luminescence that both defines and contaminates the site. The image has a distinctly non-human perspective, rendered by the long duration of the photographic capture – as if showing us the essence of a place that could not be perceived by the

82 Takashi Homma, *Shonan International Village, Kanagawa*, 1995–98

83 Simone Nieweg, *Grünkohlfeld, Düsseldorf – Kaarst*, 1999

naked eye. Rather than asking *who* took this photograph, one might reasonably ask *what* took it; one gets the sense that the unsettling contamination of the night is being recorded mechanically and empirically.

82 Japanese artist Takashi Homma (b. 1962) photographs newly built suburban housing and the landscaping around it in Japan. Everything in these developments is strategically placed, and Homma purposely amplifies the sense of the sites as a synthetic construct on the outer edges of suburban sprawl, positioning his camera at a low vantage point and photographing only when they are devoid of signs of a human community. The atmosphere of the recently constructed, blueprinted way of life, in readiness for controlled and systematized habitation, is all-pervasive. Homma's imagery develops ideas that first emerged in the 1970s, when the dehumanizing impact and politics of housing developments and the industrial use of land began to be coolly and categorically raised in photographic practice.

Other deadpan photographers shift the emphasis away from economic and industrial sites and towards less obvious contemporary subjects. Landscapes and historical buildings have an innate capacity to be understood as sites where time is layered and compacted. We engage not only with the moment the photograph was taken, but also with its depiction of

84 John Riddy, *Maputo (Train) 2002*, 2002. In his architectural photographs, Riddy finds the most balanced vantage point for the camera. This conscious decision minimizes our awareness of the photographer's perspective on (and reaction to) the sites and aims to bring the viewer into a direct relationship with the subject.

the passing of the seasons or the memories of past cultures
83 and historical events. Since 1986, Simone Nieweg's (b. 1962) photographs have concentrated on the agricultural land of the Lower Rhine and Ruhr districts of Germany. Although she has worked occasionally in other landscapes, her preference has been to photograph the places near to where she lives so that she can study them over a lengthy period of time. The deadpan aesthetic that Nieweg favours, with its signature clarity of vision and diffuse light from an overcast sky, is perfectly matched to her thoughtful, subtle observations. There is a special emphasis on the planar qualities of hedgerow banks and woodland, and the linear organization of plough furrows and garden allotment crops. Her images often include some small disruption of agricultural order, as in *Grünkohlfeld, Düsseldorf – Kaarst*, where the traces of a contaminated patch of crop are centrally positioned in the foreground, a subtle allegory of nature's resistance to farming.
84 British photographer John Riddy (b. 1959) has an ongoing interest in photography's capacity to conflate time and

evoke the history of a space. In *Maputo (Train) 2002*, the turquoise paintwork and benches become the fading signs of Mozambique's colonial past, which stretched from 1498 to 1975, when the country became independent from Portugal. Present time is shown in the train carriage at the centre of the image, an element we know will soon depart without a trace. Riddy photographs his scenes from a precise angle at which the architecture falls symmetrically – a choice that acknowledges the ability of certain angles to make the photographer's perspective (or experience) more evident to the viewer, and holds our attention as we explore the visual layering of the history embedded within a place.

85 This compositional style also pervades Thomas Struth's (b. 1954) photography – be it the camera's position in the middle of the road in his street scenes in Düsseldorf, Munich, London and New York in the 1980s and early 1990s, or the formal poses of family groups, or his ongoing portrayal of the enclosed sites of scientific and technological industry. His works make us conscious of looking not only at a clearly depicted subject but also at the photographic form into which they have been projected. Struth invites us not to feel part of the scenes or to empathize with the relationships shown, nor to think of the images as revealing heightened moments in time, but to wonder at their perspectives, at the pleasure of scrutinizing

85 Thomas Struth, *Pergamon Museum 1, Berlin*, 2001

Jem Southam, *Painter's Pool*, 2003

them as photographs. His series of works depicting galleries and their visitors includes the Pergamon Museum in Berlin, which contains ancient Greek sculpture and architecture laid out to simulate the architectural space of the public areas from which the sculptures and building facades were taken. This photograph shows us the scene as a site where contemporary social posturing meets the relics of grand civic display of long-dead societies. The poses of the figures in this photograph are public, yet strangely isolated and mannered as they individually engage with the spectacle of history and participate in this public gathering.

86 British artist Jem Southam's (b. 1950) *Painter's Pool* is a series of photographs set in woodland, looking onto a pond. The images were made at different times of the year, within a twenty-five metre radius of one another. The scene, which is in the south-west of England, looks overgrown and uncultivated – but the small stream was in fact dammed by a painter to create the pool, where he then worked exclusively. Only small signs of the painter's visits are visible, such as the ironing board on which he rested his drawing materials. Southam responded to the quandary faced by the painter – who had worked in this

87 Yoshiko Seino, *Tokyo*, 1997. Seino's pictures often contain contradictory elements; by photographing places where industry has polluted the natural world, she reveals the sites where organic life has begun to evolve in order to survive. Seino's understated aesthetic means that these images of persistent existence are subtle rather than triumphant.

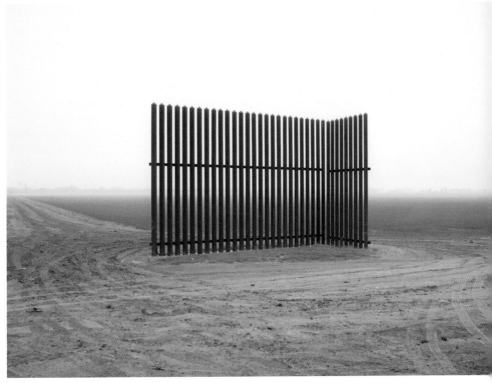

88 Richard Misrach, *Wall, Near Los Indios, Texas*, 2015

space for more than twenty years before completing a painting of the pool – by setting up a parallel photographic investigation of the site over the course of a year, with each visit offering the possibility of a new picture. Each photograph in *Painter's Pool* conveys the wonder of approaching the place and seeing it afresh each time.

87 Japanese artist Yoshiko Seino's (b. 1964) photographs often show places where nature has begun to reclaim a landscape from manmade efforts to use and shape it, subverting the intended hierarchy of nature and industry. Her choice of non-specific, marginal spaces means that it is not so much the decay of an architectural or industrial site that is emphasized, but the futility of human attempts to control nature, through Seino's visual allegories of how human neglect can give rise to a transformation back to nature.

88 For more than thirty years, American photographer Richard Misrach (b. 1949) has created poetic commentaries on landscape devastation and man's destruction of natural resources, most

notably in his ongoing photographic series *Desert Cantos*, begun in 1979, which centres on the landscapes of the American West. For *Border Cantos*, Misrach collaborated with the Mexican artist and sonic architect Guillermo Galindo (b. 1969) along the United States–Mexico border. Misrach's photographs are inspired by and installed with Galindo's sculptural forms and soundscapes, which are made from objects such as water bottles, shoes and utensils left by migrants, humanitarians, vigilantes and US Border Patrol officers along the border. The photographs are dirge-like visualizations of the environmental and human trauma of this contested site, which has become a symbol of nationalistic force without impunity and a so-called 'constitution-free zone'. In *Wall, Near Los Indios, Texas*, Misrach singles out an unfathomably disconnected portion of the 'border wall' held on a small patch of grass, encircled by vehicle tracks in the surrounding dirt on a misty landscape. The image embodies the impossibility of constructing a continuous wall through the 2,000-mile border terrain, and acts as a mournful monument to the consequences of political, social and environmental division.

89 South Korean artist Boomoon's (b. 1955) bodies of work share an implicit sense of the photographer as a guide into places from which we can observe the world and respond to

89 Boomoon, *Untitled (East China Sea)*, 1996. Because the seascape is framed with the horizon at the centre of each photograph in the series, the permutations of the cloud formations and wave patterns are the only decipherably changing elements.

90 ABOVE Clare Richardson,
Untitled IX, 2002. From the
series *Sylvan*.
91 LEFT Lukas Jasansky
and Martin Polak, *Untitled*,
1999–2000. From the series
Czech Landscapes.

it. This essentialist idea is amplified by Boomoon's choice of the natural world as his subject – places including oceans, volcanic landscapes and ice formations that by molecular and tectonic degrees share a profound state of infinite change. His series of photographs of the East China Sea, taken in the late 1990s, visualizes the idea that natural forces have infinite momentum and are governable by no one, impossible to name or hold sovereignty over, despite the ongoing contestation of its waterways and islets between South Korea and Japan. These images are consciously beyond political time, not reliant on the visual signs of contemporary economics, industry or administration, or even on those of the past, but on signs that bring us into contact with profound and destabilizing concepts about our perception of the world and our place within it.

90 The disconcerting photographs in Clare Richardson's (b. 1973) *Sylvan* series were made in farming communities in Romania, contemporary images of a world that has changed little for centuries. The clarity of Richardson's vision keeps her images free from being overtly sentimental, while revealing the strong visual links these isolated but functioning communities have with pre-modern (and pre-photographic) living. The fine balance between the sublime and romantic capacity of a landscape subject and a style of photography that is clear-cut and not obviously subjective has been a fertile creative area for contemporary photographers. Lukas Jasansky (b. 1965) and

91 Martin Polak's (b. 1966) *Czech Landscapes* concentrate on land use and ownership in the post-Communist Czech Republic. Significantly, these photographers work in black and white, which has had greater currency in early twenty-first century Eastern Europe than in the most commercially developed Western art centres, where colour photography has been much more common. To a degree, Jasansky and Polak's surveys of Czech architecture and landscape have a similar duality to the Bechers' practice: they are relevant to art in their conceptual framework, and also to conservation movements as documents of a changing country. The sense of a land administered in ways that have changed little, but which is on the threshold of late capitalism, echoes through the photographs.

92 Thomas Struth's *Paradise* series shows closely framed sections of forests and jungles whose density creates what he describes as 'membranes for meditation'. They have a synergy with his deserted street scenes of the 1980s, in which he attempted to create a photography that offered a distilled experience of complex visual scenes. In *Paradise*, every single organic element seems connected and impossible to disentangle. Struth's images are considered but intuitive in

92 Thomas Struth, *Paradise 9 (Xi Shuang Banna Provinz Yunnan)*, China, 1999

responding to these intricate sites. He uses photography as a tool for eliciting internal dialogue and contemplation in the viewer.

93 Charlotte Dumas (b. 1977) has observed tigers, wolves, dogs and horses to create startlingly vital depictions of animals in captivity, those living wild and feral existences and those trained to support and labour for us. In her 2011–12 project *Anima*, Dumas photographed the stable of horses at the Arlington National Cemetery, Virginia, trained to draw the funeral caissons of American soldiers. These noble animals, with their warhorse heritage, are depicted in darkened stable stalls in states of repose. Dumas has photographed animals at the moment of going into sleep since the mid-2000s, and the proximity of her viewpoint onto these grounded horses, glowing out of the deep blackness of the night, carries a heightened visual charge. Dumas communicates the gravity of their actual and symbolic role within war, bound up in the intensity of her portrayals of each individual, named subject.

94 Hiroshi Sugimoto's (b. 1948) photographs of museum waxworks place us in a position of critical self-awareness; they push us to meditate on the way in which the act of

photography animates a subject and creates the effect of experiencing its vital agency. *Anne Boleyn* brilliantly reflects viewers' automatic search for traces of a living person in both the waxwork model and the photograph, oscillating between intellectual awareness that the photograph depicts a handcrafted waxwork approximation of a historical figure (that references paintings made of the sitter in their lifetime), and Sugimoto's alchemical summoning of the speculative idea of Anne Boleyn into photographic form. This chapter draws to a close by considering artists who use a consciously undramatic photographic style in the field of portraiture. If there are realities or truths held within the deadpan portrait, they revolve around the very subtle signs of how people react to being photographed; the observations artists make are about how their subjects address the camera and photographer in front of them; the pause in their activities and momentary reflection upon the photographic encounter.

German artist Thomas Ruff (b. 1958) has been one of the most influential artists in shaping the parameters of contemporary art photography portraiture. For over forty years his practice has been far-reaching and wide-ranging, and can only be partially represented here. Regardless of his ostensible subject matter, which includes architecture, planetary

93 Charlotte Dumas, *Ringo, Arlington VA*, 2012. From the series *Anima*. Dumas's carefully observed photographic portraits of animals engender an empathetic response: the viewer is encouraged to contemplate their individual characters and relationality to humans.

constellations and pornography, he brings a spectrum of photographic image types into play. Rather than locating the 'signature' of his photographs in a single aesthetic approach to the medium, Ruff raises the more interesting issue of how we comprehend different subjects *through* their photographic form. He experiments with the way we understand a subject through our knowledge or expectation of how it is represented pictorially. In the late 1970s, Ruff began photographing head-and-shoulder images of his friends, reminiscent of passport

94 Hiroshi Sugimoto, *Anne Boleyn*, 1999.
95 OPPOSITE Thomas Ruff, *Portrait (A.Volkmann)*, 1998

photographs, although considerably larger in format. His sitters chose from a range of plain-coloured backdrops in front of which they would be photographed. Ruff asked his subjects to remain expressionless and look straight at the camera. With some modifications (in 1986, he replaced the use of a coloured backdrop with a pale neutral background, and also increased the size of his prints), it is a strategy that Ruff has continued to investigate. At the same time as offering great detail in the sitters' faces, right down to the hair follicles and pores in their skin, the works' blank expressions and lack of visual triggers complicate our expectations of discovering a person's character through their appearance.

96 Joel Sternfeld, *A Woman with a Wreath, New York, New York, December 1998*, 1998. Sternfeld photographs people at a respectful distance. Most of his subjects are aware that they are being photographed, and simply stop their activity for the duration of the photograph. His selection of strangers is not a rigid typology; while there are archetypal elements such as the depiction of city traders or housemaids, he has also portrayed strangers whose appearance does not confirm who or what they are.

Street portraiture is arguably the most prevalent context for deadpan portrait photography. Joel Sternfeld's (b. 1944) portraits do more than raise the question of what we can assume to know about a sitter from their outward appearance. They also propose the facts of what has transpired: Sternfeld has negotiated with a stranger to photograph them at a polite distance, asking them simply to halt what they are doing and prepare to be photographed. The subject's reaction to what is happening, which includes their resistance, their ambivalence about this brief break in their routine, becomes the portrayed 'fact'. That search for subtle visual interest is a guiding force in Jitka Hanzlová's (b. 1958) *Female* series, in which she photographs women of different ages and ethnic origins in the cities she visits. There is, in her selection of subjects, a developing typology, albeit one driven by Hanzlová's subjective curiosity as she casts female strangers as her photographic subjects; individual styles and characters seem to become legible through Hanzlová's serial and systematic approach.

96

97

How each woman reacts to the camera gives us information about her state of mind. Street portraiture in this vein becomes a transparent testimony to the photographic encounter and the possibilities the camera gives to approach and interact with strangers. It is on this that our imaginings about the sitters pivot, reinforced by the similarities and differences between the images of a single series.

98 In the late 1990s, Norwegian artist Mette Tronvoll (b. 1965) relocated her photographic portraits from her studio into the open air, taking the systemized approach to portraiture she had developed in her studio with her. The streets become a backdrop to her portraits of single people and groups. As with the other portraits illustrated in this chapter, the vantage point is straight onto the figures. This convention of photographers who belie the choice of camera angle by selecting the most

97 BELOW LEFT Jitka Hanzlová, *Indian Woman, NY Chelsea*, 1999. From the series *Female*. This image is from a series of portraits the photographer took of women she came across in the street. Each woman is shown facing and acknowledging the photographer, and we are invited to encounter them as if in passing. Because it is a series, the similarities and differences between the women's attitudes and locations becomes a way for us to apply subjective reasoning to what, beyond their gender, connects and distinguishes these women.

98 BELOW RIGHT Mette Tronvoll, *Stella and Katsue, Maiden Lane*, 2001

99 Melanie Manchot, *Cathedral, 6.23pm*, 2004. From the series *Groups + Locations*.
100 OPPOSITE Albrecht Tübke, *Celebration*, 2003

simple and 'neutral' stance means that we feel our relationship to the people portrayed is direct – that as we look at them, they look back at us.

99 In 2004, Melanie Manchot (b. 1966) orchestrated and photographed twelve spontaneous group portraits in and around Moscow. Staged in public locations where the private act of photographing is restricted and prohibited, Manchot called upon passersby to stand and face the camera. *Groups + Locations* references the history of photography in Russia, and the official uses of photography in the nineteenth and early twentieth centuries to document diverse communities and regions across the Russian Empire, while simultaneously deploying this photographic heritage as an artist's counter-argument to the scale of Putin-era state surveillance and the censoring of its citizens' right to see and be publicly seen without punitive redress.

100 Albrecht Tübke's (b. 1971) *Celebration* series takes place on the sidelines of processions at public festivals. Tübke invites his subjects to step out of the crowd and photographs them individually, as they cease their revelry for a moment. At times,

the only parts of their body not clad in costume are the hands and areas around their eyes. In Tübke's photographs, the sense of the subjects being hidden beneath a masquerade goes beyond the specifics of the events and into a metaphorical realm where little of our true identities are ever visible beneath what we consciously fashion for ourselves. Dutch artist Celine

71

van Balen's (b. 1965) photographs of young Muslim girls living in temporary accommodation in Amsterdam also work on this level. The unlined faces of youth are belied by the mature self-possession and seeming confidence with which they present themselves to, and are depicted by, van Balen.

101, 102, 103

The work of another Dutch artist, Rineke Dijkstra (b. 1959), has also focused on this period of life. In the early to mid-1990s, she photographed children and young teenagers on beaches just as they came out of the sea, before they reached their temporary encampments on dry land. Dijkstra captured the vulnerability and physical self-consciousness of her subjects,

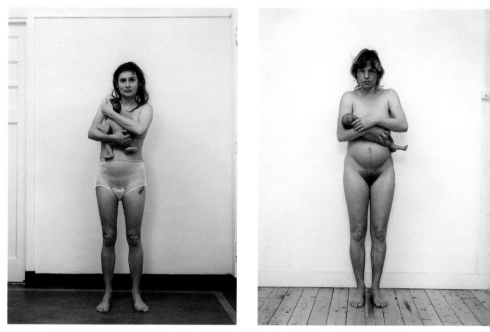

101 ABOVE LEFT Rineke Dijkstra, *Julie, Den Haag, Netherlands, February 29, 1994*, 1994
102 ABOVE RIGHT Rineke Dijkstra, *Tecla, Amsterdam, Netherlands, May 16, 1994*, 1994
103 OPPOSITE Rineke Dijkstra, *Saskia, Harderwijk, Netherlands, March 16, 1994*, 1994

caught in that transitional space of exposure between the protection of being in the water and the anonymity of sitting or lying on a beach towel. The choice of a particular moment or space in which to portray her subjects is a governing element of Dijkstra's work. For example, in her 1994 portraits of matadors, she photographed the men soon after their bullfights, bloodied and with their adrenaline subsiding, their performance and guard dropping away as Dijkstra worked. Also in 1994, she photographed three women: the first, one hour after giving birth; the second, within one day; and the third, after one week. The unsentimental approach in Dijkstra's representation of maternity focuses on the impact of pregnancy and labour on the women, its legibility perhaps lost once the women have begun to recover. These photographs visualize the profound shift in the women's changing relationships to their bodies and the instinctive protection they demonstrate towards their newborn babies, something we might never have observed without such a systematic and detached photographic style.

104 Roni Horn's (b. 1955) *You Are the Weather* consists of sixty-one photographs of the face of a young woman, taken over the

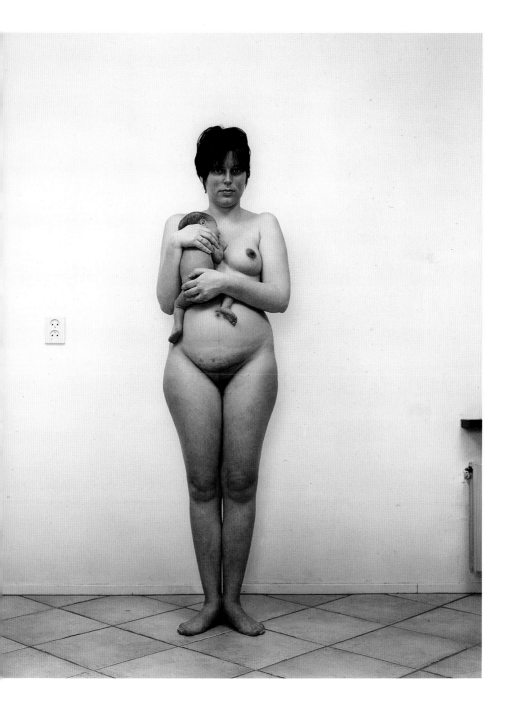

course of several days. Her facial expression changes subtly, but because of the repeated close framing of her face throughout the series, in comparing the different images the minute changes become magnified to a range of emotions, given an erotic charge by the close and intense physical scrutiny with which we are able to regard her. The title of the work in part refers to the fact that she was photographed while standing in water, and her expressions were influenced as a result of that day's weather conditions. But the 'you' of the title is also the viewer, encouraged to become a participant in the work and to imagine that it is we, as the weather, who provoke the woman's emotions and project them onto her.

In the realm of portraiture, the patient and dispassionate deadpan photographic approach can create disarmingly intimate and subtle encounters with human subjects. Dutch artist Cuny Janssen's (b. 1975) portraits often include children as her central cast of characters. They reveal their individual agency, prepossession and presence during the photographic encounter. She has worked extensively in Macedonia, Iran, South Africa, India, America and Japan, and has innovatively

105

104 Roni Horn, *You Are the Weather* (installation view), 1994–96. Horn's sixty-one photographs, all of the face of the same young woman, were taken while artist and subject travelled through Iceland together. Her facial expression changes only subtly throughout, but these changes are magnified by the intensity of the installation.
105 OPPOSITE Cuny Janssen, *Bussum, The Netherlands*, 2015

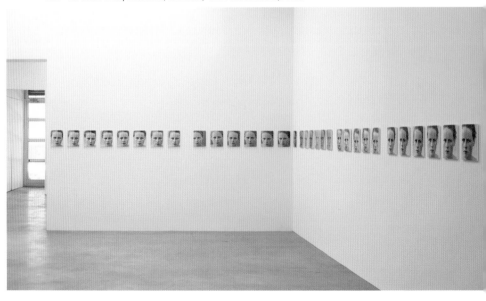

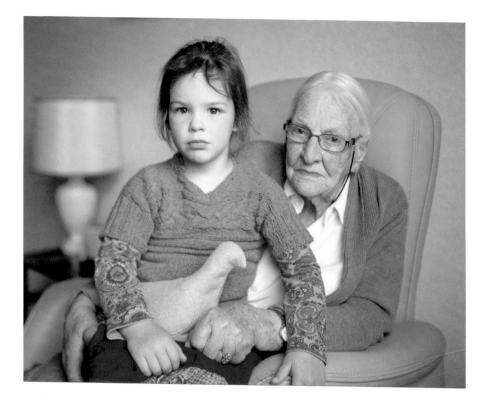

rendered her projects into book form, contextualising her portraits with photographic studies of the children's regional landscapes and natural environments. Janssen's more recent work focuses in and around her home city of Amsterdam, and shows a shift in her photographic approach towards articulating familial networks and bonds, as here in her portrait of her mother-in-law with Janssen's daughter, Ree.

Chapter 4
Something and Nothing

The photographs in this chapter show how ostensibly ordinary, everyday objects and observations can be made extraordinary by the act of being photographed. As the title suggests, the stuff of daily life is the subject, the 'nothing' of these pictures. Because we may ordinarily pass these objects by, or keep them at the periphery of our vision, we may not automatically give them credence as visual subjects within an artistic lexicon. These photographs retain the thing-ness of what they describe, but their subjects are altered conceptually because of the way they have been represented; they become a defining 'something'. Through photography, quotidian matter is given a visual charge and imaginative possibility beyond its everyday function. Shifts in scale or typical environments, revealing vantage points, simple juxtapositions and relationships between shapes or forms are employed here. The iconography for this strand of photography includes objects balanced and stacked, the edges or corners of things, abandoned spaces and fugitive or ephemeral forms such as snow, condensation and the fall of light. This inventory may seem like a list of slight and transient things, non-objects that would barely constitute subjects for photographs. But one must be cautious about thinking of this type of photography as primarily concerned with making non-subjects visible, or revealing things in the world that are without visual symbolism. In truth, there is no such thing as an unphotographed or unphotographable subject,

106 Peter Fischli and David Weiss, *Quiet Afternoon*, 1984–85. Fischli and Weiss's *Quiet Afternoon* is a series of still-life photographs, made in their studio, of ordinary objects propped and stacked together in unexpected combinations. The series has been a great influence on redirecting this traditional genre of art and photography into playful and conceptually driven territories.

and it is for us to determine a subject's significance. With this type of work, the practitioner fosters our visual curiosity by subtly and imaginatively encouraging us to contemplate the stuff of the world around us in new ways.

Since the mid-1960s, the playful conceptualism of still-life photography has had an important parallel practice in post-Minimalist sculpture. This strand of photography has been driven by related attempts to make art from the matter of daily life by breaking down the boundaries between the artist's studio, the gallery and the world. Concomitant to this has been a shared investigation into creating work from which overt signs of the artist's technical skill are absent. The viewer will therefore have a different response from that engendered by traditional virtuoso masterpieces in art history. Rather than asking how and by whose hand the work of art was made, the question becomes: How did this object come to be here? And what act or chain of events brought it into focus? Both contemporary sculpture – inspired by, among other things, Dada artist Elsa von Freytag-Loringhoven (1874–1927) and Marcel Duchamp's (1887–1968) readymades in the early years of the twentieth century – and photography can activate the same conceptual dynamic; they both create puzzles and confound

107 OPPOSITE Gabriel Orozco, *Breath on Piano*, 1993
108 Felix Gonzalez-Torres, *Untitled*, 1991. This project was initially shown on advertising hoardings in New York. The billboards depicted an unmade bed with the impressions of the sleepers left on the sheet and pillows, an evocatively intimate sight made resonant by the public context in which they appeared.

our expectations of, say, the weight or scale of objects, or the permanency of an artwork.

One of the most enduringly influential photographic projects to playfully question our expectations of the nature of a work of art was realized by the Swiss artists Peter Fischli (b. 1952) and David Weiss (1946–2012) in their *Quiet Afternoon* series. The photographs show table-top assemblages of mundane items that seem to have been found close at hand in the artists' studio. Fischli and Weiss created sculptural forms by fixing and balancing these objects together and photographing them against plain backgrounds with raking shadows, lending a comic drama to their consciously unsophisticated temporary sculptures. The seemingly ad hoc, unglamorous style of photography used in *Quiet Afternoon* suggests an affinity with another strand of art-making that emerged in the 1960s. Documentation photographs (where the photograph is not intended as the final work of art) of Minimalist sculpture and land art were motivated by the desire to create a long-term record of these works and as the visual means for disseminating their concept and physicality. Much of the art of Robert Smithson (1938–1973) and Robert Morris (1931–2018), for example, is experienced and understood through photography. Using a photograph to disseminate an ephemeral artistic act or temporary work of art contains an inherent irony and ambiguity that has been constantly exploited and reinvented in contemporary art photography.

One of the main protagonists of contemporary still-life photography is the Mexican artist Gabriel Orozco (b. 1962). Orozco's art is full of impossible, witty and imaginative games. Whether in the form of photographs, collages or sculptures, or as an animated conversation between these mediums, his installations offer exciting and playful conceptual journeys. He began taking photographs as records of found sculptures he discovered on the street and then reinstalled in galleries, the images acting as diagrams of the spatial relationships and elements he was reconstituting. Orozco's use of photography asks us to pay close attention to the nature of photographic images and the perpetual hovering between being the medium and the subject. *Breath on Piano* exemplifies his intention to activate particular trains of thought in the viewer. On one level, the photograph can be seen as a documentation of the highly fugitive act of breathing onto the seamlessly shiny surface of the piano top. But this somewhat forensic reading of *Breath on Piano* belies another equally important facet of the work, for it makes us see the image *as* image, as forms on a surface, which is a fundamental condition of a photographic print.

106

107

109 Richard
Wentworth, *Kings
Cross, London,*
1999

108 Felix Gonzalez-Torres's (1957–1996) use of photography
encouraged sensory and playful participation from the
viewer, in keeping with the effect of his magical mixed-media
installations created using objects from domestic or social
life recontextualized in a gallery environment. His untitled
billboards, initially exhibited in New York in 1991 and then
throughout Europe and America, show an unmade bed, the
couple absent, with only the traces of their bodies imprinted
on the sheets and pillows. This intimate scene was given its
drama by placing it into the public contexts of urban streets
and highways for the scrutiny of passers-by. This fusion
of public site and private sight, and the sensitivity of the
photograph, allowed the viewer to bring their own experiences

110 John Lehr,
Neon Rose, 2010

to the work and imprint their meaning on it. Originally
displayed at the height of AIDS awareness in the West,
the work's sense of loss and absence holds social and
political significance.

109 British artist Richard Wentworth's (b. 1947) photographs
capture the contradictions and visual intrigue found on
urban streets. Often, his photographs set up a visual pun
or puzzle; objects are displaced from their original function,
often reused or abandoned, and through photography they
gain new, sometimes comic characterizations. In keeping with
the phenomenological language of his sculptures, Wentworth's
photographs draw on our natural inquisitiveness to understand
alternative values or meanings of found things. In the image
shown here, car panels are wedged into a doorway, presumably
as an unconventional yet effective way of preventing access
to the property. Fantastical narratives are suggested by this

intriguing sight: the desperate measures taken to solve car-parking problems in a busy city, or the reasons for such a determined barricading of a doorway.

110 With a parallel acuity for looking photographically at the close-at-hand world, American photographer John Lehr (b. 1975) creates photographs where our attention is drawn to every detail and mark framed by his camera. Lehr often prints his photographs at a one-to-one scale, and subtly uses digital post-production to further amplify the experience of being in the presence of a place, time and ordinary detail that we might pass by, made articulate and epic by the act of photography.

111 Since the early 2000s, Jason Fulford (b. 1973) has been a photographer, publisher, collaborator and educator who shows us how expansive and rigorous photography can be in driving our experiences and processes of discovery. He is best known for his artist's books, including *Crushed* (2003), *Raising Frogs for $$$* (2006), *The Mushroom Collector* (2011), *Hotel Oracle* (2013), and for the publication of numerous artists mentioned in this chapter, in collaboration with illustrator Leanne Shapton (b. 1973), under the moniker J+L publications. Fulford demonstrates how the meaning of an individual photograph both hinges on its content and is contingent on

111 Jason Fulford, *Atlanta, GA*, 2017

the other images and texts that form a book (or installation) sequence's visual language. There is often humor, wonderment and a textual quality in Fulford's photographs, rooted in the profound playfulness with which he travels, photographs and learns about the world.

James Welling's (b. 1951) practice has often meditated on the ways that photography can give the slightest of subjects form and intellectual substance. In the 1980s, he created a series depicting draped fabrics that could either be construed as the backdrops to absent objects, or as subjects in their own right. Through subtle shifts in camera position and the fall of light onto the same physical details, Welling questions the belief that to see something from a single vantage point is to know it. As its title flat-footedly suggests, in his *Light Sources* series (1992–2001) he photographed different sources of light; the project is a prime example of the harnessing of photography to create a conceptual framework that gradually comes into being,

112 James Welling, *Ravenstein 6*, 2001. In his *Light Sources* series, Welling photographed different light sources, from the sun to fluorescent tube lighting, making use of photography's capacity to build up a broader conceptual and typological framework.
113 OPPOSITE Jennifer Bolande, *Globe, St Marks Place, NYC*, 2001. From the series *Globe*.

and its use as permission for a photographer to go out into
the world to find the pictures that are just waiting to happen.

Jennifer Bolande's (b. 1957) *Globe* series similarly
contemplates an unconscious-yet-meaningful pattern of
behaviour observed from street level. Bolande found and
photographed globes stored on the window ledges of homes
and, by means of this very simple observation, brought
our perception and understanding of the world into fresh
consideration. Most obviously, these photographs draw our
attention to the way we receive knowledge about the world from
a dwarfed, simplified model. They demonstrate how partial
our perspective is, framed as it is by the windows out of which,
and into which, we look. Human understanding from micro-

Something and Nothing **129**

114 Sharon Ya'ari, *Untitled*, 2006. From the series *500m Radius*.
115 OPPOSITE Effie Paleologou, *Aerial View #1, 2014*. From the series *Microcosms*.

to macrocosmic proportions is repeatedly explored through Bolande's work; a sense of constrained human understanding is visualized through simple and subtle observations.

114 Sharon Ya'ari's (b. 1966) *500m Radius* is a sequence of forty black and white photographs made within the eponymous 500m radius of his former studio in Tel Aviv, Israel. Ya'ari subtly contains his project, working within monochrome photography, the delineated 500m radius and a focus on the worn-out modernist utopianism of the Bauhaus, represented in the modest modernist buildings near his studio. *500m Radius* aligns contemporary photographic practice with an intelligent and diverse history that includes avant-garde photography of the early twentieth century, conceptual art of the 1960s and the spirit of New Topographics (see p. 84) that emerged in the 1970s.

115 Effie Paleologou's (b. 1961) *Microcosms* is a series of black and white photographs that similarly sets a geographical boundary for her photographic enquiry – a triangulated region of London with its points located in Bethnal Green, Old Street and Liverpool Street. In this zone, Paleologou examined the forms of orally discarded chewing gum, trammeled into the concrete

and tarmac of East London's streets. There was no shortage of her chosen subject to be found, and Paleologou's project became one of selecting examples of these fossil-like traces of metabolic forms that collectively offer a visual typology of sorts. *Microcosms* relies on photography's confusion of scale; these organic impressions upon the sidewalk register simultaneously as microscopic, actual size, and telescopic; akin to an aerial landscape image. Paleologou's photographic approach has an uncanny, forensic quality of mapping the way in which we leave our DNA traces in public, and add it to the fabric of a place.

116 The American photographer and poet Tim Davis's (b. 1970) series *Retail* depicts the darkened windows of American suburban houses at night, with windows reflecting the neon signs from fast-food joints. The photographs reveal a subliminal imposition of contemporary consumer culture onto domestic life. To see just one of these photographs may alert us to Davis's unnerving social observation, but it is through the repetition of this nighttime phenomenon that his idea becomes a theory of the ways in which our privacy and consciousness are contaminated by commercialism.

117 The photographs in *Something is Missing* (1995–7) by French artist Jean-Marc Bustamante (b. 1952) were taken on the edges of many different towns and cities, depicting the incidental

and resonant scenes that Bustamante seeks out. In the image shown here, figures on a football pitch are encased both in the foreground by the wire fence and the trailing weed, and in the background by a graveyard of urban housing in stages of neglect. These elements register both as a three-dimensional space and a series of two-dimensional picture planes that hinge on the vantage point of the photographer, and therefore of the viewer. The subject of the photograph is the entire picture and its layered complexity, drawn out of the process of walking and seeking pictures in the flow of daily life.

Architecture, in the context of this chapter, tends to be photographed at the point at which buildings have deteriorated or outlived their original purpose, with mere traces of previous human activity. Through the 1980s and 1990s, Anthony Hernandez's (b. 1947) photographic practice concentrated on such architectural spaces. His *Landscapes for the Homeless*,

116 Tim Davis, *McDonalds 2, Blue Fence*, 2001. From the series *Retail*.
117 OPPOSITE Jean-Marc Bustamante, *Something is Missing (S.I.M. 13.97 B)*, 1997

created in the 1980s, are photographs of the temporary shelters made on roadsides and wastelands by homeless people. The movements and characters of the makers of these shelters are visually retrieved in what they have left behind, a forensics of private poverty and survival. Hernandez's *After L.A.* (1998) and *Aliso Village* (2000), centre on spaces about to be demolished or in the process of gradual deterioration. He photographs what is overlooked (socially and politically as well as visually) in these decaying fields, close to the point of their erasure. In the image shown here from *Aliso Village*, Hernandez observes a small but haunting and profound piece of evidence left by previous inhabitants of the low-income housing estate in Los Angeles where he himself was born and raised.

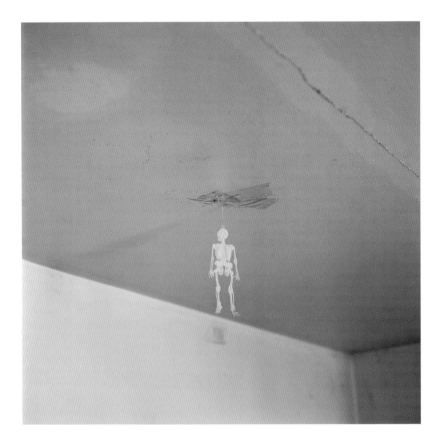

All the photographs in this chapter, in subtle ways, attempt to shift our perceptions of our daily lives. There is something anti-triumphant and open-ended, yet still resonant, in this

119 form of photography. Tracey Baran's (1975–2008) highly sensual photograph *Dewy,* of an etched glass still wet with moisture and placed on a window sill, light falling onto it through foliage, is a classic still-life image. The physicality of this uncontrived combination of planes and forms is delicately mapped. The image is reliant on our comprehension that we are looking at a composition within the tradition of still-life picture-making, found within daily life.

120 Manfred Willmann's (b. 1952) *Das Land* series (1981–93) draws out the rituals, idiosyncrasies and passing of the seasons within a community in the Steierland region of Germany. In sixty photographs made over a twelve-year period starting in 1981, Willmann conveys a pungent sense of his experiences of place. *Das Land* could be construed as a diary of the life of

the community – but Willmann's photographic practice does not hold the same degree of subjective narrative or intimacy seen in Chapter 5. Instead, what seems to have driven this project in the first place, and what is conveyed in the final selection, is the pictorial charge that can be found in a place, perhaps any place, if one looks. In the subtle drama of the exposed wood of a tree where branches have broken off under the weight of snowfall, Willmann finds more than a saccharine scene of a winter landscape.

121, 138 German artist Wolfgang Tillmans (b. 1968) has also brilliantly explored the artistic dialogue around photography's relationships to its subjects. Since the late 1980s, Tillmans has worked across various contexts, from magazines to art galleries and books, producing landscapes, portraits, fashion shoots, still lifes and abstract photography triggered by darkroom mistakes. His photographs of fruit ripening on windowsills and the contents of sparse kitchen cupboards have a simple poignancy. Another recurring motif, as shown here in *Suit*, is clothing left to dry or abandoned by its wearers on floors, doors and stair banisters. The limp sculptural forms made unwittingly by the discarding of clothes suggest the shapes

118 OPPOSITE Anthony Hernandez, *Aliso Village #3*, 2000
119 Tracey Baran, *Dewy*, 2000

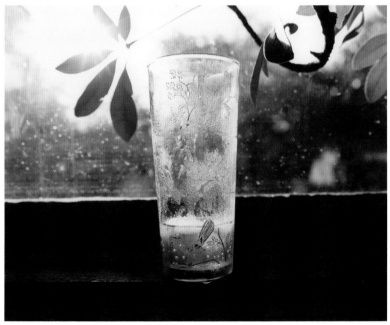

of the bodies they once contained, like a shed animal skin, and recall the act of undressing, creating a sense of sexual intimacy.

American artist Leslie Hewitt's (b. 1977) installations are comprised of sculptures and photographs that are immediate and impactful to the viewer on both bodily and imaginative levels. Her ongoing photo series show books, hand drawings on paper, Möbius brass forms, personal photographs and materials found or created in nature such as rocks and shells, each propped or stacked into delicate still lifes. The works are subtle but transparent in their articulation of her interest in the psychological space of personal narrative, and her critical stance towards historiography and its tendency for singular narratives of exclusion. All perspectives intertwine into a visual praxis for Hewitt. In her gallery installations, Hewitt counterpoints her photographs – displayed at floor level, positioned against a wall – with human-scale post-Minimalist metal sculptures, folded at angles in a wry nod towards formalism. Her subtle references to the connection and amplification of radical histories become legible as

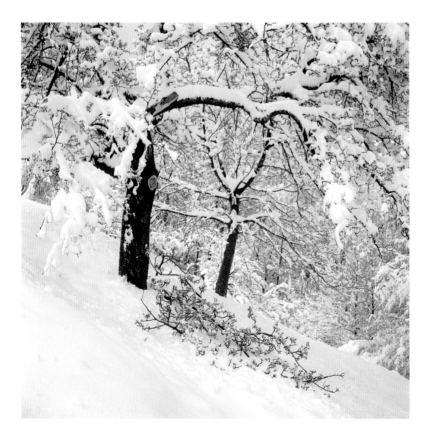

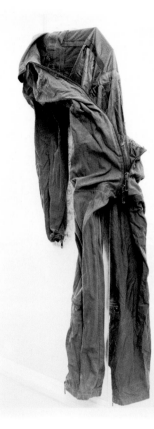

120 OPPOSITE Manfred
Willmann, *Untitled*, 1988.
From the series *Das
Land*.
121 Wolfgang Tillmans,
Suit, 1997. Although
Tillmans's photographs
are exceptionally diverse
in terms of their subjects
and processes, there
are many recurring
motifs. These include, as
here, the spontaneous
sculptures made by
clothing hung up or
dropped on the floor.

intentional and mighty visual stories through her careful
positioning of objects and photographics within each frame.

123 Nigel Shafran's (b. 1964) photography often uses forms found
in daily life – washing-up on a draining board, construction
scaffolding, grass cuttings, food on supermarket conveyor belts
and charity shop interiors. With an understated photographic
style, use of ambient light and relatively long exposures, he
transforms these scenes into poetic observations about the
ways we conduct our lives through our unconscious acts of
ordering, stacking and displaying objects. There is something
highly intuitive in Shafran's way of working, as shown here in
his portrayal of his young son's playful engineering at the end
of a meal, which creates a literal balancing act – and a symbol of
domesticity and family life. Shafran resists the urge to construct
a scene to be photographed; rather, his is a process of staying

122 Leslie Hewitt, *Untitled (Mirage)*, 2010. This ongoing series of photographs shows a wide-ranging cast of items propped or stacked into delicate still lifes that articulate Hewitt's personal narrative and critical stance towards historiography.

attuned to the possibilities of everyday subjects as a means of exploring our characters, relationships and ways of life.

124 Although Anna Fox's (b. 1961) best-known documentary work, such as her series on mid-1980s office environments, has been made outside the home, she has also captured her family life. Photographing at home offers a close-at-hand set of subjects and scenarios to satisfy a practitioner's need to see what something might look like photographically, but it also provides the opportunity to acknowledge and celebrate the particulars of their domestic life. The photograph shown here is from Fox's 2000–3 series *Gifts from the Cat*, a component of the *Notes from Home* series made in the early years of her relocation from London to the village in the south of England where she was raised. Fox has shown *Notes from Home* as an installation of concertina books, on a domestic-looking shelf.

125 Laura Letinsky's (b. 1962) photographs simultaneously contemplate the still life as a representation of the nature of human relationships through the vestiges of domesticity, and make us rethink this act of pictorial representation. Her photographs of tables immediately after and between

mealtimes have obvious compositional references to seventeenth-century Dutch still-life painting, and Letinsky draws our attention to the metaphorical and narrative potential of domestic objects when represented pictorially. The combination of flatness and plasticity in her photographs creates a tension that dismantles the monocular vantage point traditionally ascribed to photography; instead, she uses multiple perspectives and conflates picture planes, with strategically placed objects propped and levered at various angles. Letinsky's unusual, baroque sensibility, borrowed from Northern European painting, creates photographs of great beauty – but their unstable viewing position(s) also creates a sense of great precarity. This quality, within the narratives of domestic still life, suggests a series of fraught emotional states, ending and falling apart.

One of the most dramatic uses of perspective in the context of still life occurs where photographers specifically investigate the ways we see (or do not see) the things around us. In part, it is our perception of our environments rather than the things contained within them that is being scrutinized. German artist Uta Barth's (b. 1956) series *Nowhere Near* pares its subject matter down to the spaces between things. Here, she focuses on a window frame and the view beyond, the blurred forms of which mark the boundary of what is outside the photograph's visual range. We are made hypersensitive to what we do not look at

123 Nigel Shafran, *Lev's bridge*, 2006

(or edit out); what we do not define as a subject or a visible concept. Barth's photographs, when installed in galleries, resonate phenomenologically. The space between the viewer and the photographs becomes part of the interplay between space and subject, seeing and not seeing.

Filmmaker Breda Beban's (1952–2012) series *The Miracle of Death* captures the profound sense of loss that she experienced after the death of her partner and artistic collaborator Hrvoje Horvatic in 1997. Beban photographed the box containing his ashes in their home, in rooms still containing his personal belongings and signs of their cohabitation. The series documents her moving of the box, unable to give it a fixed place, an indication of her inability to reconcile herself to her loss. Beban's photographs epitomize the capacity of intimate photography to describe a detail of life simply and without obvious elaboration, and to invest it with the profundity of human emotion.

124 OPPOSITE Anna Fox, *Bird*, 2000–3. From the series *Gifts from the Cat.*
125 Laura Letinsky, *Untitled #40, Rome*, 2001. Letinsky constructs the undulating perspective found in seventeenth-century Northern European still-life paintings to develop her narratives of domesticity and intimate relationships which can be read in the remains of a meal.

128 Sabine Hornig's (b. 1964) use of photography has concentrated on the spaces between image and object, as in *Window with Door*. Conflated into the image are two ends of a room photographed through a window from outside. The building and trees behind the camera also appear, reflected in the windowpanes. In her installations, Hornig has used a more literal, sculptural manner, building her photographs into freestanding blocks and shapes that evoke the corners and edges of minimalist architecture and take the images away from the gallery wall and into a three-dimensional space. As with all the works in this chapter, her photographs take our familiarity with everyday sights and invite us to think about the way we see and experience our environments, offering a rich and imaginative glimpse of the world around us.

129 In 2005, photographer, publisher and curator Tim Barber (b. 1979) set up the website *Tiny Vices*, one of the first and most innovative online platforms for sharing portfolios of work by a range of established and emerging artists, and a resource for information about books from small, independent photobook publishers and collectives. Barber's own photographs have been

126 TOP Uta Barth, *Untitled (nw 6)*, 1999. From the series *Nowhere Near*.
127 Breda Beban, *The Miracle of Death*, 2000. Beban's visual diary of moving
the box of ashes of her artistic and life partner from room to room in their
home starkly narrates her loss. Beban and Horvatic's film and photographic
collaborations often used the repetition of acts and rituals, and there is a
sense of Beban's mirroring their shared creative process in this series.
128 OPPOSITE Sabine Hornig, *Window with Door*, 2002

strongly informed by the ways in which twenty-first century photographers began to create poetic, intimate and elliptical sequences of images for artist's books, zines and independent magazines, with each image creating a visual encounter with places and human subjects, without traditional photographic formality or conventions.

Since the early 2000s Gregory Halpern (b. 1977) has created photographic projects that narrate open-ended, human-scaled stories about contemporary America. Halpern creates elliptical encounters that intentionally do not objectify vulnerable individuals and fragile communities often politically, socially and economically held at a distance. His *ZZYZX* project, published in its primary form as a book in 2016, is a remarkably prescient retelling of the classic photographic road trip, set along a journey from the town ZZYZX in the Mojave Desert through Los Angeles and on to the Pacific Ocean. Halpern makes his departure from the photographic heritage of observing along a route in the absence of illustrative devices;

his photographs are subtle yet close, and invite the viewer to recognize both our familiarity with the everyday signs of social breakdown through his photographic concentration on homeless and itinerant lives, and our shared desire for respite and self-determination wherever it can be carved out. Halpern's finely edited visual journey into and through Los Angeles is intentionally fragmented, but collectively true to the character of travelling and passing through the city.

131 Jason Evans's (b. 1968) temporary, lyrical still-life photographs, entitled *Pictures For Looking At*, refresh our understanding of photography by recalling some of the medium's essential ingredients of chance and luck, and the intensity of photographic observation. In some exhibitions of this body of work, Evans also shows a series of plinth-based arrangements of found and made objects entitled *Sculptures For Photography*, making a delightful invitation to perceive these physical objects as photographs-in-waiting. Since 2004, Evans has uploaded a single photograph made with a digital Instamatic camera for twenty-four hours only, every day, to his website *The Daily Nice*. The project is a reminder to Evans

129 Tim Barber, *Untitled (Cloud)*, 2003
130 OPPOSITE Gregory Halpern, *Untitled*, 2016. From the series *ZZYZX*.

and the site's viewers of the talismanic character of the camera, and a device for looking out for experiences – and niceness – in our everyday.

Rinko Kawauchi's (b. 1972) photobooks – including *Utatane* [Nap] (2001), *Hanabi* [Fireworks] (2001) and *AILA* [Family] (2004) – shape subtle, elegiac narratives without the aid of interpretative text, and have been highly influential in the field of photobook publishing. *Utatane* interweaves Kawauchi's ways of perceiving the world around her with fleeting conflations of forms. The title is lyrical, even musical, in the sounds it evokes: the whirr

of a sewing machine or the sizzle of frying eggs. In *AILA,* the staccato image sequence includes photographs of animals and humans being born, hives of insects and matrices of fish eggs, dewdrops, waterfalls, rainbows and tree canopies. Kawauchi's finely edited and accumulated observations leave the reader fully nourished by the exquisite, intriguing sights actively sought out by the photographer. She is far from alone in her approach of not overcomplicating photographic strategies, and remaining true to the notion that pictures waiting to happen

131 OPPOSITE Jason Evans, *Untitled*, 2005–12. From the series *Pictures For Looking At*.
132 Rinko Kawauchi, *Untitled*, 2004. From the series *AILA*.

are all around us. Collectively, the photographers represented here, and many others, such as Federico Clavarino (b. 1984), Anne Daems (b. 1966), Anders Edström (b. 1966), J. H. Engström (b. 1969), Mikiko Hara (b. 1967), Fumi Ishino (b. 1984), Ron Jude (b. 1965), Osamu Kanemura (b. 1964), Martin Kollar (b. 1971), Ed Panar (b. 1976), Aaron Schuman (b.1978) and Mike Slack (b. 1970), create subtle photographic forms out of incidental everyday observations. This practice reinforces the enduring idea that a camera gives its carrier actual and psychological permission to scrutinize life for its beauty, wonder, absence and humour.

133 Nan Goldin, *Siobhan at the A House #1, Provincetown, MA*, 1990
One of the many qualities of Goldin's photography is her capacity to combine a
sense of the emotionally charged and spontaneous observation of her loved ones
with a highly developed aesthetic sensibility. This unguarded and frank portrait
has a rich colouration and painterly quality.

Chapter 5
Intimate Life

This chapter looks at how narratives of domestic and intimate life have been presented in contemporary art photography. The apparently unselfconscious, subjective, day-to-day, confessional modes of many of the photographs shown here contrast markedly with the measured and preconceived strategies that are also at play within the scope of contemporary art photography. We generally take pictures at symbolic points in life, at times when we acknowledge our relationship bonds and social achievements. They are moments we want to hold on to, emotionally and visually: our shared cultural events and rites of passage. In family photography and video, the celebratory is sought out through the visualization of functioning, predominantly heteronormative, familial roles. What remains absent in such images, however, are things we perceive as culturally taboo, incidental or self-determined versions of family and emotional intimacy. Art photography, on the other hand, while often borrowing the aesthetics of family and social photography, regularly substitutes the emotional opposite for the expected scenarios: the events and contexts of sadness, family disputes, addiction, illness and deviations from the conventional mediated norm become its subjects.

Intimate photography is also a reconstitution of the subtexts already present in our personal images. We can all find the undercurrents of specific family relationships in our private photographs. Who stands next to whom in the group portrait? Who is absent? Who is taking the photograph? And with hindsight, we can search for visual clues to later events as evidence of predestination: can we see signs on the wedding day of a later divorce? Or something in a child's posture that predicts their path into adulthood? Similarly, intimate photography is an exercise in pathology, an

editing and sequencing of seemingly unguarded private moments that reveal the origins and manifestations of the subjects' emotional lives.

133, 134
The photographer who has had the most direct and obvious influence on the photography of intimate lives is the American Nan Goldin (b. 1953). Her ongoing exploration of her chosen family of friends and lovers not only chronicles the narratives of this circle but has also, in a number of ways, set the standard by which intimate photography and its creators are compared. Although Goldin began taking pictures of her friends in the early 1970s, it was not until the early 1990s that her work gained international acclaim. Goldin's first photographs, taken in her late teens, were a series of black and white images entitled *Drag Queens*, which empathetically portrayed the daily lives of the two drag queens with whom she lived, and their social circle. In the mid-1970s, Goldin attended the School of the Museum of Fine Arts in Boston, Massachusetts. During a year's leave from the programme, when she had no access to a darkroom to develop or print her black and white film, she began to use colour slides.

In 1978 Goldin moved to the Lower East Side of Manhattan and continued to record events, situations and her friendships. The first public projections of her slide images were held in New York clubs in 1979, either with a music sequence selected by Goldin or as an accompaniment to live gigs. She modified her soundtracks to include music that had a personal resonance to her and her friends and songs that offered a musical parallel to the imagery. In the early 1980s, the audience for Goldin's shows were mainly artists, actors, filmmakers and musicians, many of whom were her friends and appeared in the images. Goldin's inclusion in the 1985 Whitney Biennial, New York, marked the first high-profile institutional interest in her work, and the following year her first book, *The Ballad of Sexual Dependency*, was published, bringing the intensity of her prolific image-making to a wider audience. By this point, Goldin was consciously sequencing her photographs into themes that directed the viewer to think beyond the specifics of her subjects' lives, about generalized narratives of human experience. *The Ballad of Sexual Dependency* was a personalized contemplation of the nature of subjects such as sexual relationships, male social isolation, domestic violence and substance abuse. Goldin's essay in the book powerfully states the psychological necessity for her to make photographs of her loved ones. Her description of the effect of her sister's suicide at the age of eighteen, when she was eleven years old, vividly justifies the sense of urgency with which she photographs what

134 Nan Goldin, *Gilles and Gotscho Embracing, Paris*, 1992. The tenderness between lovers has been one of the presiding themes of Nan Goldin's photography for close to thirty years. This touching observation of Goldin's friends Gilles and Gotscho is part of a series that she made in 1992 and 1993, as Gotscho supported his lover Gilles until his death from AIDS-related illnesses.

is emotionally significant to her, as a way of holding onto her own version of her history.

By the late 1980s, Goldin was being invited to exhibit at art institutions and events around the world, and she also began to have solo exhibitions. Her work has been continually influential, feeding back into the art-school system from which she came and heralding intimate photography, with a narrative determined by the artist, as a valid strategy for photographic art-making. In the early 1990s, with the publication of *I'll be Your Mirror* (1992), Goldin's photographs of those around her counterbalanced celebration with loss. Her intense record of the impact of HIV and AIDS-related illness, drug addiction and rehabilitation on her and her friends' lives offered art audiences a profound engagement with these social issues, spelled out in personal terms. Goldin also began to photograph people with whom she felt an affinity, but who were not longstanding friends. *The Other Side* (1993) showed transvestites and transsexual people in cities she visited, principally Manila and Bangkok. Although Goldin is

Intimate Life

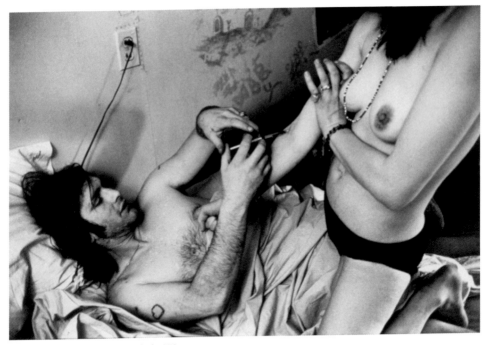

135 Larry Clark, *Untitled*, 1972

sometimes perceived exclusively as a recorder of counterculture lifestyles, as her life and those of her intimate circle change, new subjects emerge. In the twenty-first century, as she broke her cycle of drug addiction and become a prominent anti-pharmaceutical activist in the fight against America's opioid addiction epidemic, she began, literally, to see more sunshine, and has incorporated daylight into her photographs as opposed to the flash-illuminated low light of clubs and bars of her earlier work.

Goldin's openness about her traumatic childhood and her battles with addiction are central to our belief that her intimate photographs are a genuine record of a personal life, and not simply pseudo-empathetic observations. There is an inbuilt protection of intimate photography from especially negative art criticism. By developing a body of work over time, the photographer links their life with the continued taking of photographs. A new book or exhibition is rarely judged an outright failure, because that would in some way suggest a moral criticism of the photographer's life, as well as of their motivations. This has been the case with the reception of another long-term photographer of intimate life, the Japanese

artist Nobuyoshi Araki (b. 1940). Araki initially came to prominence in the 1960s for his grainy, dynamic photographs of Japanese street life. As a contributor to the Provoke Group's magazines and books, his work was part of one of the most daring and experimental periods for photography and innovative graphic design. Araki is best known as one of the key art photographers to present sexually explicit work. He is the epitome of the 'promiscuous photographer', taking tens of thousands of pictures, using a range of cameras, with a predatory fluidity that gives a woman's body, a flower, a bowl of food or a street scene a literal and psychological sexual charge. Araki is a major celebrity in Japan, having published over 500 books of energetically gridded, juxtaposed and sequenced photographs, but it was not until the early 1990s that he became well known outside Japan.

Araki's acceptance as an artist in the West has relied on the subjectivity as well as the boldness of his work. His photographs of young Japanese women are seen as a visual diary of his sex life; he claims to have had sex with most of the women depicted. The infrequency with which men appear (typically as clients or sexual partners of the women whom Araki photographs) is important in preserving this reading of the work. Sometimes the relationship between the

136 Nobuyoshi Araki, *Shikijyo Sexual Desire*, 1994–96

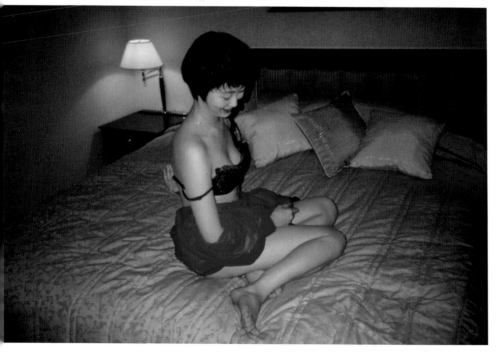

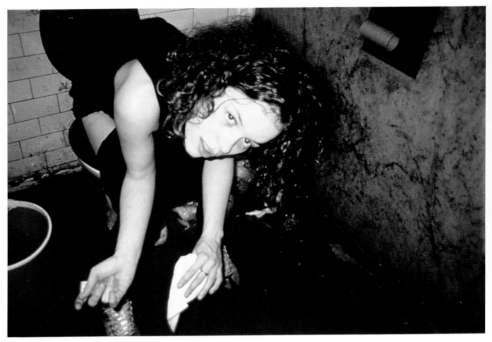

137 Corinne Day, *Tara sitting on the loo*, 1995
138 OPPOSITE Wolfgang Tillmans, *Lutz & Alex holding each other*, 1992

photographer and his models is described as collaborative, with the suggestion that Araki and his cameras are conduits for these women's sexual fantasies. The reading of his work as diaristic, chronicling his genuine desire for these women, curtails much of the potential debate about the possible pornographic and exploitative aspects of his work. This critical shying away from some of the obvious readings of Araki's images demonstrates how intimate photography can circumvent debates that surround so many other contemporary art photographers and photographic imagery in general.

135 American photographer and film director Larry Clark's (b. 1943) explicit portrayals of teenagers and young adults have, like the work of Goldin and Araki, been highly influential on contemporary photography. His books – *Tulsa* (1971), *Teenage Lust* (1983), *1992* (1992) and *The Perfect Childhood* (1993) – all centre on a self-destructive combination of sex, drugs and guns in the hands of out-of-control young people. *Tulsa* contains grainy black and white photographs taken by Clark throughout his twenties, starting in 1963. They are his most strictly autobiographical works, diaristically documenting his youth

and that of his friends. By the time *Teenage Lust* was published, Clark was approaching thirty, and his portrayal of youth was transferred to a younger generation, with whom he empathized as well as socialized. The sense of Clark's being an insider, recording the teenagers' nihilistic progress into adulthood, is emphasized in an essay in which he both describes experiences from his own life that mirror the events in his photographs, and declares his motivation as an adult to take the photographs he wished he had made as a child. Although Clark received some art-world recognition in the 1980s, it was not until the release of his independent film *Kids* in 1995 that he became well known to a wider audience. This led to a revisiting of his earlier books and a greater acknowledgment of his troubling debunking of anodyne or lyrical representations of teenagers.

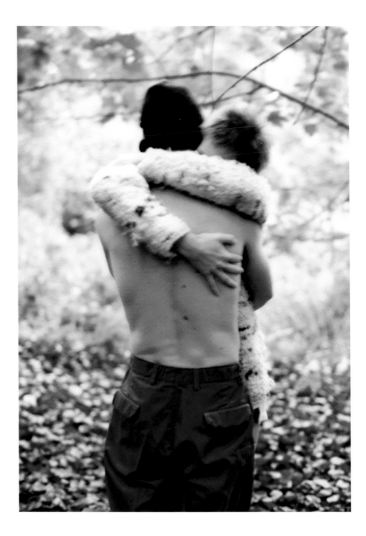

In the mid-1990s, the implications of subjective photographic realism were centred not in the art world but in the sphere of fashion photography. A thorough exploration of the relationship between art and fashion is beyond the scope of this book, but it is important to mention that as photography developed its standing in the art market, stylistic signs from artistic practice inevitably found their way into fashion photography. In particular, the rise of intimate photography offered a spur for the injection of greater realism into fashion images. Starting in the late 1980s, mainly with photographers, stylists and art directors based in London, what soon became known as 'grunge' fashion photography began to appear on the pages of lifestyle magazines. Inspired by books such as Goldin's *The Ballad of Sexual Dependency* and Clark's *Tulsa* and *Teenage Lust*, the emerging fashion photographers of the 1990s and their creative collaborators sought to counter the faked glamour of high-production fashion shoots prevalent in the mid-1980s, and instead represented fashion as it was customized and defined by young people. Younger models were cast, heavy make-up and hairstyling were abandoned and bare studios and unglamorous, often suburban interiors replaced exotic locations. In its perpetual search for the

139 Zachary Drucker and Rhys Ernst, *Relationship, #44 (Flawless Through the Mirror),* 2013
140 OPPOSITE Jack Pierson, *Reclining Neapolitan Boy,* 1995

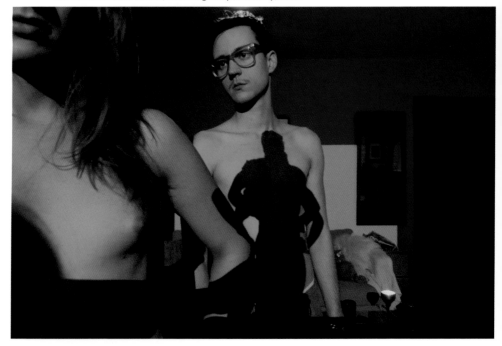

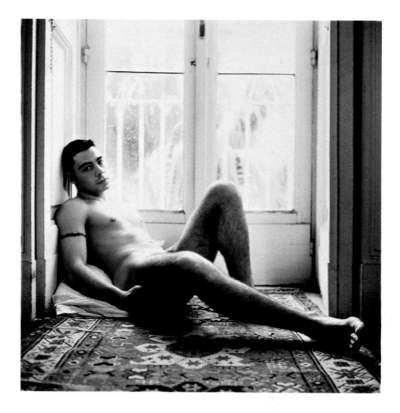

new, the fashion industry as a whole soon began to absorb these anti-commercial gestures into its print advertising and magazine editorial pages, prompting increased media criticism that accused the fashion world of promoting child abuse, eating disorders and drug-taking. In May 1997, then-President Bill Clinton made an infamous speech that brought the term 'heroin chic' into general currency. Clinton was primarily attacking advertising campaigns that used gaunt, unsmiling models who, he claimed, glamorized drug addiction at a time when heroin was becoming a fashionable social drug. On the whole, contemporary art photography escaped the censures faced by fashion photography – though Clinton did cite the work of Dan [sic] Goldin in his speech – perhaps because of the same inherent self-protective qualities mentioned previously in this chapter. Without the authenticity of the photographer's biography or the possibility of presenting the sad and emotionally ugly flipside of intimate life, fashion photography, with its obvious commercial remit, was bound to be the target of social antipathy.

Despite their rare and sustained confrontational spirit, Corinne Day (1965–2010) wisely chose not to re-present her fashion photographs of the early 1990s in the art world. Day's first involvement in photography was as a fashion model. She began to take photographs of her fellow models, who used her images in their portfolios, and this brought her to the attention of the art director at *The Face* magazine in London, who responded to the lack of pretension or conceit in Day's pictures. With her knowledge of life on both sides of the camera, Day used the commissions she received to debunk the glamorous myth-making of fashion photography. Her seeming lack of commercial ambition for her fashion photographs was rare, and her casual start in photography was as artless as could be wished for, a desirable prerequisite for photographers of intimate life. Her book *Diary* (2000), a personal chronicle of her life in the late 1990s, focused on the period when she suffered a life-threatening seizure that led to hospitalization and the discovery of a brain tumour. Images of Day in hospital leading up to an operation to remove the tumour and her recovery appear like staccato notes through the book's photographs of the highs and lows of her social circle. The only texts in the book, apart from endmatter, were the handwritten titles to the pictures, reminiscent of Larry Clark's *Teenage Lust*. In terms of content, Day's drive to photograph vulnerable and intimate

moments in her and her friends' lives resonates with the
tradition established by Nan Goldin.

Wolfgang Tillmans has been inaccurately described as
someone who started out in fashion photography and then
made a switch to fine art. In fact, Tillmans demonstrated from
the outset a confident understanding of the potential to shift
the meaning and currency of his images by experimenting
with a range of contexts including magazines, art galleries
and books. In the early 1990s, the anti-commercial stance of
youth magazines meant that these were exciting and highly
accessible vehicles for a young photographer's work. Tillmans's
photographs of friends, clubbers and ravers from the early
1990s, often using a snapshot aesthetic, found a relatively
natural home in the pages of London-based *i-D* magazine.
But his investigations were driven by something much more
interesting than the challenge of getting his pictures seen.
Tillmans takes the reproducibility of the photographic image
and makes it dynamic: he has mixed postcards, tearsheets,
inkjet prints and colour prints in an array of sizes that creates
an exciting, challenging non-hierarchical way of looking at
photographs. His installations, which use his back-catalogue
of images like raw matter, shaped into new rhythms and

141 OPPOSITE Nick Waplington, *Untitled*, 1996
142 Ryan McGinley, *Gloria*, 2003

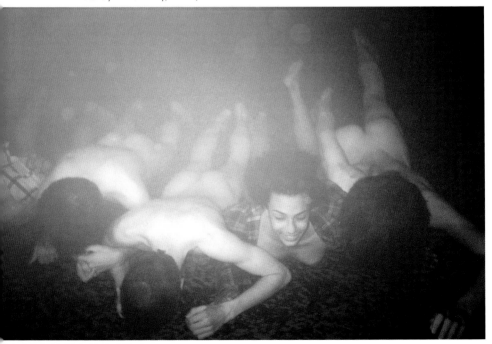

interrelations for each site, bring another level of immediacy to the experience of his photography and the materiality of the medium. As typified in Tillmans's work, the move away from the more traditional and rarefied gallery presentation of images in frames hanging in a line became one of the hallmarks of exhibiting art photography.

Zackary Drucker (b. 1983) and Rhys Ernst's (b. 1983) *Relationship* is a subtly thematic sequence of photographs made throughout their 2008–14 relationship. As MFA art students when their relationship began, both were establishing their independent art practices, Ernst predominantly as a filmmaker, and Drucker a performance artist. The photographs that they made together, of each other and their environments, were not intended to be viewed publicly; the project began in a pre-social media era. *Relationship* is a touching narration of coupledom and the intimacies of domesticity and family holidays, the gender transitions that both Drucker and Ernst were going through while in their relationship forming one of the narrative strands. As artists, their knowledge of photography and how to make pictures is embedded in this private cache of images, which was first shown publicly at the 2014 Whitney Biennial after one of its

143 Ren Hang, *Untitled 51*, 2012
144 OPPOSITE Elle Pérez, *Nicole*, 2018

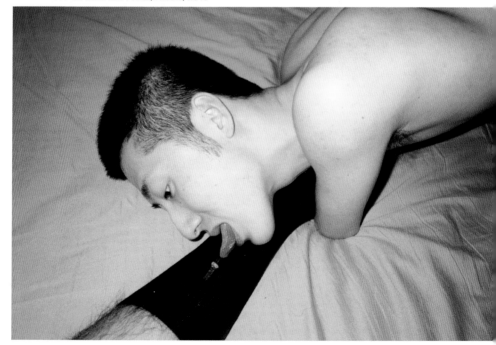

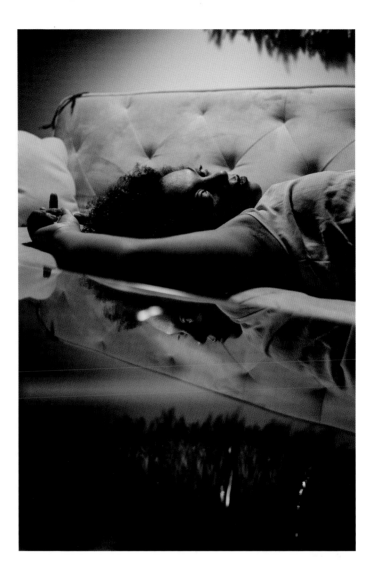

co-curators saw Drucker and Ernst's video collaboration *She Gone Rogue* on a studio visit, and encouraged them to think of their photographic collaboration as an intimate work of art in its own right.

The tempo and narrative embellishment that casual photography could give mixed-media art installations came into vogue in the early 1990s. Jack Pierson's (b. 1960) pictures of nature, semi-naked figures and male nudes typify how sensuous photography could be in dialogue with installation

140

145 Hiromix, from *Hiromix*, 1998. By the age of twenty-four, Hiromix had published five books of her photographs. This in part reflects the suitability of diaristic, intimate photography to the book format, using juxtaposition and visual rhythm on the page to create narrative. It also indicates the popularity in Japan for realizing photographic projects as books, which have in turn influenced photography book design in the West.

146 OPPOSITE Ka Xiaoxi, *Mr Sea Turtle*, 2015. From the series *Never Say Goodbye To Planet Booze*

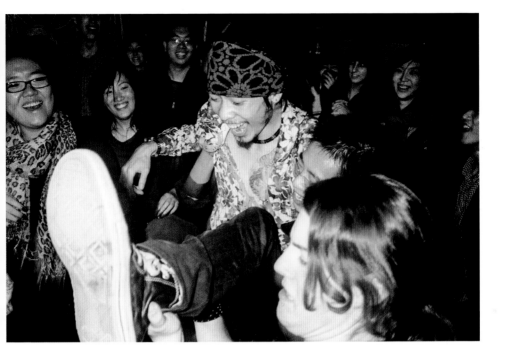

pieces, such as his *Silver Jackie* (1991), a small platform with a trashy metallic curtain hung behind it. Pierson's inclusion of intimate photography suggested who or what reflected his visual or sexual desires, and enhanced the sense of his art as being hinged on autobiographical narratives. But given the staged feeling of many of the photographs – to the point that they take the forms of popular media clichés – Pierson also seems to have been consciously investing contemporary art with the vocabulary of vernacular genres of photography.

141 The complex, energized sequence of images and handwritten notes in Nick Waplington's (b. 1965) book *Safety in Numbers* (2000) is an ambitious, high-momentum look at youth culture in an intense period of global travel. The project was a collaboration with the British magazine *Dazed and Confused*, which committed to publishing Waplington's project in instalments in the form of a supplement. The sense of shared attitudes, as well as the particulars of the social groups that Waplington moved through – from New York to Tokyo to Sydney – is captured in both the casual photographic style and the book design. Similarly, Vinca Petersen's (b. 1973) photographs of late-1980s rave culture in the UK and travelling with sound systems in Europe in the 1990s come together in

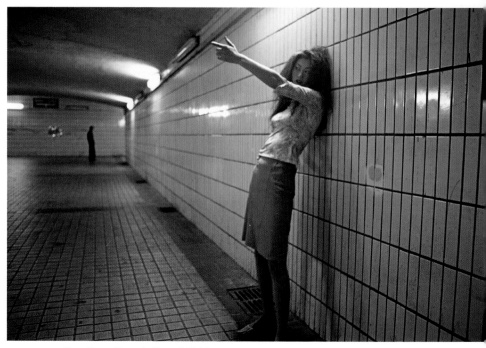

147 Yang Yong, *Fancy in Tunnel*, 2003

her book *No System* (1999) in a personal record of the excitement
and challenges of a collective, transient way of life.

142 Ryan McGinley's (b. 1977) 2003 exhibition at the Whitney
Museum of American Art in New York was advertised in terms
that suggested that intimate photography had become an
established genre, with young practitioners like McGinley now
making authentic records of their lifestyles in full awareness
of the traditions of this type of work within contemporary art.
As a teenager McGinley had met Larry Clark, and had later
taken up photography while studying graphic design in New
York. The implication of this public biography is that, early on,
he knew that there was a possibility that his images of his and
his friends' lives could one day receive public attention. Many
of McGinley's photographs were, like Nan Goldin's early work,
taken on Manhattan's Lower East Side (though it had been
gentrified beyond recognition since the late 1970s) – perhaps
an indication that McGinley's photographs of intimate life
were a response to and rephrasing of a recognized heritage
for the twenty-first century. What is new in his work is a lack
of the angst and pathos apparent in so much earlier intimate

collaboration with his subjects to help shape narratives for the public context of the art world.

143 In contrast, Chinese artist Ren Hang (1987–2017) was a self-taught photographer who chronicled his own intimate life and those of his close circle of friends in Beijing, where he lived from the age of seventeen. His photographs reached and resonated with a global audience on social media, in self-published books and international exhibitions. Their wide reach was in part due to the championing of his photographs by the artist and activist Ai Weiwei (b. 1957). Hang's beautiful and confident visual narration of sexuality and queerness put at him at odds with Chinese authorities, and he was arrested multiple times for breaching the broad and ill-defined PRC legislation enacted to censor pornographic material and penalize its distributors.

144 Through their installations and exhibitions, American artist Elle Pérez (b. 1989) uses the material properties of photographic prints to hold the human intimacy and raw relationality of the act of photography. Pérez's photographic relationships with

148 Elina Brotherus, *Le Nez de Monsieur Cheval*, 1999. From the series *Suites Françaises*.

their subjects are collaborative, with photographer and subjects actively staging the photographs in ways that amplify their LGBTQ+ community's experiences just enough to be registered and legible without spectacularizing them into objectifying or fetishizing visual currency. Pérez gives us a photographic proximity that is premised on intimacy; we are invited into a space of alterity within these narratives of familiarity.

Hiromix's (Toshikawa Hiromi) (b. 1976) snapshot photographs, including self-portraits and images of her friends, travels and domestic life, have brought her cult status in her native Japan. The promotion of her diary-like photographs centres on her place as one of a new generation

149 OPPOSITE Annelies Strba, *In the Mirror,* 1997
150 Elinor Carucci, *My Mother and I,* 2000

of photographers who have adopted the spontaneity and immediacy of Nobuyoshi Araki, but have their own attitudes and stories to tell. Hiromix delivers a sense of the artistic liberation that intimate photography can offer: the persona of the photographer being bound up in description of their life, rather than in adherence to stereotypical notions of youth culture and gender binaries .

146 Ka Xiaoxi (b. 1985) is a pivotal figure in Shanghai's fashion, music and art-focused culture, as both one of its primary photographic chroniclers and a cultural interlocutor who supports China's emerging creative talent. Xiaoxi acknowledges references to the spirit and aesthetics of fashion and art photographers creating magazines, books and fashion shoots

129 in New York and London, including Tim Barber (see Chapter 4), in his early work from the mid-2000s. In 2015, he published his book *Never Say Goodbye To Planet Booze,* which, over the course of 200 images, builds a vital, up-close portrayal of friends and strangers, in clubs, private spaces and open-air festivals, who inhabit and define contemporary lifestyles and creative expression in China.

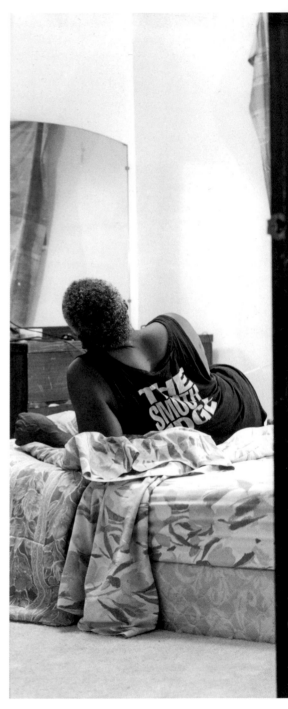

151 LaToya Ruby Frazier, *Me and Mom's Boyfriend Mr. Art*, 2005. From the series *The Notion of Family*. This series articulates the bonds and strengths of characters within one family, while telling a broader tale of the decline of industry in the so-called American Rust Belt, and its impact upon the communities constructed around and within it.

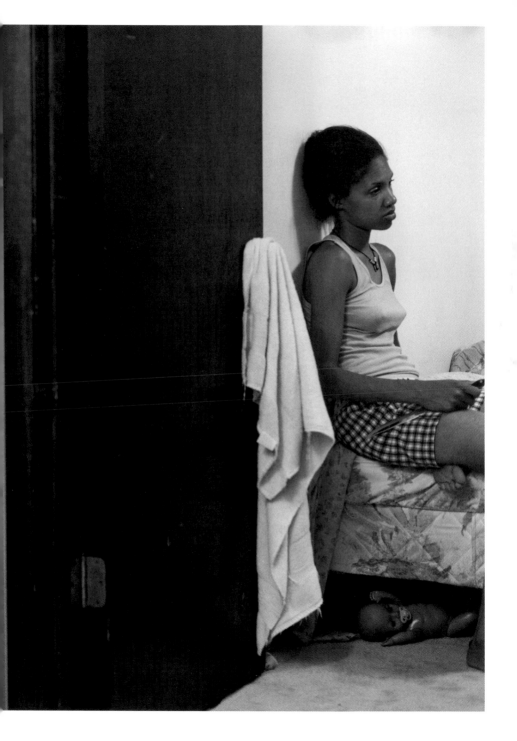

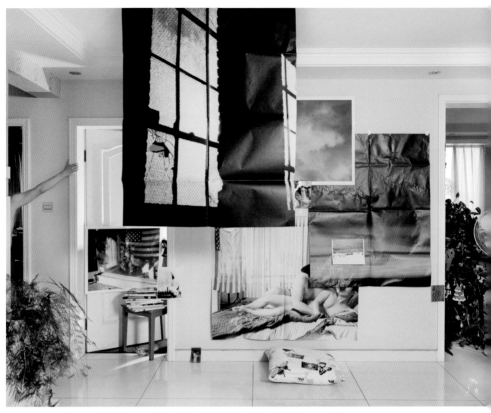

152 Guanyu Xu, *Space of Mutation,* 2018. From the series *Temporarily Censored Home.*

147

Intimate photography produced by 'Gen Z' artists, which often involves an entire group presenting their lives for consumption as art, has precedents including the work of Chinese artist Yang Yong (b. 1975), who photographed his circle of friends to evoke the attitudes of young urban people living in 'new China'. His early images were mainly taken at night in the streets of one of China's financial centres, Shenzhen, and staged in collaboration with his subjects. The photographs are not especially performative; emotions such as boredom are sometimes the focus. There is an air of waiting, of having little to do. There is a sense that Yang Yong and his collaborators are consciously imbuing their own lives with attitudes and postures that refer to fashion and lifestyle magazines, a Chinese version of the global representation of youth culture that took shape in art photography in the 1990s.

Photography of intimate life also includes portraits and self-portraits of detached and solitary figures. States of psychological isolation have been a recurring theme in the photographs of Finnish artist Elina Brotherus (b. 1972), who has poignantly photographed her life at times when she felt at her most uncertain or unstable. *Suites Françaises* is a series made while Brotherus was undertaking an artist's residency in France in 1999, struggling with the separation from her regular life and her inability to communicate fully in a foreign language. Post-It notes giving the French words and phrases that Brotherus was learning are placed around her modest living accommodation. The photographs show the technique she employed to try to learn the language with touching and comedic effect; the childlike phrases also had a practical use in the navigation of daily life in a foreign country.

149 Annelies Strba's (b. 1947) long-term photographic project focused on her immediate family, her two daughters and her grandson Samuel-Macia, convey a sense of a family used to photography as an integral part of their daily lives. The tilted camera angle and image blur indicate that Strba works unobtrusively and quickly to record her family's routines and interactions. She is rarely shown in her photographs, but her presence and point of view are felt in the observations she makes. At times, this is evident when her subjects face and react to the photographer and her camera. In more subtle ways, Strba's place within her family is implied in her choice of when to photograph them as they eat, sleep, wash and move about their home. In her book *Shades of Time* (1998), Strba interweaves her domestic images with landscape and architectural views as well as old family photographs, to give the historical, geographical and personal context for the depiction of her family.

151 As a college student in the early 2000s, LaToya Ruby Frazier (b. 1982) took her role as the photographer within her family towards a deeper and wider authorship of a family's story within the contextual and critical arc of the legacy of post-industrial climates upon individual lives and communities. Since the early twentieth-century, Frazier's family has lived in Braddock, Pennsylvania, working in the Edgar Thomson Steel Works that was established by Andrew Carnegie (1835–1919) in 1875. Over a twelve-year period, Frazier's sustained research, writing and photographic practice culminated in her 2014 book and related exhibitions, *The Notion of Family*. This body of work contains still lifes, landscapes and portraits in which Frazier both observes and collaborates with her family. Collectively, the photographs within *The Notion of Family* articulate the bonds

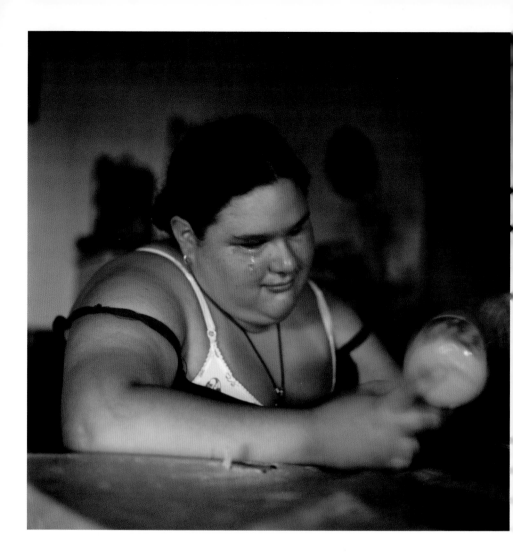

153 Alessandra Sanguinetti, *Vida mia*, 2002
154 OPPOSITE Tina Barney, *Philip & Philip*, 1996

150, 156

and strengths of characters within one family, while narrating a wider story of the impact and decline of the so-called 'dirty industries' upon entire communities, and the lives and bodies that have laboured within them.

Both Elinor Carucci's (b. 1971) and Ruth Erdt's (b. 1965) photographs of their respective families sensuously emphasize the archetypal narratives of personal lives, for example the bonds between mother and daughter or the growing pains of children. The search here is for a form of photography that, while remaining an account of the relationships between the photographers and their loved ones, abstracts each scene and omits the specificity of detail in order to give us a sense of the universality of these relational bonds and moments in life. Both Carucci's and Erdt's works make use of a conscious paring down of details such as dress and mise-en-scène that would date or overly particularize a photograph. This approach keeps symbolic and non-specific readings of their

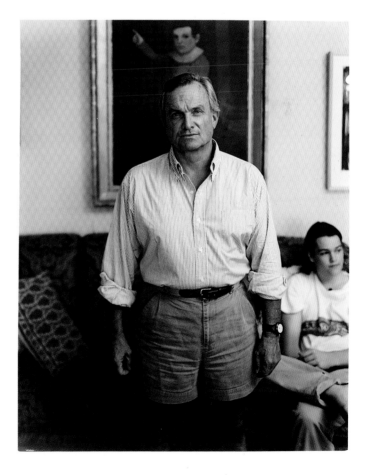

depictions of their personal relationships at the fore. In Karen Miranda Rivadeneira's (b. 1983) *Other Stories* series and book (published in 2016), her relationships with the women in her family are similarly centred. Rivadeneira collaborated with her female relatives to create images that are both intimate and intentionally loaded with objects and symbols that mark her family's Ecuadorian Indigenous heritage.

Guanyu Xu's (b. 1992) *Temporarily Censored Home* series depicts installations of his self-portraits and intimate photographs of other men, interwoven with his family's photographs and pages he tore from magazines as a teenager that cover the walls, floor and furniture of his parents' home in China. Now living in America, his return to China and into his own history becomes a photographic act of asserting and acknowledging his identity as a gay man. The dissonance of his relationality in the two

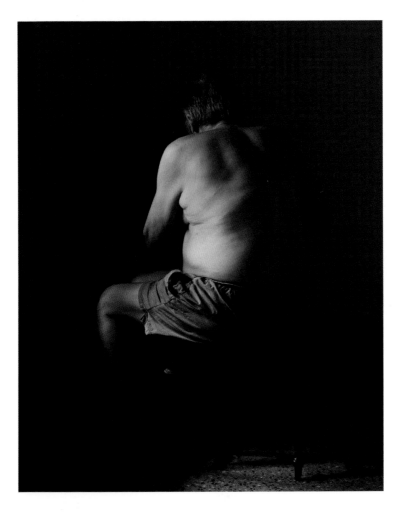

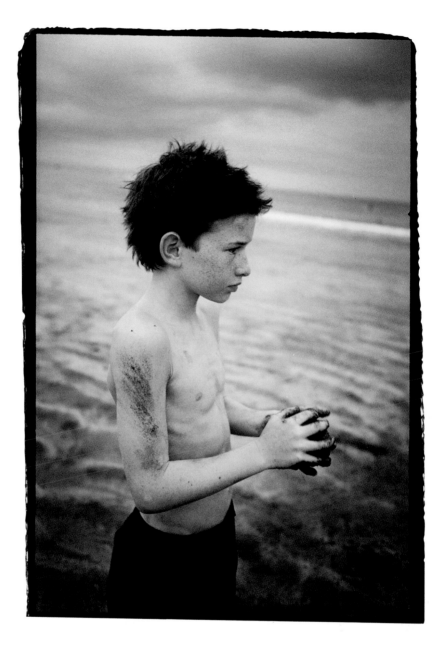

155 OPPOSITE Bharat Sikka, *Untitled*, July 2017. From the series *The Sapper*. Sikka's *The Sapper* project is a document of Sikka's long-term, nuanced and multi-layered portrayal of a father and former 'sapper' of the Indian Army Corps of Engineers. 156 Ruth Erdt, *Pablo*, 2001.

Intimate Life

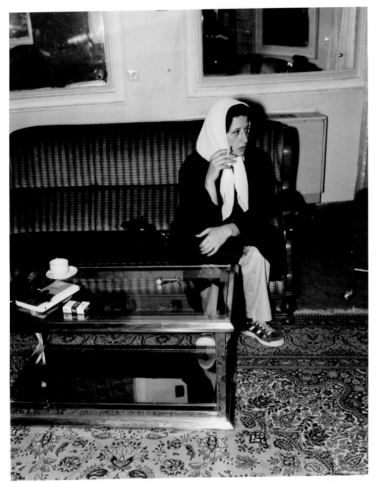

157 Shirana Shahbazi, *Shadi-01-2000*, 2000. Shahbazi's series of photographs of daily life in Tehran widen and cut across received views of what life in the Middle East, and particularly Iran, might look like.

central geographical axes of his life is installed in a space where his sexuality was unspoken, and in a country where LGBTQ+ visibility is highly censored and socially taboo.

The photographic collaboration between Alessandra Sanguinetti (b. 1968) and two female cousins growing up in a rural community outside Buenos Aires, Argentina centres on the girls' decisions about how to represent themselves, often involving theatrical performances and role play. The role of the photographer is one of recording or facilitating the girls' self-expression rather than as a choreographer of

153

their representation. From this close, trusting relationship between Sanguinetti and the cousins developed the possibility of Sanguinetti being able to make other, more observational images that caught the girls – now young women – when they were out of their performed characters.

154 Tina Barney's (b. 1945) photographs of her affluent American East-Coast family are one of the benchmarks for art photography's capacity to visualize familial bonds outside the mannerisms of casual photography. Barney describes her photographic approach as being akin to an anthropological survey, recording the rituals, gestures and environments that reveal underlying personal relationships. In a manner similar to nineteenth-century photographic portraiture, activity and motion go on behind the camera as Barney rapidly composes her shots, the subjects compliantly suspending their animation as she works. The spatial connections between her subjects become pronounced in her photographs, and demarcate signs of psychological closeness and distance between family members.

155 Bharat Sikka's (b. 1973) *The Sapper* project is as multi-layered as the relationship that it narrates between a father and adult son. The title offers an explanation of the

158 Richard Billingham, *Untitled*, 1994. Beginning in the early 1990s, Billingham created a memorable visual record of his family life as 'sketches' for his paintings; in 1996, a book of these photographs, *Ray's a Laugh*, was published as a creative work in its own right.

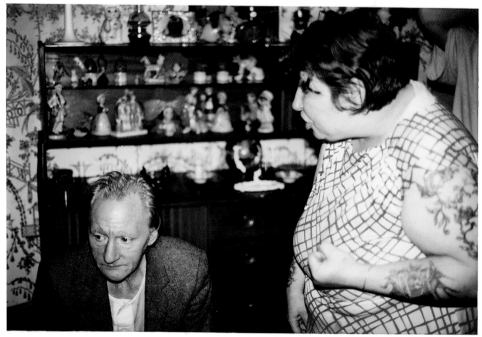

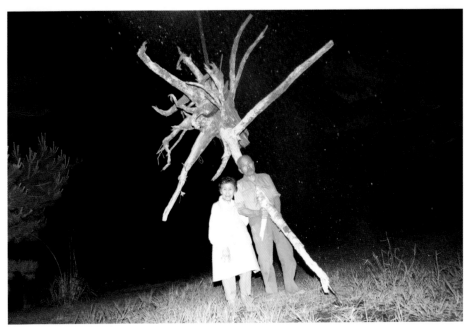

159 Lieko Shiga, *Spiral Shore*, 2010. From the series *Rasen Kaigan*.

circumstances, behaviours and predilections that can be read into Sikka's long-term portrayal of the father, a former 'sapper' of the Indian Army Corps of Engineers. Throughout his constellation of photographs and photographic objects is a narrative of companionship, with neither the patriarch nor the photographer commanding superiority over the other. There is a negotiated equality that happens within the photographic space that they create together, where ideas are exchanged, observations quietly made and authorship fluidly passed between them. Photography remains a conduit for visual 'proof' and, in the context of this chapter, shows us the difference between the public, constructed facade of human culture and the private realities of our intimate lives.

Iranian artist Shirana Shahbazi's (b. 1974) photographs of daily life in Tehran cut across expectations of media-led perceptions of daily life in the Middle East. In Shahbazi's mosaic-like installations, some formal, others casual in composition, and the large-scale paintings of her images by Iranian billboard painters, she uses and confounds the stereotypes of Islamic art and daily actuality, proposing that a culture of such size, history and complexity cannot be represented through one visual form.

158 The meteoric rise of British artist Richard Billingham (b. 1970) began in the early 1990s when he started to create a memorable record of his family life. At the time, he was studying fine art (specializing in painting) at Sunderland Art College, and he had taken a series of photographs of his parents, Ray and Liz, and his brother Jason as 'sketches' for his paintings. Billingham was encouraged to consider these, rather than his paintings, as a direct articulation of his family dynamics and a body of work in their own right. In 1996, a book of his photographs, *Ray's a Laugh*, was published, with a minimal amount of text and a sequence of images of Ray drinking home-brewed beer and falling over, Liz and Ray fighting and Jason playing computer games in their cramped and untidy council flat in the West Midlands. On a primary level, Billingham was using the camera to find formal compositions within his encounters with his family, and his photographs carry the stance of someone seeking a more critical understanding of the daily reality of his life. Billingham had no idea when taking these photographs that they would end up on the walls of London's Royal Academy in its infamous 1997 'Sensation' show – but the characterization of his practice as simply taking snaps of his family, without artistic vision or genuine creative authorship, speaks more to a move to position him as a social and cultural outsider to art than to the visual eloquence of his portrayal of his family.

159 In 2009, Japanese artist Lieko Shiga (b. 1980) began living and then photographing in the small town of Kitakama on the northeast coast of Japan, eventually creating what became her book *Rasen Kaigan* [Spiral Coast], published in 2013. Shiga spent her first year in Kitakama becoming part of the community and learning about its collective history through the individual stories of the inhabitants, including how they had cleared land for farming by digging out pine trees with only hand tools. She became the town's quasi-official photographer, documenting their festivals and rituals. Within a year, an elderly woman asked Shiga if she would make a photograph that captured her and this remote and ancient place in readiness for her funeral. In 2011, Kitakama was destroyed by the Tōhoku earthquake and tsunami, with many of the inhabitants killed in its wake. The pine forest that ran for 80km from the town to the Fukushima Daiichi Nuclear Power Plant was flattened. Shiga continued to photograph in the wake of the disaster, creating a deeply personal ode through her phenomenological photographs that summon up the spirits of the place and its inhabitants, both past and present.

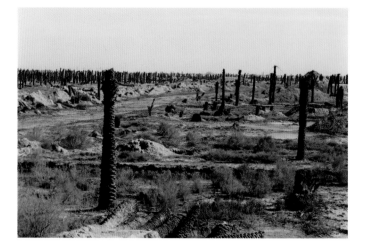

Chapter 6
Moments in History

The contemporary art photographers who take on the challenge of documenting human experience and the events that shape our world employ multiple strategies that expand far beyond the traditional stances of photo-reportage established in the mid-twentieth century. Faced with a gap left over the course of the ensuing decades by the decrease in commissioned documentary projects, the disappearance of picture-based news magazines and the rise of television and digital media as the most immediate carriers of information, photography's answer has been to make an asset of the different climates and context that art offers. The photographers whose work is shown here include those who make long-term photographic projects – some arriving after the climactic moment of world events to engage with the consequences of their impact, others working to bring us into the closest proximity and least objectifying vantage points upon human life. The use of medium- and large-format cameras not normally seen at the sites of war and human disaster – at least, not since the mid-nineteenth century – has become a recognizable sign of photographers seeking to frame the world in a measured and contemplative manner.

One of the most influential photographers working in this mode is French artist Sophie Ristelhueber (b. 1949). From her photographs of Beirut in the early 1980s during the Lebanese Civil War, to her depiction of the fragile borders of Uzbekistan, Tajikistan and Azerbaijan at the beginning

160

160 OPPOSITE Sophie Ristelhueber, *Iraq*, 2001. Sophie Ristelhueber has described her experiences in Iraq in 2000 and 2001 as 'a striking shortcut of thousands of years: from the oldest civilizations who had lain on this land to those of the first Gulf War, while the American F-16s were flying over our heads on surveillance missions. The fossilized vision is a pattern that haunted me since the Beirut work, a cycle of more than twenty years that is on the verge of ending.'

of the new century, Ristelhueber has visualized the tragic repetition of the destruction of nature and civilizations. In 1991, in the wake of the first Gulf War, she worked in Kuwait, making aerial photographs of the traces of bombing and troop movements and, on the ground, photographing the poignant residues of combat, such as abandoned clothing and mounds of spent explosive shells. The project was entitled *Fait*: 'fact' and also 'done' or 'made' in French. The bleak, unfathomable chain of consequence and effect in war is very pronounced in Ristelhueber's images of Iraq in 2000 and 2001. In some of her starkest visualizations of the destruction of war, burnt tree stumps act as metaphors for the loss of life as well as the ecological decimation of the region.

161 Zarina Bhimji (b. 1963) works with film and photography to recount the physicality and passage of time held within spaces. In so doing she considers the ways in which images can resonate with narratives of elimination, extermination and erasure. In her lightbox series, among them *Memories Were Trapped Inside the Asphalt*, Bhimji returned to Uganda, from where she and her family, along with all others of Asian ancestry, had been expelled in 1972 at the order of the sitting president, Idi Amin. The still lifes act as a metaphor for an altered and suspended situation, in which the logic of the everyday no longer applies. Her aesthetic evocation is similar to that of other artists in this chapter: she chooses forms that function as allegories which, through their extreme economy of means, remain open-ended and intentionally unresolved.

The use of allegory is also shown in the work of Anthony
162 Haughey (b. 1963), who has photographed at territorial borders, including the Balkans in the late 1990s, as part of *Disputed Territory* (1998–), a project that began on the borders of the Irish Republic and Northern Ireland. It is in the details of his photographs that a sense of a place or culture, indelibly changed by traumatic events, can be found. In post-conflict Bosnia-Herzegovina, and Kosovo, Haughey utilized the slight and ambiguous traces of past acts of violence that have become a prevalent iconography of civil trauma within contemporary
163 art photography. Ziyah Gafic's (b. 1980) photographs, also made in Bosnia-Herzegovina during the 2001–02 aftermath of civil war, often capture the return to ordinary life with the results of the conflict's genocide dramatically present. In the photograph shown here, the Commission for Missing Persons had organized the excavation of the bodies of massacred Muslim villagers in Matuzici. They are laid on white bags behind a mosque for identification. The dissonance between the skeletons and the beautiful view across the landscape,

161 Zarina Bhimji, *Memories Were Trapped Inside the Asphalt*, 1998–2003. Bhimji describes her project about Uganda as 'learning to listen to difference: listening with the eyes, listening to changes in tone, differences in colour'.

with signs of domestic activity in the carpets hung up to dry, is profoundly shocking.

The artistic conventions used to translate social events and the consequences of history into visual forms are now well established. British artist Paul Seawright's (b. 1965) series *Hidden*, a mournful narrative about the futility of war, was produced in 2002, when he was one of the artists commissioned by the Imperial War Museum in London to respond to the conflict in Afghanistan. In *Valley,* Seawright displays a twisting hill road, littered with artillery shells, in a compositional manner reminiscent of the earliest photographs of conflict zones by British photographer Roger Fenton (1819–1869), whose images of the Crimean War included an April 1855 photograph of a desolate landscape with an arrangement of cannon balls in the aftermath of battle.

164

162 Anthony Haughey, *Minefield, Bosnia*, 1999
163 OPPOSITE ABOVE Ziyah Gafic, *Quest for ID*, 2001
164 OPPOSITE BELOW Paul Seawright, *Valley*, 2002. From the series *Hidden*.

165 French artist Luc Delahaye's (b. 1962) *History* series memorializes contemporary world events with epic gravitas, using a panoramic format and monumentally sized photographic prints. Delahaye began the series in 2001, adding an average of four photographs per year; the artistic status of his work is signalled by its rarity in comparison to editorial photography. *History* revolves around military conflict, and includes images taken in war zones such as Afghanistan and Iraq, and others showing the consequences of war, such as the trial of former Yugoslav president Slobodan Milošević in The Hague in 2002. Delahaye takes a subject more familiar in photojournalism and creates historical tableaux (see Chapter 2), rendering the materiality of traumatic recent history strongly resonant and haunting. This photographic approach is shocking, in part because some of his subjects – such as here on *Kabul Road*, where a group of men pose for the camera with corpses in the centre – are so composed, aesthetically impeccable and definite.

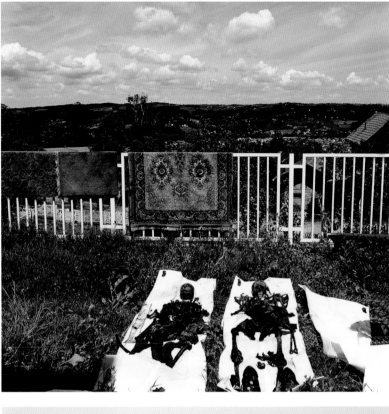

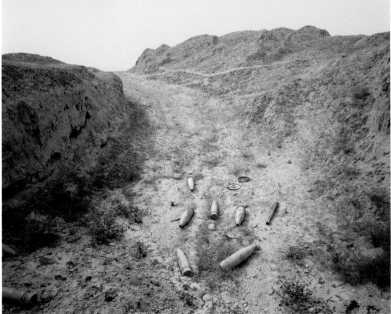

This mediation of contemporary world events through pre-existing modes of image-making is clear in Simon Norfolk's (b. 1963) photographs of Afghanistan, in which the skeletons of bombed-out buildings are depicted as the romantic ruins of past civilizations on deserted plains, reminiscent of late-eighteenth-century Western landscape paintings. There is a legitimate and specific reasoning behind this return to a pictorial style of the past, which makes pointed and ironic reference to the fact that, because of the decimation of war, this ancient and culturally rich region has been returned to a pre-modern state, as well as simultaneously offering a vantage point onto a post-apocalyptic landscape.

In his writing and photographs over the course of forty years, Canadian artist Allan Sekula (1951–2013) put forward one of the strongest arguments for why and how art can accommodate thorough, politicized investigations of the major economic and social forces that shape our world. Sekula's photographs are intentionally difficult to reduce to iconic images or soundbites on the subjects he researched. Working in this way, he resisted being consumed by the art market while maintaining a prominent place in international (especially European) exhibition programmes. In *Fish Story*, a vast undertaking spread over many years, Sekula examined the realities of the modern maritime industry. His photographs, slide sequences and texts interweave the history of sea trade routes with the problems facing this industry. Rather than international sea ports being represented as ahistorical, functional places, Sekula depicts this trading, dispersed across the world's seas, as an often-forgotten but politically resonant structure through which to deeply observe the histories and consequences of globalization.

165 Luc Delahaye, *Kabul Road*, 2001. From the series *History*.

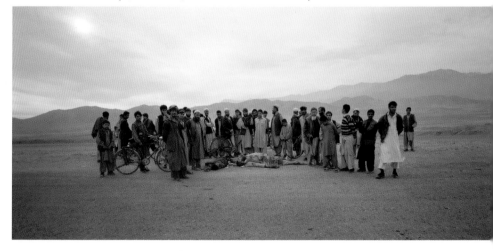

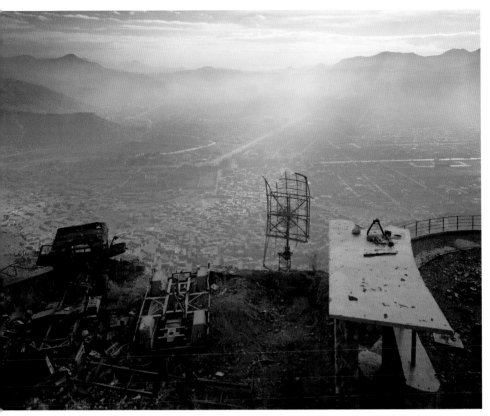

166 Simon Norfolk, *Destroyed Radio Installations, Kabul, December 2001*, 2001. Norfolk's images of a decimated Afghanistan depict the landscape in a similar vein to the European artists of the Romantic era, who painted the decline of great civilizations. The war in Afghanistan has scarred the landscape, and Norfolk photographs the remains like an ancient archeological site.

168 Paul Graham's (b. 1956) *American Night* series was made over a five-year period from 1998. Most of the photographs are disarmingly bleached-out images of roadsides and pedestrian walkways where barely visible African American figures walk. The dramatic overexposure of these photographs is suggestive of the political invisibility and social blindness to poverty and racism in America. Clear, colour-saturated photographs of ostensibly wealthy suburban homes punctuate the series, reflecting Graham's stark narration of the condition of contemporary American society. His use of such startling aesthetic difference frustrates our expectations of photography's documentary style and capacity, and acts as a visual metaphor for social inequity.

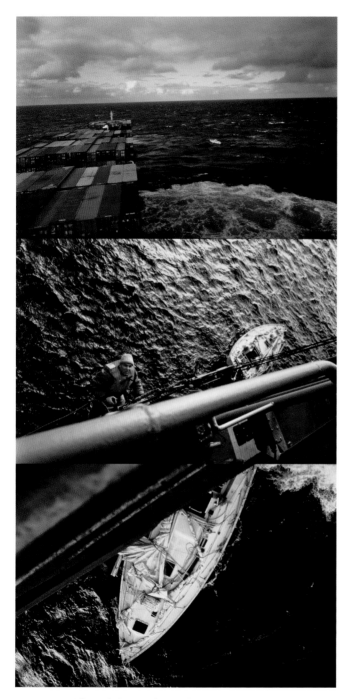

167 Allan Sekula, *Conclusion of Search for the Disabled and Drifting Sailboat 'Happy Ending',* 1993–2000
168 OPPOSITE Paul Graham, *Untitled 2001 (California),* 2001 and *Untitled 2002 (Augusta) #60,* 2002. From the series *American Night.*

169 Richard Mosse (b. 1980) has followed the journeys of refugees from the Middle East and North Africa into Europe. His *Heat Maps* series documents the overcrowded refugee camps and migrant staging sites along those routes. *Moria in Snow, Lesbos* shows the refugee containment camp on the Greek island of Lesbos during challenging wintry conditions. Moria is where the European Union and Turkey's strategy for halting refugees' migration into mainland Europe is enforced. For *Heat Maps*, Mosse used a thermographic camera (most commonly used by the military and law enforcement) mounted on a robotic tripod to photographically 'map' the encampments. Close to 1,000 individual frames are tiled together to create monochromatic, panoramic expanses that capture the dreadful specificities of overcrowding, confinement and precarity that delineate the present-day refugee crisis.

170 Trevor Paglen's (b. 1974) projects have been field-defining in their proposals for how the covert forces that govern militarization, infrastructures and institutions might be visualized artistically. In his 2008 series *Other Night Sky*, Paglen created long-exposure photographs of the night sky in Nevada that mapped the flight paths of classified American military

169 Richard Mosse, *Moria in Snow I, Lesbos*, 2017. From the series *Heat Maps*.

aircraft and drones. *National Reconnaissance Office Ground Station (ADF-SW) Jornada del Muerto, New Mexico Distance ~16 Miles*(2012) is part of his series *Limit Telephotography*, in which he used high-magnification telescopes to photograph classified military sites. The resulting 'telephotographs' are almost painterly in their soft distortion of these secret locations, caused by the blurring of frequencies over which light travels for scores of miles between his subjects and the telescopic camera. Paglen's artistic signature is invariably based on utterly meticulous long-term research and his upending of the conventional means by which to visualize the hidden machinations of governmental and military forces.

171 Oliver Chanarin (b. 1971) and Adam Broomberg's (b. 1970) *Spirit is a Bone* (2015) project co-opts a sophisticated four-lens facial recognition system developed by the Russian government for identification of individuals at public demonstrations, transit spaces and state borders. Using 3D modelling software, the system combines the four angles of photographic capture to construct a 360-degree rendering for the purposes of state surveillance and control. Broomberg and Chanarin created portraits of a wide spectrum of Moscow's citizens, including Pussy Riot member Yekaterina Samutsevic (b. 1982). *Spirit is a Bone* is rooted in the early twentieth-century practice of

Moments in History

creating vast taxonomies of people using photography – for the purposes of repressive pseudoscientific research and data building, and the photographic counter-intention to represent a nation's ethnicity and diversity. Embedded within *Spirit is a Bone*, however, is the distinction that the subject no longer needs to be present or conscious of their participation in the portrayal of their likeness.

The depiction of marginalized, socially overlooked groups has been a central concern of documentary photography since the coining of the term in the 1920s. The fact that today these images are likely to manifest in their primary form in artist's books and exhibitions, rather than primarily as editorial stories in magazines or newspaper supplements, is a sign of the shift

170 Trevor Paglen, *National Reconnaissance Office Ground Station (ADF-SW) Jornada del Muerto, New Mexico Distance ~16 Miles*, 2012. For his *Limit Telephotography* works, Paglen used powerful high-magnification telescopes, akin to those used to observe and read far-off planets and matter in astrological space, to photograph classified military sites that are secured from public view within remote areas of America and its overseas restricted sites.
171 OPPOSITE Oliver Chanarin and Adam Broomberg, *The Revolutionary*, 2012. From the series *Spirit is a Bone*.

in the context of photography in the twenty-first century. Where photographic projects concentrate directly on human subjects and the consequences of social crisis or injustice for communities, one of the most prevalent forms is the ostensibly neutral, undramatic 'deadpan' style of photograph encountered in Chapter 3. A claim often made about such photography is that it allows the subjects to control their representation, the photographer bearing witness to their existence and self-possession. Essays and captions accompanying the photographs are often crucial here, used to carry factual information about what the subjects have endured and survived and the circumstances in which the photograph was taken. At times, quotes from the subjects are also displayed, not only to give them a voice, but also to imply the role of the photographer as their mediator and witness.

Fazal Sheikh (b. 1965) has primarily photographed the passage of displaced communities and the stories of individuals and families living in refugee camps. The photograph shown here is from his series *A Camel for the Son*, in which Sheikh photographed Somali refugees in camps in Kenya. Concentrating on the mainly female refugees, he recorded interviews with them about the conditions they had

172 Fazal Sheikh, *Halima Abdullai Hassan and her grandson Mohammed, eight years after Mohammed was treated at the Mandera feeding centre, Somali refugee camp, Dagahaley, Kenya,* 2000. From the series *A Camel for the Son.*
173 OPPOSITE Chan Chao, *Young Buddhist Monk, June 1997,* 2000. Chan Chao has described his *Something Went Wrong* series as 'very much a kind of self reckoning'. The series was made on a number of visits to refugee camps bordering on his native Burma (now Myanmar) and portrayed people who had been displaced or forced out of the country after he had migrated West.

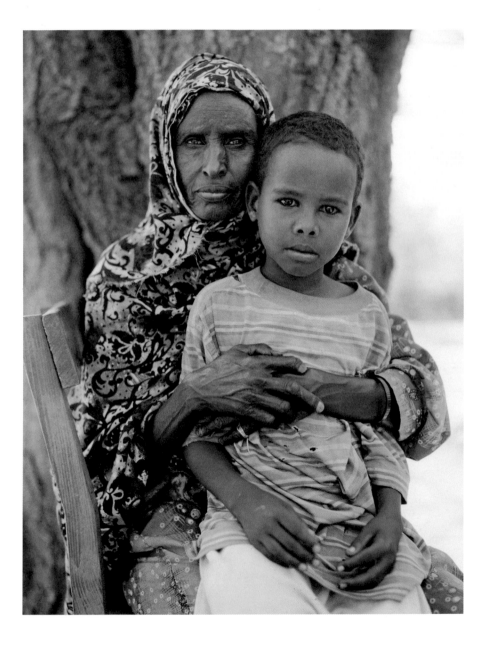

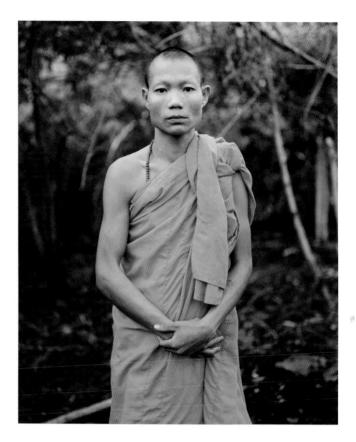

withstood and the human rights abuses they had survived in Somalia and in the camps. Sheikh's singling-out of sitters, asking them to engage with his camera at a distance from the chaotic ebb and flow within their living quarters, gives them a dignified and enduring quality, strengthened by the use of black and white analogue techniques. Together with texts transcribed from the interviews that detail their individual stories, the photographs hover somewhere between portraits of each person and a collective portrayal of a community surviving an all-too-familiar chapter of trauma and injustice.

173 Chan Chao's (b. 1966) *Something Went Wrong* is a series of portraits of refugees who fled Myanmar (previously Burma) after the repressive State Law and Order Restoration Council took power in 1988. Single figures, stoically conducting their lives in displaced communities, are shown temporarily halting their routine in the jungle squatter camps to be photographed. The extended title of *Young Buddhist Monk, June 1997* states that

the young man was a former member of the ABSDF, an armed student group. The effect of the caption is to both intensify and complicate the image; the photograph is revealed to be an encounter with a human at a specific point in their personal history, shaped by the might of political and militaristic violence and force.

174 American artist Jess T. Dugan (b. 1986) creates photographic portraits that bring the viewer into profound proximity to lived experiences of gender, sexuality and identity outside of heteronormativity. From 2013 to 2018, Dugan collaborated with social worker and academic Vanessa Fabbre, work that culminated in the book and photographic portfolio *To Survive on this Shore*. This far-reaching project consisted of Dugan's portrait photographs and interviews that they and Fabbre conducted with older transgender and gender nonconforming adults across the U.S. It pays uniquely expansive testimony to the courage and inventiveness of underrepresented older transgender generations that have fought for equity and their human rights.

175 Deirdre O'Callaghan's (b. 1969) *Hide That Can* project is a culmination of four years of spending time with and portraying the residents in a men's hostel in London. The photographic series is slow-paced, and opens up a close vantage point onto a displaced and socially marginalized community of mainly Irish men in later life, who came to London as young adults to earn money as manual labourers. O'Callaghan moved to London in the early 1990s in search of work, as did many young Irish men and women, and this forms the basis of her affinity with the hostel's residents. Initially, she photographed the men only occasionally, spending more of her time becoming a familiar face in the hostel. Her photographic project became part of the men's daily routine, and O'Callaghan would talk to them about their personal histories, becoming a witness to their situations.

176 Danish artist Trine Søndergaard's (b. 1972) photographs of women sex workers, either with their clients or off-duty around the Central Station in Copenhagen, Denmark, were taken in 1997–98 . The lack of glamour or performativity in the images speaks to the reality of the women's situation, and consciously normalizes and individualizes them in contrast to the cultural and media stereotyping that is the mainstream depiction of female prostitution. Søndergaard's project does not concentrate on the salacious moments of the women's working lives, but is tempered through depictions of their daily routines and quotidian environments. As a result, we are given entry points into understanding how they survive the dehumanizing effect of their work and their social exclusion.

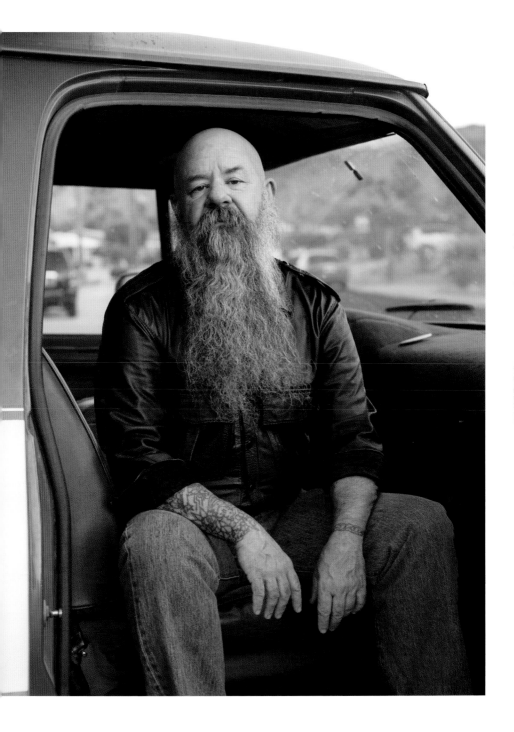

174 Jess T. Dugan, *Sky, 64, Palm Springs, CA, 2016*, 2016. From the series *To Survive on this Shore*.

The Ukranian artist Boris Mikhailov (b. 1938) has taken pictures in many different guises since the 1960s: as an engineering photographer, a photojournalist and now a prominent figure in contemporary art. These shifts to some degree reflect the sanctioned possibilities of being a photographer in Communist and post-Communist Ukraine. Mikhailov began his *Case History* project, of more than 500 photographs, in the late 1990s. In this work, he paid homeless people in his hometown of Kharkov to pose for him. They re-created scenes from their personal histories or Christian iconography, or undressed to show the ravages of poverty and violence on their bodies. Mikhailov has described his relationships with the subjects of *Case History* as collaborations, and the frank, intense depictions of those he considers to be his anti-heroes are motivated by a combination of his emotional closeness to his subjects and understanding of the brutal realities of their lives. But there is a tension in Mikhailov's work: it can also be seen as a voyeuristic spectacle. Mikhailov's payment of his subjects to pose and perform

175 Deidre O'Callaghan, *BBC 1*, March 2001. O'Callaghan's *Hide That Can* project portrays the residents of a hostel for men in London. O'Callaghan also accompanied some of the men on holidays back to Ireland and witnessed the transformation of the men's behaviour and self-esteem when outside their institutionalized daily life. In a few instances, the Irish men were reunited with their families on these holidays, sometimes after decades of having no contact.

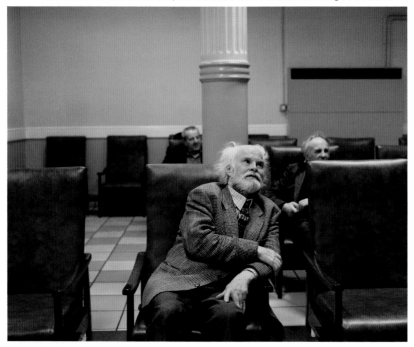

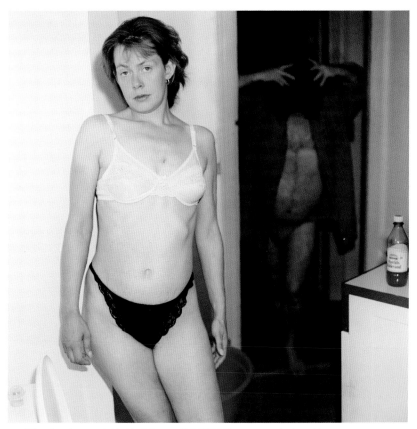

176 Trine Søndergaard, *Untitled, image #24*, 1997. The women depicted in Søndergaard's photographs are prostitutes. They are invariably shown as being conscious of the camera, collaborating with the photographer in the documentation of their lives and trade.The male clients are rarely fully shown, more often represented as temporary and anonymous presences.

for the camera is, for him, little more than a mirror image of the degrading reality for the disenfranchised of the former Soviet Union.

178 In 1982, Roger Ballen (b. 1950) began photographing the homes and people of small town South Africa, observing and photographing his many Boer subjects as individuals but also as archetypes of introverted communities. In the late 1990s, it became clear from his photographs that Ballen's relationship with the people and places on the outskirts of Johannesburg and Pretoria had changed. His work became more obviously staged compositions of people, animals and the interiors they inhabit; in recent years, it has become more abstract,

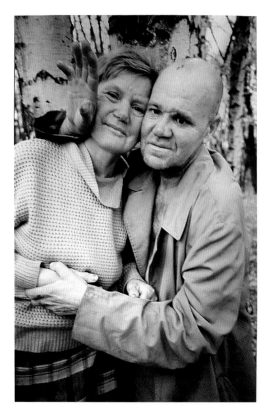

177 Boris Mikhailov, *Untitled*, 1997–98. From the series *Case History*.
178 OPPOSITE Roger Ballen, *Eugene on the phone*, 2000

depopulated by his familiar human subjects. Ballen has described the Brechtian theatricality of his photographs as being jointly directed by him and his subjects, many of whom he has photographed for years. To shift to overtly aestheticized, depoliticized territory was seen by some as an inappropriate visualization of post-apartheid South Africa. Ballen's photographs are black and white in the tradition of humanist documentary photography, but purposely withdraw from narrating a social or political context. He appears to be drawn to the forms that are constructed in the places he photographs, using monochrome to emphasize the formal qualities within the photographic frame rather than seeking to represent his values and beliefs in the subjects he photographs.

One of the most important thrusts of contemporary art photography that centres on human life is the endeavour of artists to find ways to narrate human experience and survival without objectifying or othering their subjects. Since the mid-nineteenth century, photography has been implicated in

in criminalizing social resistance and activism; as evidence in support of eugenic theories; the vehicle for voyeurism and surveillance; the constructed visual endorsement of social elites; and the hubristic records of colonial and imperial power. Contemporary artists find ways to counter this heritage and to reclaim the equally long-held possibilities of the medium as a conduit with which we see others, and can be seen.

Between 2012 and 2015, American artist Kristine Potter (b. 1977) photographed the remote landscapes of western Colorado, and the men she encountered living as farmers, itinerant ranchers and lone homesteaders there. For her *Manifest* project, Potter worked with a large-format camera and colour film, and in her post-production process, rendered delicate photographs in black and white that translates the feeling of the sun drenched, high altitude desert region. Potter channels a long history of both the depiction of the American West and the masculine embodiment of Manifest Destiny, the mid-nineteenth-century expansionist concept that underpinned the settlers' claiming of the North American continent. Potter

consciously works to subvert and reframe both the role of photography in the establishment of the American West and the depiction of symbolically fragile visualizations of masculinity and human survival, in her acute analysis of its contemporary iterations and manifestations.

American photographer Jim Goldberg's (b. 1953) *Open See* project, which began in 2003, centres on the experiences of migrants who have sought refuge and are held in Greek territories, with additional photographic journeys to the regions from where many of the immigrants came in the 2000s, including Ukraine, India, Bangladesh, Senegal and Liberia. Goldberg's narration uses multiple photographic approaches, ranging through large and medium format photographs, grainy 35mm black and white images and video. The empirical mass of *Open See* consists of hundreds of Polaroid portraits that Goldberg made during his interactions with individual subjects. Many of the Polaroids are inscribed with the subject's name, their message and sometimes their drawings. Goldberg

179 Kristine Potter, *Topher by the River*, 2012. From the series *Manifest*.
180 OPPOSITE Jim Goldberg, *Saleem, Athens*, 2004. From the series *Open See*, 2003–9

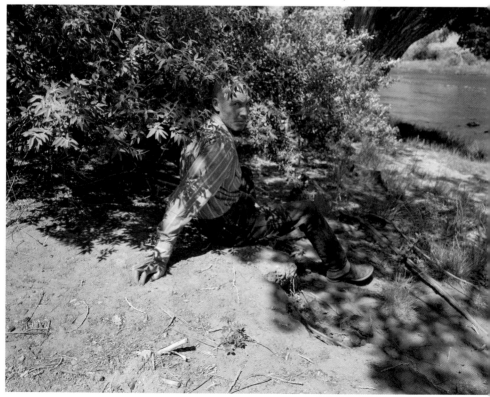

has used this device of giving pictorial space to the words of his subjects since his 1970s project *Rich and Poor* (1977–85), which showed the deep-seated class divisions in America, followed by his humanizing look at the lives of young people in California excluded and failed by society in *Raised by Wolves* (1986–95). Goldberg's mixing of observations and translations, direct quoting of his subjects and hand-drawn embellishments provide a powerful entreaty to see beyond reductive newspaper headlines. *Open See* holds multivalent stories about the tragic and indomitably hopeful things that people say and do to survive, and which Goldberg calls for us to hear and see.

8 For close to twenty years, Zoe Strauss (b. 1970) has used photography as a device for social interaction and consciousness raising, focusing on portrayals of everyday life in America. Every year for the first decade of the twenty-first

181 Patrick Waterhouse, *Hip-Hop Gospel and Tanami. Restricted with Athena Nangala Granites*, 2016. From the series *Restricted Images: Made with the Warlpiri of Central Australia*, 2018. Working with members of the Warlpiri language group, in Yuendumu and Nyirripi communities, Waterhouse invited his collaborators to 'restrict' his black and white photographic prints, symbolically addressing the troubling colonial legacy of photography in Australia.

182 OPPOSITE Carolyn Drake, *Untitled*, 2014. From the series *Internat*, 2006–17. Drake's *Internat* project (2017) centres on her long-term engagement and collaboration with girls – now young women – deemed disabled and interned in a remote, former Soviet state-run hostel in the Ukraine.

century, Strauss installed an exhibition of her photographic portraits, still lifes and landscapes, made both in Philadelphia and communities across America, in a space below the overpass of the I-95 State Highway (the main corridor along the east coast of the United States) in South Philadelphia. Strauss's project facilitated the community's creation of a public arena in this ignored urban zone. In 2012, in collaboration with the Philadelphia Museum of Art and two outdoor advertising companies, Strauss's *Billboard Project* made another timely social intervention and constructed a symbolic 'journey' across fifty-four billboard sites in Philadelphia. Strauss's intention, as with all of her photographic activism, is to acknowledge and situate both the beauty and conflict of everyday life as a public and shared experience.

Through collaboration, British artist Patrick Waterhouse's (b. 1981) *Restricted Images: Made with the Warlpiri of Central*

Australia (2018) works generatively through the problematic legacy of colonial photography in the service of ethnography and anthropology, and its representation of Indigenous nations. Working from the well-established Warlukurlangu Artists centre, which supports the cultural lives of the Warlpiri language group in Yuendumu and Nyirripi communities, Waterhouse invited his collaborators to modify his photographic prints – to 'restrict' their Western, antecedent colonialism – with dot painting traditional to these Aboriginal communities. In so doing, Waterhouse's project creatively enacts a symbolic maintaining of cultural identity and agency by its subjects.

182 American artist Carolyn Drake (b. 1971) creates deeply layered accounts of lives outside of received narratives. Her capacity to construct ways to engage and participate with her subjects leads to portrayals of human existence that do not objectify but instead articulate daily experiences that resonate with the human consequences of social history, visualize her subjects' emotional and creative intelligence and speak to the emancipatory photographic power of 'being seen'. Her book *Two Rivers* (2013) tells human-scaled stories set between the Amu Darya and Syr Darya rivers in Central Asia, a once-fertile region transformed when the rivers were diverted for irrigation by the former Soviet Union. For her self-published book *Wild Pigeon* (2014), Drake spent seven years travelling in Xinjiang in western China, photographing and creating with the Uighur communities there. *Internat* (2017) centres on a community of girls – now young women – interned in a former Soviet state-run hostel in Ukraine. In 2006, Drake moved to Ukraine, returning in 2016–17 to photographically collaborate with the women, many of whom were still resident in the house in which they grew up. Together they staged performance-based and art activities in the communal areas and gardens, using materials and objects close at hand and activating the participants' imaginations into collective creative processes.

183 Since 2011, John Edmonds (b. 1989) has created photographic projects that constellate around the representation of personhood, intimacy and black identity. In his 2011–17 *Immaculate* series, Edmonds photographed men of colour in their domestic environments. Using a medium-format film camera, Edmonds combined observation with subtle direction of these intimate photographic encounters with his subjects. His project *Hoods* (2016), which he began as an MFA student, shows his subjects turned away from his camera, hoodies concealing their skin and faces. Each hoodie is captured in bright sunlight and in full textural detail, and signifies both

the loaded social and political symbol of black masculinity, with its connections to state and corporate racial profiling, and a garment of protection and invisibility. Edmonds's *America, The Beautiful* (2017) is part of his *Du Rag* series, inspired by the wearing of du rags by young men of colour in the Brooklyn neighborhood in which he was living. Edmonds brings the delicacy and intimacy of his earlier portraits made using the cast of available light together with an almost painterly codification of colour and classical composition that has run through all of his work since.

The continued affinity with analogue photography displayed by photographers coming to the medium in the twenty-first century, at a time when digital capture is the default means, is part of the re-animation of photography's broad, subjective and historic terrain. Jamie Hawkesworth (b. 1987) advocates for the slow and consequential processes of analogue photography in his use of photographic film and crafting of prints in a traditional wet darkroom. His *Preston Bus Station* is set in the top-lit, looped arcade of the waiting areas in the central bus station in Preston in the north of England. His first photographic attempts to portray the strangers that he met in this transitory space, learning how to approach strangers and ask them to pause their transit and interact with him, was as a student in collaboration with the photography project *Preston is my Paris*, founded by Adam Murray. They created a free newspaper of the group's portraits and observations from this first collaborative project. Hawkesworth returned alone over two years later (on hearing that the bus station was slated for demolition, from which it was later reprieved) and asked people waiting, taking cover from the rain and passing through if he could photograph them in the available light of the bus station.

Star Montana (b. 1987) was born and raised in the Boyle Heights district of Los Angeles, a predominantly Mexican American community that is currently resisting the wave of gentrification and threat of cultural erasure from this East Los Angeles neighbourhood. Montana has created bodies of work that focus on her family and friends and, over time, narrate the intricacies and challenges that they face. Using analogue processes – the means that was initially most readily available to her – she has also created environmental portraits of visually underrepresented members of the Latinx community in the Industrial Corridor of her home city. Montana's photographs show her subjects holding their selfhood, individuality and sense of agency within the urban context that they navigate, accompanied by her textual narration of the relationships and circumstances of each photograph.

184

185

The capacity of a traditional version of photography to visualize definitive encounters with people and places who are markedly absent from mainstream visual media, to make their presence enduringly resonant and rich with specificity, has been an important artistic strategy in chronicling and calling for social change. In the midst of the AIDS crisis in the late 1980s and early 1990s, American photographer Catherine Opie (b. 1961) created her first projects that centred LGBTQ+ identities and relationships. In her *Domestic* (1995–98) series, Opie created intentionally un-stylized and subtly radical depictions of queer households across America that serve to visually naturalize the domesticity and everyday existence of non-heteronormative couples and families.

Perhaps one of the most culturally renowned photographers and visual activists to have come to international prominence in the twenty-first century is Zanele Muholi (b. 1972). Their ongoing project *Faces and Phases* is a series of close to 500 portraits of black lesbian, trans men and gender-

6

186

183 John Edmonds, *America, The Beautiful*, 2017. From the series *Du Rag*.
184 OPPOSITE Jamie Hawkesworth, *Preston Bus Station*, 2013

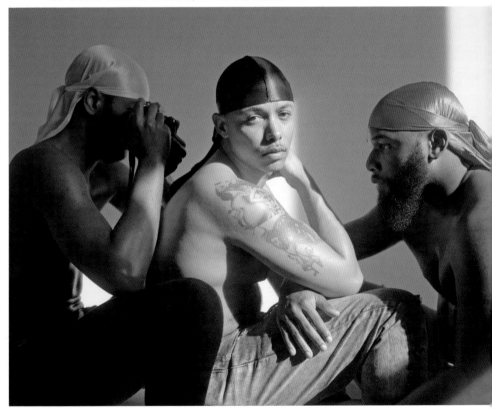

nonconforming people, most of whom are living in South Africa. As with the related series *Brave Beauties*, which portrays trans women, Muholi's intention for this body of work is to create an increased visual presence for their community within culture and media. As with all of the artists that conclude this chapter, Muholi is exceptional and determined in creating a visual record of our time through their representation of human agency, diversity and visual presence. Their photographs form a multivalent reminder of the right to be seen and embody humanity, even against the odds of repression, discrimination and marginalization.

Without a doubt, the 2010s have been an incredibly fertile period of photographic practice that takes the viewer into situations and provides vantage points from which to consider

the overarching social factors that militate and challenge
communities and individuals in eloquent and sensitive ways.
A mere sampling of the outstanding photobooks created by
artists that uniquely tell contemporary human stories includes
Laia Abril's (b. 1986) *On Abortion* (2018), Matthew Connors's
(b. 1976) *Fire in Cairo* (2015), Sam Contis's (b. 1982) *Deep Springs*
(2017), Rose Marie Cromwell's (b. 1983) *El Libro Supremo de la
Suerte* (2018), Andres Gonzalez's *American Origami* (2018), Flurina
Rothenberger's (b. 1977) *I love to dress like I am coming from
somewhere and I have a place to go* (2015), Nicholas Muellner's
(b. 1969) *In Most Tides An Island* (2017), Ka-Man Tse's (b. 1981)
Narrow Distances (2016) and Vasantha Yogananthan's (b. 1985)
multi-book project *A Myth of Two Souls*.

185 OPPOSITE Star Montana, *Sarah*, 2016. From the series *I Dream of Los Angeles*. Montana's work has focused on her close family and community of friends, and, as here, portraits of members of the visually underrepresented Latinx community in her home city of Los Angeles.

186 Zanele Muholi, *Nhlanhla Mofokeng Katlehong, Johannesburg*, 2012. Visual acitivist and photographer Zanele Muholi's ongoing project *Faces and Phases*, as with their previous series *Brave Beauties*, works to remediate the LGBTQ+ community's lack of visual presence within culture and media.

187 Vik Muniz, *Action Photo 1*, 1997. Vik Muniz copied this photograph of the abstract expressionist painter Jackson Pollock by Hans Namuth by drawing the image in chocolate syrup and then photographing it. This suitably dripping re-presentation of the famous artist makes for a dynamic mental relay: we recognize this as a photograph of a drawing of a photograph of, what has become, a syrupy mystification of the creative act of the artist.

Chapter 7
Revived and Remade

Since at least the mid-1970s, the theory of photography has been concerned with the idea that photographs can be understood as processes of signification and cultural coding. Postmodernist analysis has offered alternative ways for understanding the meaning of photographs outside the tenets of Modernism, which predominantly considered photography in terms of its authorship and the aesthetic and technical developments and innovations of the medium, presumed to have a discrete, inner logic. Modernist criticism created a canon of 'master' practitioners, the 'few' who could be distinguished from the 'many' makers of photographs. In photography's Modernist canon, the 'few' are those who typify formal and intellectual transcendence over the functional, jobbing, vernacular and popular anonymity of most photographic production. Postmodernism, in contrast, considered photography from a standpoint not intended to serve the construction of an elevated pantheon that mirrored those established for painting and sculpture. Instead, it examined the medium in terms of its production, dissemination and reception, and engaged with its inherent reproducibility, mimicry and falsity. Rather than being evidence of the photographer's originality (or lack of it) or statements of authorial intention, photographs were seen as *signs* that acquired their significance or value from their place within the larger system of social and cultural coding. Heavily influenced by the principles of structural linguistics and its philosophical off-shoots, structuralism and post-structuralism, particularly as formulated by French thinkers such as Roland Barthes (1915–1980) and Michel Foucault (1926–1984), this theory posited that the meaning of any image was not of its author's making or necessarily under their control, but was determined only by reference to other images or signs.

This chapter considers contemporary art photography born of this way of thinking. What is apparent when viewing these pictures is that they offer experiences that hinge on our memory's stock of imagery – both image types and iconic images: family snaps, magazine advertising, stills from films, historic photographs, famous paintings and so on. There is something deeply familiar about these works; the key to their meaning comes from our own cultural knowledge of generic as well as specific images. These are photographs that invite us to be self-conscious of what we see, how we see, and how images trigger and shape our emotions and understanding of the world. Postmodernist critiques of photographic imagery have been an invitation to both practitioners and viewers to explicitly acknowledge the cultural coding that photography mediates.

188, 189 The work of American artist Cindy Sherman (b. 1954), with its invocation of mannerisms from cinematic stills, fashion photography, celebrity images, pornography and painting, is in many respects the prime example of postmodern art photography. Of all the photographs that have received critical attention since the late 1970s for their appropriation and pastiche of generic types of visual images, it is Sherman's that are most widely written about and, especially since the 1990s, heralded. Her *Untitled Film Stills* series consists of seventy modestly sized photographs showing a single female figure

188 Cindy Sherman, *Untitled #48*, 1979. From the series *Untitled Film Stills*.
189 OPPOSITE Cindy Sherman, *Untitled #400*, 2000

portrayed in scenarios that evoke enigmatic yet narratively charged moments from 1950s and 1960s films. One of the most startling aspects of the series is the ease with which each feminine 'type' is recognizable. Even though we know only the gist of the possible film plots being staged, because of our familiarity with the coding of such films, we begin easily to read the narratives implied by the images. *Untitled Film Stills* enacts the argument advanced by feminist theory that 'femininity' is a construction of cultural codes and not a quality naturally inherent in or essential to women. Both the photographer and the model in the pictures is Sherman herself, making the series a perfect condensation

of Postmodernist photographic practice: she is both observer and observed. And since she is the only model to appear, the series also shows that femininity can be literally put on and performed, changed and mimicked by one actor. The conflation of roles, with Sherman as both subject and creator, is a way of visualizing femininity that confronts some of the issues raised by images of women: *who* is being represented? *by* whom is this projection of the 'feminine' being constructed? *for* whom?

One of the best-known artists to work in a manner clearly linked to Sherman's practice is the Japanese photographer Yasumasa Morimura (b. 1951), who began dressing and performing for an ongoing photographic project entitled *Self-Portrait as Art History* in 1985. The first work in the series shows the artist as Vincent van Gogh (1853–1890), the most famous European artist in Japan at the time. Fame is the salient theme of the photographs, as Morimura pursues the alignment of his malleable, gender-fluid identities with those of famous artists and actresses and art's most glamorous archetypes. His photographs repeatedly direct us to the two roles that he takes on: the playful ego of the photographer and the cult status of the artists and actors that he visually embodies for the camera.

Photographic representation has been both subject and device in the work created by pan-media artist and filmmaker Rashid Johnson (b. 1977). His photographic work in the 2000s has included self-portraits and portraits of male friends and artistic peers for his project *The New Negro Escapist Social and Athletic Club*. In his representation of both himself and other men of colour, Johnson visually connects contemporary experience with wider collective memories, drawing on the ideas and visual assertion of black cultural figures including composer and musician Miles Davis (1926–1991) and writer and activist W.E.B. Du Bois (1868–1963) to create his own pantheon of creative excellence. In *Self-Portrait with my hair parted like Frederick Douglass* (2013), Johnson channels the articulation of individuality and personhood through photography deployed by the orator, abolitionist and statesman Frederick Douglass (1818–1895) in the nineteenth century. Douglass is likely the most photographed American in the nineteenth century, commissioning over 160 portraits during his lifetime, writing and lecturing about the power of photography to bring individual lives into the public sphere and consciously using his photographic presence and agency to destroy the dehumanization and enslavement of Africans and African Americans.

190

191

190 Yasumasa Morimura,
*Self-Portrait (Actress) after
Vivien Leigh 4,* 1996

Johnson's approach calls to mind *Zabat* (1989), by the Scottish artist, writer and curator Maud Sulter (1960–2008), a series of nine large-scale staged portraits of black women artists and intellectuals who each represent nine allegorical characters based on the Greek muses, displayed in heavy gilded frames, akin to grand, historic portrait paintings. British artist Heather Agyepong (b. 1990) has performed, embodied and reanimated the representation of famous black women of the nineteenth century in her photographic meditation on the life and work of British-Jamaican nurse Mary Seacole (1805–1881) and in her restaging of *carte-de-visite* portraits of Lady Sarah Forbes Bonetta (1843–1880) the West African Egbado princess of the Yoruba language group who was the adopted goddaughter of Queen Victoria (1819–1901).

Present-day, quotidian photography is also critically remade by contemporary artists, relying on the assumptions we collectively make when viewing images whose conventions and implied meanings are already a naturalized and automatic in our daily reading and interpretation of images. In the image shown here from Norwegian artist Vibeke Tandberg's (b. 1967)

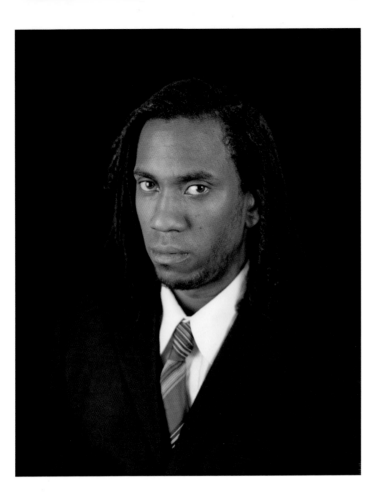

Line series, we read the image as an environmental portrait that is captured at a moment of intimate connection between the photographer and their subject. In fact, Tandberg orchestrates and embellishes the photograph using digital manipulation to blend fragments of her own facial features with those of her friend – illustrating that a photographic portrait, no matter how guileless it may seem, is a construct, and partly the photographer's projection of herself onto her subject.

191 Rashid Johnson, *Self-Portrait with my hair parted like Frederick Douglass*, 2003. From the series *The New Negro Escapist Social and Athletic Club.*
192 OPPOSITE Vibeke Tandberg, *Line #1 – 5*, 1999. At first glance, Tandberg's portrait of Line seems to be a straightforward photograph of her friend in her home. By using digital technology to merge her own facial features with those of her friend, Tandberg has literally invested the image with the intimacy and connection that exists between photographer and subject.

One of the most infamous photographic performance projects of the social media age is Argentinian artist Amalia Ulman's (b. 1989) *Excellences and Perfection* (2014), in which Ulman scripted and performed a durational 'life makeover' for her Instagram and Facebook accounts. Over the course of three months, Ulman constructed and photographed an identity specifically scripted for image-led media platforms, intentionally simulating the narratives, textual language and aesthetic tropes of personality brand building. In so doing, Ulman proved (like her forebear, Cindy Sherman) that femininity is a construct rather than an inherent state, and one that we collectively, unquestionably and readily consume.

A mixture of observation, performance and photography underpins the work of Nikki S. Lee (b. 1970) who is known for assimilating herself into a range of social groups, mainly in America, and visually 'passing' as a member of the respective

community – as seen in her *Hispanic, Strippers, Punk, Yuppie* and *Wall Street Broker* projects. Her process involves closely observing the social conventions, dress and body language of these groups, and appropriating all aspects of their self-representation, changing her weight, hair, eye and skin colour accordingly and encoding her body and presence within her photographic records. The photographs of Lee, ostensibly camouflaged within the group portraits, are taken either by a friend who accompanies her on the projects or by a member of the 'infiltrated' group.

194 Trish Morrissey's (b. 1967) *Seven Years* provides a link between Morrissey's own family experiences, remembered through personal photographs, and the common tropes of domestic photography that can be the trigger for re-remembering and reappraising identities and familial relationships. In collaboration with her elder sister, who is the other performer in the series, Morrissey attempted to make the subject of *Seven Years* the subtexts of relationships that are embedded in family photographs in general, and specifically in imagery of her own family. The props and clothing are a combination of objects found in Morrissey's parents' attic and secondhand items she collected for the staging of each photograph.

193 Nikki S. Lee, *The Hispanic Project (2)*, 1998
194 OPPOSITE Trish Morrissey, *July 22nd, 1972*, 2003. From the series *Seven Years*.

195 American photographer Collier Schorr's (b. 1963) *Helga/ Jens* project portrays a German schoolboy named Jens in poses and scenarios in the German landscapes and interiors. These poses are taken from the *Helga* paintings and drawings by American artist Andrew Wyeth (1917–2009), made public in 1986, which controversially and explicitly showed Wyeth's sexual fascination for the young woman. Schorr's previous photographs often centred on the representation of youthful masculinity, offering something of a visual respite from the abundance of photographic bodies of work that concentrated on young female subjects in the 1990s. In the intermediate stage of the *Helga/Jens* project shown here, Schorr attached small contact prints of her staged images that were responses to Helga paintings with contemporary props and critical twists on gender dynamics and sexual projection. Schorr's project is not only a restaging of another artist's body of work. She uses the *Helga* paintings as a cue to think about the relationship between artist and model conveyed in Wyeth's images; concerned with dialogue rather than mimicry, Schorr's photographs become a way through which she can actively pursue her own investigations to the point where desire and projection of the artists come together.

196 The artistic appropriation of visual styles and stereotypes is also utilized by Zoe Leonard (b. 1961) and Cheryl Dunye (b. 1966)

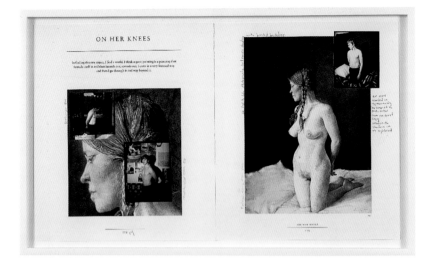

in *The Fae Richards Photo Archive*. Leonard and Dunye created an archive of photographs of a fictional woman called Fae Richards, supposedly an early to mid-twentieth-century black film and cabaret star. The photographs, created for Dunye's film *Watermelon Woman*, are careful forgeries of signed publicity shots, film stills and personal photographs, complete with the creases and stains of tattered vintage prints. These items were then displayed like historical ephemera in glass-topped cases. Richards's constructed biography is an amalgamation of events from the lives of real twentieth-century black artists, but her portrayal as a successful, creative, affluent and happy lesbian who died peacefully in old age is staged as a deliberate contrast to the more typical narrative tropes of the lives of many black singers and performers from the era as tragic and flawed.

The delivery of counter-memory or history through a fictionalized account is the basis of *The Atlas Group Project* (1989–2004), made principally by the Lebanese artist Walid Ra'ad (b. 1967). The work is an artistic testimony of the human-rights abuses and social consequences, as well as the role of the media, in the Lebanese Civil War (1975–91). This mixed-media project includes slides, video footage and the notebooks of Dr Fadi Fakhouri (now deceased), the foremost historian of the war. Ra'ad has presented Fakhouri's archive and interpreted his legacy through screenings, photographic reproductions and slide lectures, so that it is not apparent whether it is genuine archival material or – as is really the case – a fake. The work examines how the idiosyncrasies of archives can trigger partial

195 OPPOSITE Collier Schorr, *Jens F (114, 115)*, 2002. From the series *Helga/Jens*.
196 Zoe Leonard and Cheryl Dunye, *The Fae Richards Photo Archive*, 1993–96.
Leonard and Dunye created an archive of photographs of a fictional woman called
Fae Richards, supposedly an early to mid-twentieth-century black film and cabaret
star. The photographs, created for Dunye's film *Watermelon Woman*, are displayed
like historical ephemera in glass-topped cases.

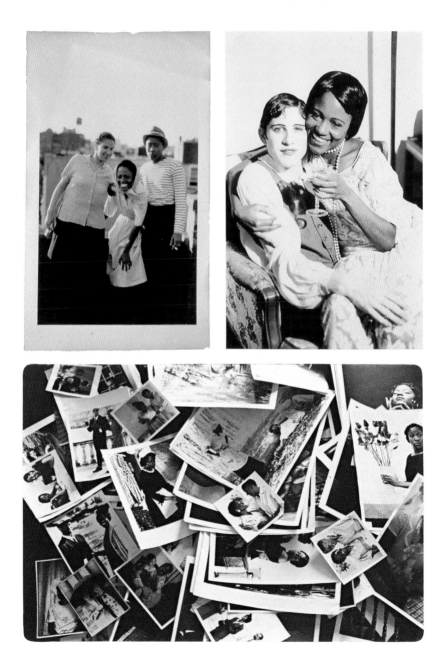

and emotive understandings of social unrest and history, and calls for us to consider how the presence of visual material carries an inherent resistance towards the tide of social and cultural erasure.

Tracey Moffatt's *Laudanum* series of nineteen photogravure prints (a subtle photomechanical printing process developed in the mid-nineteenth century) creates a vivid and fantastical narrative, presented in the physical form of the past. Moffatt draws on popular Victorian melodrama, which would have been presented as a sequence of lantern slides or stereoscopic photographs for parlour entertainment, and also refers to the dramatic use of shadows in early twentieth-century German Expressionist film. The two characters in her photographs are a Caucasian woman and an Asian servant, and the psychodramas that Moffatt stages centre on slavery in terms of colonialism, class, sexuality and addiction. Moffatt's approach to representing

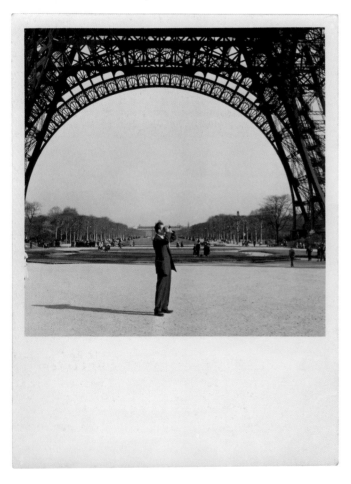

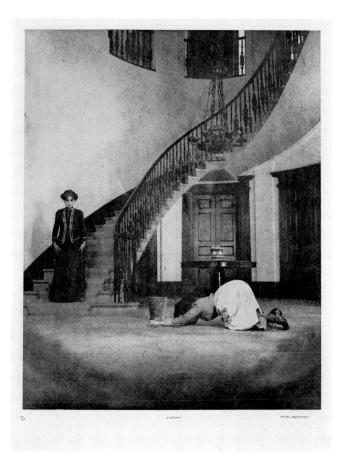

the conditions of history gives us an experience of how sociohistorical issues that are explored through anthropology and writing can be imaginatively addressed through art.

199 Dutch artist Aleksandra Mir's (b. 1967) *First Woman on the Moon* involved the epic operation of constructing a simulation of a lunar landscape on a sandy strip of the Dutch coastline for the thirtieth anniversary of the first landing on the moon in 1969. Mir's project includes fake publicity images for a corps

197 OPPOSITE The Atlas Group/Walid Ra'ad, *Civilizationally We Do Not Dig Holes to Bury Ourselves (CDH:A876)*, 1958–2003. Displayed alongside this image is the caption 'Document summary: the only available photographs of Dr Fadi Fakhouri are a series of self-portrait photographs that he produced in 1959 during his one and only trip to France. The photographs were preserved in a small brown envelope titled in Arabic "Never that I remember".'
198 Tracey Moffatt, *Laudanum*, 1998

199 Aleksandra Mir, *First Woman on the Moon*, 1999
200 OPPOSITE Hans-Peter Feldmann, page from *Voyeur*, 1997

of all-female astronauts, representing them as a cross between
stereotypes of air stewardesses and wives of astronauts waving
off their spouses, envisaged in an ironically cheerful version
of the performance art of the late 1960s. In the photograph
shown here, Mir also pokes fun at land art of the same period
by building a huge sandcastle into which she has planted an
American flag; a slanting aerial view captures the temporary site
for posterity with the earnestness of a professional photographer.

Contemporary art photography's appropriation and
reworking of imagery is also achieved by collating existing
photographs, often vernacular and anonymous, into grids,
constellations and juxtapositions. To a certain degree, the
role of the artist here is like that of a picture editor or a
curator, shaping the meaning of photographs through acts
of interpretation rather than image-making. This artistic
modality has become an incredibly fertile area throughout the

late twentieth and twenty-first centuries, and the exceptional
contributions of artists including Martha Rosler (b. 1943), Lutz
Bacher (b. 1941) and Sylvia Kolbowski (b. 1953) have set a high
standard of criticality, political critique and wry exposure.

German artist Hans-Peter Feldmann's (b. 1941) principal
output is books of photographs, in a range of sizes from small
flipbooks, such as *Voyeur,* to large-format volumes, and make
playful juxtapositions and repetitions of found, stock and
gathered anonymous images. Without captions or dates, the
experience of Feldmann's sequences is of viewing photographs

201 Tacita Dean, *Ein Sklave des Kapitals*, 2000. From the series
The Russian Ending.

free of function and history, a context-less context, dependent
on the triggering of thought processes through the relations
between images within the sequence. The experience of looking
at his non-hierarchical approach to photographic imagery –
drawn from the glut of vernacular and popular imagery of the
twentieth-century – is highly effective in reminding us how
subjectively and subconsciously we interpret photographs.

201 British artist Tacita Dean's (b. 1965) *The Russian Ending* series
developed from her finding some early twentieth-century
Russian postcards at a fleamarket. Some depict events that are
easy to read, such as a funeral procession or the aftermath of
war, while others represent strange performances or rituals,
their significance now hard to discern . Dean re-presents the
postcards, enlarged and softly printed as photogravures. Each
image is shown with her handwritten annotations. These notes
are scattered throughout the images' compositions, reading like
a film director's thoughts on how the narrative of each scene
might be developed. As the title of the body of work suggests,
Dean pays special attention to the range of dramatic endings
to the screenplays she describes. She examines how uncertain
and ambiguous our understanding of history is when gleaned
from pictorial forms, and how heavily implicated the director or
image-maker is in the fictionalizing and slanting of history.

202 The American artist Richard Prince (b. 1949) emerged in the first wave of Postmodernist photography in the late 1970s. In his photographs of billboard advertisements, he cropped out the branding and texts to show only the grainy colour-saturated visual fantasies of twentieth-century capitalism. The romanticized visions of American cowboys in the Marlboro cigarette advertisements that Prince re-photographed in 1986 lift popular imagery and storytelling to both critique and champion the seduction of advertising. In his *Untitled (Girlfriends)* series, he compiled a cache of amateur photographs of the two archetypal trophies of biker culture – girl and machine – that offers an observation of macho culture. The compositional repetition within the selection renders the series legible as almost a photographic genre of its own.

203 German artist Joachim Schmid (b. 1955) salvages discarded photographs, postcards and newspaper images. He organizes these items into archives and recycles their meaning by creating taxonomies of the most artistically under-valued types and tropes of photography. He began his *Pictures from the Street* project, consisting of almost a thousand photographs found in different cities, in 1982. The only criterion for a photograph to be added to the archive is that Schmid must have found it discarded; every photograph he picks up is added. Some are scratched and worn, others are ripped or defaced. By being discarded, the photographs represent the loss of personal memories and also their active rejection. Schmid's

202 Richard Prince, *Untitled (Girlfriend)*, 1993

203 Joachim Schmid, *No. 460, Rio de Janeiro, December 1996*, 1996. Schmid's ongoing *Pictures from the Street* project is made up of all the photographs that he has found lost or thrown away on the streets. In some, the sense of the subject's being consciously rejected or deleted from the previous owner's emotional life is especially pronounced.

processes of archive-construction emphasize that what is being retrieved from the pictures is their status as evidence: the contiguity between image and object can be shaped to create re-engagement with forgotten histories and our projected fantasies of their historical and emotional resonance.

204 In 1991 the American photographer Susan Meiselas (b. 1948) initiated a monumental project of archive-retrieval. Meiselas was at that point well known for both her photojournalistic projects, such as her award-winning footage of the 1978 insurrection in Nicaragua, and her innovative strategies for exhibiting and catalyzing cultural dialogue through photography. In the early 1990s, after the first Persian Gulf War, she began to photograph the mass graves and refugee camps of Kurds in Northern Iraq, dispossessed and persecuted by Iraq's leadership. The Kurdish peoples' homeland of Kurdistan had been carved up in the aftermath of the First World War, and Kurdish identity and culture has been threatened ever since. Meiselas activated a collective re-finding of personal photographs, government documents and media reports that had been dispersed internationally within the Kurdish diaspora. The history of Kurdistan and its relationship with the West could be explored in the archive that Meiselas instigated. *Kurdistan: In the Shadow of History* is an extensive book,

exhibition and web-based initiative in which these regrouped archival materials are used as a catalyst for remembrance, not only for Kurdish people but also the journalists, missionaries, and colonial administrators who had encountered Kurdish culture in Kurdistan's history.

In 2010, photographer Anusha Yadav (b. 1975) founded the *Indian Memory Project*, which is an online archive that brings together personal and amateur photographs from the nineteenth and twentieth centuries. The stories of each submitted photograph and related text collectively provide histories and narratives from across the Indian subcontinent. Use of the library or archive model as a way to shape meaning, narratives and material histories is also very much present in Paul Soulellis' (b. 1968) *Printed Web* publication, started in 2014 following the establishment of his *Library of the Printed Web*

204 Nadir Nadirov in collaboration with Susan Meiselas, *Family Narrative*, 1996. 'Our family still lives in the village. The special relocation caused people for decades to fight for their physical survival, so our grandfather struggled so that our family got an education. This is who we've become: (centre) Karei Nadirova, grandmother and mother of the fathers of Sadik, Anvar and Nadir Nadirov; (counter clockwise) Rashid, president "Pharmacia", shareholders association of northern Kazakhstan; Zarkal, teacher; Abdullah, teacher; Azim, vice president, oil shareholding company "Shimkent Nefteorient"; Falok, mother; Nazim, head of Urological Department of Shimkent Regional Hospital; Zarifa, director of kindergarten; Kazim, Ph.D., dean of Kazakhstan's Institute of Chemistry and Technology; and Azo, housing administrator, Shimkent.' 1960s, Nadir K. Nadirov

project a year earlier. The *Printed Web* has been a meeting point (and physical archive) for the work of close to 200 artists who draw on images, GIFs, bots, feeds and other algorithmically structured image media to make their own subjective, revealing interpretations of our contemporary image environment at large, with Soulellis taking on the overarching role as its artist-librarian.

In the twenty-first century, photography's history as a material medium in the service of science, journalism, advertising and surveillance – to name but a few arenas – is evidently rich with the potential to be recontextualized and interrogated. Artists working in this area shift, extend and amplify the effect of images in incredible acts of picture editing, creating installations and photobooks. Swiss artist
205 Batia Suter (b. 1967) creates installations of picture books and images scaled up from reproductions of reference volumes; they are highly sensory and, on the surface, simple new configurations of images, awakened from dormancy.
206 The Swedish artist Lotta Antonsson's (b. 1963) *Arrangement* installations combine mirrors, shells and coral, photography books and loose and framed photographic collages presented on wood grained plywood plinths, sometimes with mirrored tops or pale wooden frames, displayed at various heights. They invite viewers to choreograph their movements amongst the vantage points she lays out, and find the contingent meanings between the arranged elements. While living in Berlin, Antonsson trawled the city's flea markets and collected runs of issues and multiple copies of the publication *Das Magazin*,

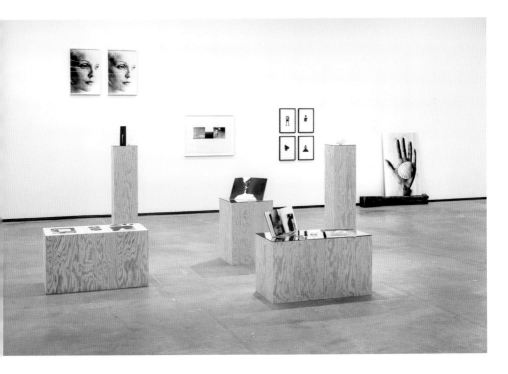

205 TOP Batia Suter, *Wave, floor version #1*, 2012. Installation at Le Prairies, Biennial for Contemporary Art, Rennes, France.
206 ABOVE Lotta Antonsson, *Arrangements I – V*, 2010–12. Installation at Marabouparken, Stockholm, Sweden.

Revived and Remade

207 Lyle Ashton Harris, *Blow up IV (Sevilla)*, 2006

208 Carmen Winant, *My Birth*, 2018. Installation at 'Being: New Photography 2018', The Museum of Modern Art, New York, 18 March 2018 – 19 August 2018

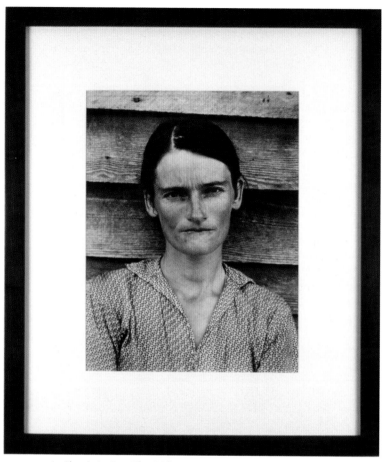

209 Sherrie Levine, *After Walker Evans*, 1981
210 OPPOSITE Susan Lipper, *Untitled*, 1993–98. From the series *Trip*.

the DDR's equivalent to America's *Playboy* in its combination of journalism, literature and female nude imagery, first published in 1954. Making use of these magazines, Antonsson's *Arrangements* circle the visual and ideological contradictions between the actual emancipation of women in the DDR regime (and the wider context of 1970s feminism) and the symbolic representation and photographic control of women's bodies. Artists who similarly create installations and publications that invite our viewership to be critical include Basma Alsharif (b. 1983), Maryam Jafri (b. 1972), Charlotte Moth (b. 1978), Rosângela Rennó Gomes (b. 1962), Abigail Reynolds (b. 1975) and Stanley Wolukau-Wanambwa (b. 1980).

207 Lyle Ashton Harris's (b. 1965) *Blow up IV (Sevilla)* is a wall
collage made up of his own and found photographic images.
The composition's central, largest picture, one that is replicated
many times in the piece, shows the famous French footballer
Zinedine Zidane (b. 1972) reclining as his legs are massaged
before or after a match. In both formal composition and implied
racial dynamics, the image resembles Édouard Manet's painting
Olympia (1863), a photocopy of which also appears in *Blow
up IV (Sevilla)*. Harris makes a map of visual and ideological
connections stemming from the central image, avoiding
a hierarchy that privileges his own images (which include
commissioned photojournalism) over those he has collected
and instead combining them to create a visceral and spectacular
account of the racial codification and bias embedded in art
and media imagery. Harris restates a Postmodernist idea,
blending high criticality and personal narrative to suggest that
all photography inherently carries representational meaning
beyond the making or intent of the photographer.

208 Carmen Winant's (b. 1983) *My Birth* (2018) installation and
book is a remarkable contribution to this field of contemporary
art practice. Winant's project brings together 2,000 images
of women giving birth, drawn from medical pamphlets and
archives, the very few illustrated publications for (and by) women

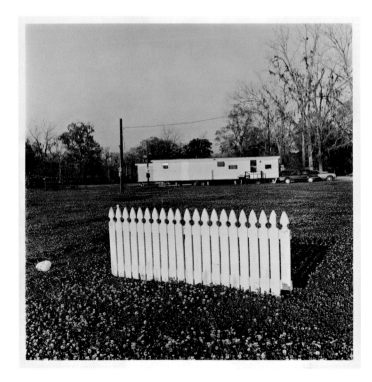

about what will happen during labour and private caches of women (including her mother) giving birth. Organized into the stages of childbirth, *My Birth* is a profound testimony to the cultural silence and pictorial absence of (and lack of familiarity with) the overwhelmingly bodily process for women of giving birth. *My Birth* calls forth not only a timely contemplation of the politics of women's bodies and fertility, but also specifically speaks to the ideological bias that hides women artists' maternity from public discourse and, in so doing, underplays and ignores the nature of women's creative labour.

209
112, 219 Sherrie Levine (b. 1947) and James Welling are two pioneering artists who, in the early 1980s, drew particular attention to the role of materiality in photography. Each played a part in laying the groundwork for current trends in contemporary art photography. Levine's appropriation of classic photographs by Walker Evans (1930–1975), Edward Weston (1886–1958) and Eliot Porter (1901–1990) serves as an axis point for the ideas outlined in this chapter. There is an enduring audaciousness in the way that Levine rephotographed images by canonical photographers from the printed pages of exhibition catalogues, mounting, framing and presenting them in contemporary art galleries. A work such as *After Walker Evans* (1981) was neither an attempt at forgery nor an especially ironic gesture. Instead, Levine's direct appropriation of an object – in this instance, a strikingly intimate photograph of a woman in abject poverty taken in 1936 during the Great Depression – calls forth as its subject the elucidatory power of a photograph to convey emotions and the

211 Seung Woo Back, *Utopia #001*, 2008
212 OPPOSITE Florian Maier-Aichen, *The Best General View*, 2007

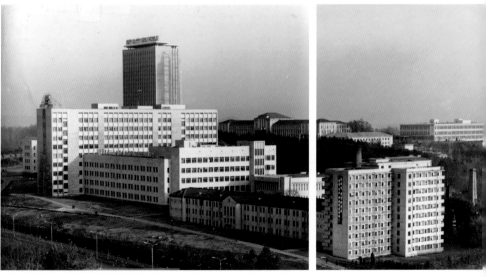

investigative curiosity of the photographer. Levine's treatment of Evans's photographs was, in some ways, no different from the motivation of any photographer to explore a subject that intrigues them – but her photographic work was provocative, in part, because Evans's photographs were not anonymous or vernacular, nor the conventional raw image material for new artistic thinking. Levine's project foregrounds her (and perhaps our own) responses to Walker Evans's images – responses that are led, if not determined, by his intentions and authorship. The proposition of Levine's own authorship is contentious. It

is not located in an overlay of a 'signature' photographic style nor a radical shifting in the meaning of Evans's photograph by Levine's recontextualization. Rather, it is sited in her role as editor, curator, interpreter and art historian. Undoubtedly, Levine's artistic stance has provided a predictive and enduring position for contemporary artists to shape in divergent ways, including Christopher Clary (b. 1968), Mishka Henner (b. 1976), Elisabeth Tonnard (b. 1973) and Florian Maier-Aichen (b. 1973).

212

Since the first photographs, all photographic practice has been created and understood in comparison with and relation to earlier images. Other photographs became the hurdles over which to jump, the standards to meet and the discourses to counter. In American photographer Susan Lipper's (b. 1953) *Trip* sequence, consisting of fifty black and white photographs of small-town America, the artist identifies not only various sites but also the heritage of their representation within American documentary photography . Lipper finds in these contemporary places connections with pre-existing images – as here in the formal reference to American photographer Paul Strand's (1890–1976) *The White Fence* (1916), a photograph that has come to embody a key moment in photography's Modernist history.

210

The source material for South Korean artist Seung Woo Back's (b. 1973) *Utopia* series (2008–11) are propaganda posters

211

213 Markéta Othová, *Something I Can't Remember*, 2000

214 Christopher Williams, *Kodak Three Point Reflection Guide, © 1968 Eastman Kodak Company, 1968. (Corn) Douglas M. Parker Studio, Glendale, California, April 17, 2003*, 2003

and postcards of large scale civic and industrial buildings in North Korea. Back added colour to the images' backgrounds, referencing Russian Constructivist printed material of the early twentieth century. He then divided the image files into parts that were sent to over a dozen countries, with the same printing instructions arriving at each photo lab. Back then compiled the resulting prints into the large-scale, multi-frame works in the *Utopia* series, emphasizing the fragmented and faulty translation of these symbols of socio-political regimes.

214 American artist Christopher Williams's (b. 1956) photographs seem, at first glance, to be of disparate subject matters and styles. But there is a palpable, if uneasy, sense of a coherent visual language set up by the dynamic between his images; we are encouraged to attempt to break the code of each photograph and the relationships between them. Behind the seamless surface of Williams's photographs lies significant research, and a layering of meaning distilled down to its simplest form. In one often-discussed example, Williams was taken with how corn byproducts figure in virtually every aspect of our daily lives and even, surprisingly, in photography itself – a corn byproduct is included in the lubricant used to polish photographic lenses,

215 Alec Soth, *Sugar's, Davenport, IA*, 2002

and also in the chemicals used for fine art photographic prints, including Williams's own. Corn byproducts were even used to make the artificial corncobs that Williams photographed. Corn and photography are therefore both the subject and the material of his photograph. Williams's decision to use the style and production values of a commercial still life photographer in this instance serves as a way to direct the viewer away from searching for a signature or personalized narrative of the subject.

One of the most persistent ideas activated in late-1970s Postmodern photography is that a photograph is an image of a pre-existing image and not an unmediated depiction of its given subject. One of the key bodies of photographic work made in the twenty-first century, the American photographer Alec Soth's (b. 1969) *Sleeping by the Mississippi* (2004), embodies

215

a fertile balance between sustaining photography's long-held promise to frame and record places and situations, and consciously acknowledging that this quiet, slow idea of photography inevitably summons up a crowded history of observing and journeying through the world. Soth's series of portraits, landscapes, interiors and still lifes were made on his journeys along the Mississippi River, depicting the people and places he encountered along the way. It is clearly part of William Eggleston's (b. 1939) legacy (Soth visited Eggleston as part of his exploration of the American South); the photographs also contain elements of the 'deadpan' aesthetic discussed in Chapter 3, as well as the conventions of nineteenth- and early twentieth-century portraiture. Contemporary art photography draws on and reconfigures a range of traditions, both artistic and vernacular.

Katy Grannan's (b. 1969) series *Sugar Camp Road* also makes use of a pre-existing style and photographic genre through which to portray a subject. Grannan advertised for models for the series in local American newspapers. Her subjects were strangers, and decided in advance what they wanted to wear and how they wanted to be posed. She was, therefore, in part taking the picture the sitters had already imagined for their portrayal. In this image, the subject decided upon a lyrical representation

216 Katy Grannan, *Joshi, Mystic Lake, Medford, MA*, 2004. From the series *Sugar Camp Road.*

that reflected the pose of the Venus de Milo statue as well as kitsch 1960s commercial photography, with the hazy sunlight passing through her flimsy dress.

217 Roe Ethridge (b. 1974) deftly uses image sequencing and layout design in his books and exhibitions to create a dynamic visual flow. His repertoire includes portraits staged in studios, shot in a quasi-fashion image style (and some images literally outtakes

from commercial shoots), deadpan architectural photographs and elegant still lifes that recall images by Paul Outerbridge (1896–1958) and Edward Steichen (1879–1973). Ethridge's confident and diverse photographic practice twists and repurposes the image types that we all see, drawing our attention both to subjects and to the generic or familiar modes of representing them and giving them an often wry visual substance.

In his books and installations, Norwegian photographer Torbjørn Rødland (b. 1970) presents his images in non-linear juxtapositions and sequences, traversing the lexicon of photographic beauty and seduction with impressive photographic acumen. Through this aesthetic framework, he choreographs narratives and positions of viewership that often border on the kitsch and taboo. At the heart of this lies the expression of the possibilities that Postmodernist practice represents for contemporary art photographers: to be able to knowingly shape the subjects that intrigue them, conscious of the heritage of the imagery into which they are entering, and to see through the pictures we already know.

218

217 OPPOSITE Roe Ethridge, *Lip Stickers*, 2018
218 Torbjørn Rødland, *Nudist no. 6*, 1999

219 James Welling, *Crescendo B89*, 1980. Welling's *Foil* series referenced the classic history of early twentieth-century photography in its presentation of small, mounted and traditionally framed black and white prints. He created his seemingly abstract and transcendental photographs from variably lit sheets of crumpled aluminium foil.

Chapter 8
Physical and Material

The title of this chapter is derived from a short, eloquent essay by the artist Tacita Dean (see Chapter 7), written for the catalogue *Analogue* and published in 2006 to accompany her film *Kodak*. The forty-four-minute film was made in Kodak's Chalon-sur-Saône factory, and shows the large machines used for making analogue camera film at work, at first inexplicably threaded with brown paper rather than translucent film. *Analogue* was made at a crucial juncture in the technological story of photography, when there were strong indications that the mass production of analogue camera film would cease in reaction to digital-capture cameras becoming the default photographic technology for professional and amateur photographers. In *Analogue*, Dean quotes a manager at the factory who, when asked why Kodak's analogue film stock will become obsolete, replies that no one notices the difference between analogue and digital photography any more. This chapter concerns artists who not only notice the difference, but who consciously fold the shifting meanings and associations of photography into the narrative of their work.

In broad terms, digital photography – and the ease and speed of its dissemination – has radically reshaped photography's commercial industries and the ways that we use photography in our professional and personal lives. There has been a shift in our understanding of what photography encompasses within an ever-expanding image environment and, concomitantly, what it means to propose photographic works as art. More than ever, this involves some disclosure of the context and conditions that have shaped the completed artwork. Contemporary art photography has become less about applying a pre-existing, fully functioning visual technology and more concerned with active choices in every step of the process.

This is tied to an enhanced appreciation of the materiality and 'objectness' of the medium that reaches back to the early nineteenth-century roots of photography.

It is in this climate that the artists represented in this chapter explore an increased consciousness of the physical characteristics of photographic prints, no longer the default platform for photography but an increasingly rarefied craft divorced from our day-to-day experiences of the medium. Some of the artists discussed in this chapter look at the vast amount of visual information that is at our disposal and how that affects our reading of, and the relationships between, the images that we see. Others capitalize on the resonance of photography's analogue past, a resonance made all the more weighty by the now ubiquitous nature of digital image-making. The desire to hold onto enduring elements of analogue photography's rich history, especially its permission to experiment and to embrace the mistakes and luck of an imprecise science, is clearly at play in this chapter. Doomsday prophecies about the complete extinction of analogue photographic papers and films have dissipated, and outside the commercial photographic industries of fashion, advertising and journalism, where there were reprographic and other economic imperatives for embracing new technologies, the late 1990s and 2000s saw a period of hybridization between traditional analogue photography and the promise of digital techniques.

One figure within contemporary art who has heavily influenced the idea of photography as an experimental and material art form is the American artist James Welling . While associated with Postmodernist appropriation artists in the 1980s, Welling has always created work on a somewhat different plane to that of his generation of critical photographic thinkers. In the early 1980s, he made a series of over fifty small, elegant, black and white photographs of creased aluminium foil. The photographs were displayed in a modernist style with mounts and black frames, and hung in a linear sequence on white walls, in a provocative gesture that made the viewer aware of both the unreconstructed pleasure of the prints' formal qualities, and the consciously Modernist conventions that operate within them. As an artist, Welling has knowingly straddled two positions with his practice: he is both a photographer who explores the medium through experimentation and the crafting of prints, and a Postmodernist with an understanding of what he appropriates and the manner in which he cites.

Arthur Ou's (b. 1974) *Primer* (2011) series enacts a parallel bridging – a critical appropriation of the aesthetics and materiality of Modernist photography, and a genuine pleasure

220 Arthur Ou, *Primer,*
2018–19

in the experimental possibilities that photography still
provides. As we will see with all of the artists represented in
this chapter, Ou makes a series of active and consequential
decisions in his rendering of this series of small photographs.
He captures details of glacial rock surfaces found in the
New York City area using a 4 x 5 view camera – a venerated
photographic format that photographic artists in the twenty-
first century have kept in play. The artist layers a single
exposure of the rock formations in each photograph, adding
at least three layers of exposure depicting drawn line-like
wire forms that he coats with primer paint in his studio.
The resulting prints are tinted with wax pigment by hand,
accentuating the forms that Ou finds within the combination
of multiple exposures, and further interweaving the painterly,
sculptural and photographic registers that he brings together.

221, 222 For close to forty years, Ellen Carey's (b. 1952) artistic practice
has embodied physical and material experimentalism. Her
work is incalculably prescient to the enquiries and processes
of many contemporary art photographers. The trajectory of
Carey's photographic approach, from her beginnings amid
early Postmodernism (see Chapter 7) to our contemporary

221 LEFT Ellen Carey,
Dings and Shadows, 2013
222 OPPOSITE Ellen Carey,
Self-Portrait, 1987

digital image environment, is both unique and resilient. Her self-portrait series from the mid-1980s, made with Polaroid 20 x 24 film sheets, transcends the era of its production. Using in-camera geometric and patterned filters and masks, optical refraction, multiple exposures and lighting with colour gels, Carey created a series of auratic, vital, almost metaphysical images of selfhood. Jumping into the twenty-first century, her series *Dings & Shadows* (2010–) is an energized articulation of the glorious possibilities of darkroom experimentation. Working without a camera, she created each photogram (shown in large, immersive grids) by crumpling the photographic paper in the light-tight space of the photographic darkroom, exposing it to flashes of light that hit and refract off the 'dings' that Carey has made. She thereby summons forth the highly colour-sensitive properties of chemical photography, with the internal contradiction – once the prints are flattened – that the immediate dimensionality of light and shade is the result of cameraless, non-representational means, revealed in her naming this facet of her practice *Struck by Light*.

223 Hannah Whitaker's (b. 1980) photographs over the past ten years have melded 'straight' photographic processes with emphatic graphic disruptions. Created using hand-cut, thick

paper masks of idiosyncratic geometric patterns and shapes, which go into the dark slide with her 4 x 5 film, Whitaker's photographic approach anticipates but does not fully control the resulting image. The viewer experiences a quasi-optical game, oscillating between photographic and purely graphic registers that often concentrate on representations of female bodily forms. In some of the works, the photographic image wins out over Whitaker's manual gestures. In others, the masks' conscious references to Modernist art are put into a visual conversation with the photographic image, which in turn becomes a material within a wider optical scheme. Whitaker's processes allow for aspects that she cannot determine – a submission of sorts to the inherent qualities of photography's analogue heritage as a porous and not-fully-determined process or material.

In her ongoing series *Cubes for Albers and LeWitt*, begun in 2011, Canadian artist Jessica Eaton (b. 1977) creates multiple exposures of a simple white cube, calibrated to a range of colours. The series' title cites the artists Josef Albers (1888–1976) and Sol LeWitt (1928–2007), pointing out the project's

223 Hannah
Whitaker,
Reach 2, 2017

intersection with Minimalist art practices of the mid-twentieth
century. This creates a timely reminder of photography's innate
capacity for visual economy in an experimental mode. In an era
where, from photographic capture to final rendering, digital
processes are the prevailing defaults of the medium, Eaton's
analogue version of photography – its in-camera, analogue
mentality and mechanisms – strikes a resonant cultural chord.
There is a gendered significance in the degree of experimental
acumen that Eaton is committed to; her work demonstrates a
female-gendered capacity to claim photography's twentieth-
century history and reanimate it for contemporary viewership.
It wasn't until the late 2000s and Eaton's emergence as a
cultural voice that many of the apocalyptic fantasies of digital
image-making usurping analogue photography in its entirety
began to wane. Camera film became a 'boutique' product, with
some beloved stocks going back into production, and while
chemical wet darkrooms remained an endangered species

they did not entirely disappear, especially in those art schools that (accurately) anticipated a new generation of image-makers who wanted to experiment with the analogue history of their medium. Analogue photography was no longer the default technology, but it remained an elegant and effective means of rendering visual form.

Liz Deschenes's (b. 1966) work explores the idea of visual perception and its intersection with the technologies and experiences of photography and film. Her *Transfer* series (1997–2003) consists of a suite of bold, pure sheets of colour made with the dye-transfer technique, which is now a highly specialized and rare colour printing process. Using printing pigments and extremely accurate printing matrices, the dye-transfer process has legendary status in photographic history, principally because of William Eggleston's use of its rich colour saturation for his iconic photographs of the 1970s, which were key to the acceptance of colour photography as a critical and artistic medium. By creating pure- and single-colour versions of dye transfers, Deschenes calls attention to the process itself. Similarly, her *Black and White* series (2003) presents a set of monochrome analogue photographs, printed with different height and width ratios commensurate with now

224 Jessica Eaton, *Cfaal 2213*, 2018. From the series *Cfaal (Cubes for Albers and Lewitt)*.

defunct film stock. Her seven-piece series *Moiré* (2007) makes obvious allusions to Bridget Riley's (b. 1931) Op Art paintings from the mid-1960s, but equally refers to the moiré effect of the interference of pixels and raster lines on digital television screens. Significantly, Deschenes created the *Moiré* series using an analogue camera: she photographed a perforated piece of paper with a large format 8 x 10 camera, producing two copies of the negative, which she then intentionally misaligned in the enlarger to create the pulsating optical illusion. Her use of analogue processes to simulate digital technologies in *Moiré* is typical of her continuing investigation into the nature of image-making.

Phil Chang's (b. 1974) startlingly simple works, made since 2014, present strokes of printing pigments on different stocks of inkjet paper. Each work is titled with the type and colour of the ink and the brand name of the paper stock, a reminder of the industrial authorship of photographic materials. These striking works distil and focus our thoughts on the undiluted effect of contemporary photography's ubiquitous materials, without the distraction of an ostensible photographic subject. Through their deliberate, non-figurative simplicity, Chang articulates the material properties of photography while questioning what can constitute a photographic object. His apparently simple repetition of the stripe of pigment ink through each unique

225 OPPOSITE Liz Deschenes,
Moiré #2, 2007
226 Phil Chang, *Replacement
Ink for Epson Printers (Magenta
and Red 172201) on Epson
Premium Luster Paper*, 2014.
Made without the use of
a camera or film, Chang's
work reconsiders what might
constitute a 'photograph' in the
context of contemporary art.

and hand-rendered gesture removes the medium's infinite
reproducibility. Neither painterly nor obviously photographic,
Chang's work reminds us of what we forget to see and what gets
lost in photographic depiction.

227 In a different but no less striking manner, Marten Elder
(b. 1986) draws attention to photography's status as a medium
of translation and, specifically, to the fundamental properties
of digital photographic capture – our contemporary default
image-making technology. The standardized settings of digital
camera software are set to simulate the colour registration
created by analogue film capture, which is also a simulation of
human perception of light, shade and colour. In reality, a digital
camera sensor is highly attuned to the exact particularities of
the colour range of light – beyond human perception. Elder
strips away the software's set translation of light, and selects
and processes the colour 'temperatures' within the image's
digital data, making his own visual translation. The startling
colour relationships held within digital capture become the
pictorial structure of Elder's photographs – outweighing

227 Marten Elder,
noc 9, 2013

the depth of field and shadows with which photography
conventionally makes its subjects legible to us.

228 An early prompt for Matthew Porter's (b. 1975) multiple-
exposure still life arrangements were the later paintings
and lithographs of the French artist and co-instigator of the
early-twentieth-century Cubist art movement Georges Braque
(1882–1962). Braque's legacy of radically breaking down a single
vantage point perspective, and the possibilities that this opens
up for studio-based photographic practice in the present era,
is central to the meaning and effect of Porter's photographs.
As with all of the artists represented in this chapter, he
subjectively balances the ostensible subject of a photograph
(and the style of that perspectival and aesthetic frame), and
the amplified effect of his choice of photographic technique.
Means and subject are made inseparable within the construct
of Porter's photographs.

Jason Evans's (b. 1968) *NYLPT* project is a resounding example of how an artist might re-animate essentialist ideas about photography by creatively and imaginatively harnessing the new behaviours of images in the digital environment. There are two facets to *NYLPT*: eighty double-exposure, black and white street photographs sequenced in a duotone printed book, stylistically referencing the conventions of photobooks of the 1980s and paying homage to the photographic history from which Evans draws, and an app that allows this photobook to be read on a tablet, computer or smartphone. Using a randomization algorithm more typically used for generating online security codes, the app displays a randomized sequence of 600 double-exposure images from the project fixed into a landscape format. Each unique sequence is accompanied by a sound element, generated from scratch each time the app is started using sixteen inbuilt synthesizers whose range of frequency and duration have been set by Evans (who listened to drone music as he was making the photographs). The experience of the *NYLPT* app is deeply meditative, and evokes the infinite possibilities of the photographic act. At the heart

228 Matthew
Porter, *This is
Tomorrow*, 2013

of the project is the enduring quality of photography, in particular street photography, as an activity that is governed by chance. It celebrates the randomness of both lived experience and photographic observation.

Honouring the inspiration that photographers have drawn from the mistakes that happen in photography's multilayered and consequential processes, from image capture to final printing, is a prominent facet of contemporary art photography. Whether through adopting analogue film and wet darkroom processes or finding the glitches in digital photography and image software, artists have reclaimed the idiosyncratic and experimental characteristics of an especially enduring idea of photography. American artist Eileen Quinlan's (b. 1972) series *Smoke & Mirrors* is a highly self-conscious exploration of making photographs. Each of the images is unmanipulated, with an emphasis on the imperfections and mistakes inherent in analogue photographic processes. Quinlan offers a meditation upon photography's qualities of luck and happenstance. She cites historical references, ranging from early twentieth-century paranormal photography to the formal imperatives of Modernism, photographic abstraction and the seductive qualities of twentieth-century commercial still-life photography.

Since the mid-2000s, Japanese artist Taisuke Koyama (b. 1978) has worked with experimental processes that generate visualizations of photographic happenstance via the automated

230

231

229 Jason Evans, *Untitled* from *NYLPT*, 2005–12
230 OPPOSITE Eileen Quinlan, *Yellow Goya*, 2007. From the series *Smoke & Mirrors*.

mechanics of digital capture. Underlying his *Light Field* series (2015–) is Koyama's contemplation of the shift in image-making from a material-based (film) era to the sensor-based dominance of digital image capture. Using a handheld scanner, Koyama placed a sheet of creased translucent or iridescent film onto a flatbed scanner. As the LED light scanned, Koyama drew the sheet of film across the flatbed scanner's surface and, with his other hand, moved the handheld scanner. The resulting images, devoid of an ostensible subject, are records of Koyama's physical action and his interventions into the movement of light, and the testing of the properties of sensor-based image capture.

232 For twenty years, the artist Penelope Umbrico (b. 1957) has brought ideas and histories of photography into direct dialogue with the collective, everyday experiences of imaging technologies and the use of search engines. Broadly, her

231 Taisuke Koyama, *Light Field 031*, 2015. Koyama investigates the infinite possibilities of phenomenological variance – linking the repeated scrutiny of the scientific gaze and its reliance on trial and error with our present image environment.

enquiries focus on conscious and unconscious image-making behaviours – both in terms of how humans take and circulate information and transactions through photographs, and also how we can deduce the behaviour of images through search engines in order to give them mediumistic properties. Her ongoing series *Broken Sets and Bad Display (eBay)*, which she commenced in 2007, is indicative of her artistic approach. She sources images of broken and badly displaying LCD TVs being sold for parts on customer-to-customer online platforms. Seasoned vendor–customers upload photographs of the TVs for sale with the screens switched on to show the extent of the breakage and confirm basic electronic working order. Inadvertently, the photographs depict quasi-Modernist abstract patterns of colour, with fragments of the disrupted broadcast shown in some images. Umbrico frames and sandwiches her photographic enlargements (further pixelating and abstracting these found images) in plexiglass, mimicking the reflective

surface-substrate of the TVs and creating a further sense of the material presence of the broken screens.

Dutch artist Anouk Kruithof (b. 1981), perhaps best known for her innovative artist's book projects since the mid-2000s, similarly renders material form from a cache of image-documents. In *Concealed Matter(s)* (2016–17), Kruithof took screenshots of images from the US Transport Security Administration Instagram feed that recorded weaponry seized at airports, with the photo ID of the suspended offenders digitally blurred into sweeps of colour. Kruithof printed and enlarged the abstracted identification information onto sheets of malleable latex, which were then presented draped over the wall fixtures for security cameras.

233 A magically granular use of photography is found in the British artist Cornelia Parker's (b. 1956) pan-media *Avoided Object* series. Parker selects objects that have survived as the physical manifestations of (often side-stepped) histories, and uses photography to bring viewers into close proximity with these material traces – such as the equations chalked onto a blackboard by the physicist and mathematician Albert Einstein (1879–1955), where we are invited to comprehend the remains of history through metaphor and intuition. In Parker's microphotographs of the grooves of a vinyl record owned by Hitler (1889–1945), one thinks about the history of the object, including when and by whom the scratches on the surface were made, but also the aberrant duality of Hitler as both aesthete and despot.

234 Walead Beshty (b. 1976) is perhaps best known for his photograms, which are made by folding large sheets of photographic paper into three-dimensional shapes while in the pitch black of a darkroom and then exposing the temporary structures to light. The tears and creases left in the paper,

232 Penelope Umbrico, *News*, 2018. From the series *Broken Sets and Bad Display (eBay)*, 2009–ongoing

as well as the shapes of colour made by the folded paper's irregular exposure to light, create strong declarations of the unique materiality of photography. Beshty treads a fine line between presenting works of overwhelming beauty and making the conditions of the work's production explicit. This is also true in the context of his more obviously sculptural works, such as his series of double-laminated safety-glass sculptures, made to the copyrighted proportions of the FedEx boxes in which they are shipped from one exhibition location to the next. As their global tour via air freight ensues, the glass sculptures are damaged and even lost, the evidence of their process of distribution becoming part of the work.

Mariah Robertson (b. 1975) is best known for her emphatically alchemical works and installations. She directs her experimentation by masking and exposing hand-cut sheets and rolls of metallic photographic paper, which she takes into her analogue wet darkroom and pours, sprays and pans with photographic fixers and developers to create intricate, unique, multi-hued prints. She can anticipate and shepherd the form and colouration achieved by her highly intuitive and unpredictable processes, but ultimately has to follow what begins to unfold as her materials respond to chemicals and

233 Cornelia Parker, *Grooves in a Record that belonged to Hitler (Nutcracker Suite)*, 1996. In her *Avoided Object* series, Parker selects objects that have survived as the physical traces of side-stepped histories, and uses photographic technologies to view them from an often uncomfortable vantage point.

234 Walead Beshty, *3 Sided Picture (Magenta/Red/Blue), December 23, 2006, Los Angeles, CA, Kodak, Supra,* 2007

light. Such material-led practices, in which subject and process are inextricable, are a prescient mode of contemporary art photography embodied in the work of artists including Bianca Brunner (b. 1974), Sam Falls (b. 1984), Tom Lovelace (b. 1981), Maya Rochat (b. 1985) and David Benjamin Sherry (b. 1981).

For many of the artists represented in this chapter, their strategies for engaging and dealing with the constant flow and flux of our contemporary image environment centre on studio-based practices that abstract, layer, slow down and materialize photography. In both her recent short films and her photographic installations and books made since the late 2000s, Sara Cwynar (b. 1985) invites us to think about how the meaning of images is invariably conditional, implanted with subtextual biases and open to multiple interpretations. *Tracy (Gold Circle)* (2017) is both formally complex and easily readable as a tableau of mediated representations of femininity, brought together as an endlessly repeating cycle of tropes. Cwynar worked with her subject and friend, graphic designer Tracy Ma, to stage portraits against draped colour backdrops in which Ma enacts the

236

conventions of commercial representations of women. Cwynar gathered collections of now-obsolete objects, mainly produced on an industrial scale in the mid-twentieth century, and a selection of amateur and advertising images that resonated with Ma's physical gestures and the artist's photographic approach. Cwynar then positioned these images and objects on glass structures assembled on her studio floor, photographing them from above before combining the layers of her elaborate, material meditation on the values of representation.

237 Sara VanDerBeek's (b. 1976) photographs from the mid-2000s each show a sculptural form made by the artist, which creates a physical framework for photographic images taken mainly from the pages of magazines and books. These sculptural structures are strange and idiosyncratic, and clearly handcrafted. By setting her found photographs in three-dimensional space, dramatically lighting the scene and then taking the image (she does not exhibit the sculptures, just the final photographs), VanDerBeek creates a magical interplay between photography as a personal language of imagery and a physical and material form.

235 ABOVE Mariah Robertson, *001*, 2016
236 OPPOSITE Sara Cwynar, *Tracy (Gold Circle)*, 2017

Matt Lipps (b. 1975) also makes meticulous, laborious photographic constructions. For his *Library* series (2012–13), Lipps used photographic reproductions from a seventeen-volume set of books by Time-Life that introduced its predominantly American audience in the 1970s to the scope of twentieth century photography. After carefully removing the reproductions from the books' pages with a scalpel blade, Lipps mounted and propped each image on card and positioned them on glass shelves for the vantage point of his camera. The coloured backdrops for the arrangements are scanned, Photoshopped abstractions of photographs that Lipps made in high school, resplendent in their eager mimicry of photographic tropes by the medium's 'masters', including Irving Penn (1917–2009) and Ansel Adams (1902–1984). Each of the final, large photographs in *Library* represents one of the books in the Time-Life series, and maintains the volume titles – including *Documentary*, *Photojournalism*, *Great Photographers* and the tantalising *Special Problems*. Freed from their layout and captions, these photographic motifs are re-animated, prompting us to seek out connections and meanings that speak not only of the history of photography but the histories told through photographic apparatus.

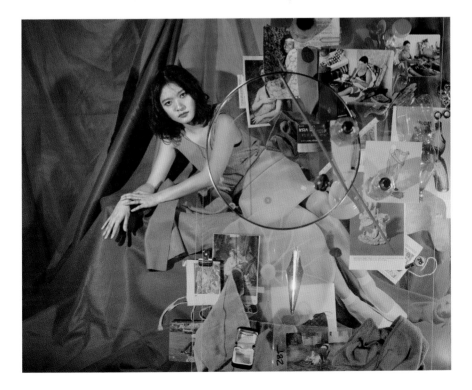

237 Sara VanDerBeek, *Eclipse 1*, 2008. VanDerBeek constructs small sculptural pieces that emphasize the material qualities of the photographic images she assembles as well as the personal connections that they constitute for her.

The re-animation of existing photographic imagery is used to full imaginative effect by artist Daniel Gordon (b. 1980). Using images culled from online sources, Gordon constructs elaborate scenes and three-dimensional collages, which he then photographs; the interplay of two-dimensional photographic depth and actual three-dimensional space is mesmerizing. There is, without doubt, a commentary made in the way that Gordon creates visual splendour and vitality out of the scraps of generic images of virtual objects, made for online temptation and consumption.

Such visceral, dynamic experiences of photographic practice, which play between enduring and fugitive ideas of authorship and the construction of meaning and narrative in image-making, is an especially pronounced area of contemporary art photography. Artists including Maja Bajevic (b. 1967), Sebastiaan Bremer (b. 1970), Brendan Fowler (b. 1978), Jason Lazarus (b. 1975), Aspen Mays (b. 1980), B. Ingrid Olson (b. 1987), Lisa Oppenheim (b. 1975), Clunie Reid (b. 1971), Abigail Reynolds (b. 1975), Will Rogan (b. 1975), Em Rooney (b. 1983), Alison Rossiter (b. 1953), Theo Simpson (b. 1986) and Suné Woods

239

(b. 1975) create highly subjective works that draw out the embedded and contingent meanings held by photography, with startlingly direct and expressive relationships to its properties.

Photographic processes developed from the late 1830s to the 1850s have been revived in recent years as a way of returning to early photography's alchemical tracings of the physical presence of living things – both as a space for unfettered experimentation and a site where representation can be rethought. Myra Greene's (b. 1975) *Character Recognition* (2006–7) is a series of close-up self-portraits made using the mid-nineteenth-century wet-plate collodion process. A layer of light-sensitive liquid collodion is brushed onto a glass plate that, while still wet, is loaded into a large-format camera and exposed to capture the negative image. By the 1860s, this technique had almost entirely replaced earlier processes to become the default method of photography during its burgeoning industrialization. Greene's choice of this now defunct and laborious photographic process is a direct calling-forth of photography's history in the service of colonialism and eugenics. She uses the technique to redress its embedded racial

238 Matt Lipps, *Frontiers*, 2013–14. Juxtaposing his personal photographic history – pictures he took in high school – with photographic reproductions from 1970s Time-Life volumes, Lipps prompts a reconsideration of the history of photoraphy and its apparatus.

239 Daniel Gordon,
Simple Fruit, 2016

Physical and Material

240 Myra Greene, *Character Recognition, plate #57*, 2006–7. Greene's use of the mid-nineteenth-century wet-plate collodion process for her *Character Recognition* project calls forth photography's use in the service of colonialism and eugenics. Through her series of self-portraits, Green counters the embedded history of this laborious technique.

dehumanization, and claim its visual terrain as a tool for her self-representation of black personhood. The effect of Greene's close framing of her face and body, including her profile, teeth and thighs, sways between re-enactments of records of enslaved Africans and African Americans at the point in history when the wet-collodion process was in commercial use, and its countering through the undeniable, physiological presence of the artist.

241 Adam Fuss (b. 1961) has been one of a very few contemporary artists to revive the first patented photographic process, the daguerreotype. This type of photograph is, like the wet-plate collodion process, a unique image in that there is no negative from which to print multiples. The photographic image is etched by light-sensitive chemicals onto a silver-coated plate, the areas where the light hits the plate most strongly becoming frosted. Fuss's daguerreotypes, like their nineteenth-century ancestors, have their own inbuilt revelatory quality as the viewer moves his or her body and eyes to try to see the ghostly image. The artist has used the process for suitably elegiac subjects such as lace christening dresses, butterflies, a swan and, here, a faint self-portrait. He is also known for his large-scale photograms, made mainly in the studio; he has

photographed rippled water, flowers, rabbit entrails, wafts of smoke and the flight of birds using this technique.

The photogram (also called a photogenic drawing), in which small objects are placed on light-sensitized writing paper and exposed to the sun, is the earliest photographic process. When washed, a negative silhouette of the object is left on the paper surface. Utilizing only the chemical element of photography, without camera equipment, the photogram is a viscerally immediate way of making an image, and one that

does not mirror human perception. British artist Susan Derges (b. 1955) has used this process to record the movement of river and seawater. Working at night, Derges placed large sheets of photographic paper, held within a metal box, beneath the surface of a river or sea and then, after taking the lid off the box, flashed the paper with light so that the movement of the water is captured on the surface of the paper. In some of her photographs of the River Taw in southwest England, Derges positioned the light above the branches of trees that have grown over the river's edge so that they are captured as shadows over the water. The colour of the prints depends on two key factors: the amount of ambient light from towns and villages contaminating the night sky and the temperature of the water

241 Adam Fuss, from the series *My Ghost*, 2000

as it changes through the year. The photographs are at a human scale and size, and when seen in a gallery they have a powerful phenomenological effect. We feel submerged beneath the intricate, unique flows of water. Derges's photographs have reconstituted the kinds of experimentation that galvanized photography's earliest practitioners in contemporary art. By taking her darkroom into the night landscape and using the flow of rivers and seas as a quasi-strip of film, she offers a reminder of the responsive and intuitive manner of photography's early history and its capacity for communicating artists' ideas today.

Such a characterization of photography's enduringly experimental nature – especially in the ways that photographic techniques are placed in close dialogue with the artist's chosen subject – is also shown in the highly physical presence of Matthew Brandt's (b. 1982) photographs. Each large work in his *Lakes and Reservoirs* series (2012–14) begins with Brandt making a 'picture perfect' image of the landscape in which he is working; a classic landscape photograph. He prints the image using the analogue C-type printing process with industrially standardized developing chemicals. Once the print is fixed and dried, he adds water from the site in which the photograph was made. Each developed print uniquely manifests the literal distress of the chemical reaction between the C-type photographic paper and process, and the photochemical compounds and residues from the lake or reservoir that distort the print's colouration and surface, and physically materialize the inseparability in Brandt's work between process and subject.

Meghann Riepenhoff's (b. 1979) cameraless cyanotype photographs make their own contemporary statement about

242 Susan Derges, *River, 23 November, 1998*, 1998
243 OPPOSITE Matthew Brandt, *Rainbow Lake WY 1*, 2013. From the series Lakes and Reservoirs.

photography as a time-honoured vehicle for discovery of the natural world. Riepenhoff consciously pays homage to Anna Atkins (1799–1871), who adopted the cyanotype process at its public announcement in 1841 and created magnificent images of botanical specimens that she collected on British shorelines, publishing the first photographically illustrated book, *Photographs of British Algae: Cyanotype Impressions*, in October 1843. Riepenhoff's visceral photographs receive and hold the energy and life force of water, capturing the below-surface movement of waves on coastal and bay shorelines and the characteristics of rainfall, often interrupted by the curves and slants that she sets up beneath the sheets of sensitized photographic paper. Collectively, these cyan-blue water-flow patterns become physical entreaties to the viewer to consider our relatively short presence within the glacial time of the Earth, and visual prompts with which to meditate on our individual relationships with nature. Her works are also perhaps experienced as markers, warning us to pay attention to our interconnectedness with and dependence upon fugitive, disruptive and ever-changing elemental forces.

The photographers represented in this chapter encourage us to engage with the wonder and experimentation that are still to be found in photography. The enduring capacity of photography to abstract and give form to our experiences is continuously reworked and revived, both through reference to analogue traditions and the tools of digital photography. In an era in which we receive, take and disseminate as well as tag, browse

and edit photographic imagery, we are all more invested, and more expert, in the language of photography than ever before, and we have a greater appreciation for how photography can be a far from neutral or transparent vehicle for bridged and framed moments of real time. The contemporary art photographers described here rephrase our material and physical understanding of photography's past, while continuing to expand the vocabulary of photography as contemporary

244 Meghann Riepenhoff, *Littoral Drift #844 (Point White Beach, Bainbridge Island, WA 11.28.17, Five Waves)*, 2017

art. They show us ways of working and thinking that have real substance and direction in an increasingly digitized sphere, with its constantly shifting values and evolving sense of what it means to make photographs.

245 Barbara Kasten, *Progression Eight*, 2018. In light of the present-day challenge for visual artists to negotiate independent positions within a vast image environment, the fluidity of Kasten's stances over the course of five decades, and her generative curiosity throughout, is a remarkable model for Postinternet artists.

Chapter 9
Photographicness

As we commence the third decade of this century, the forms and ideas that shape photography as contemporary art are expansive, vital and multivalent. Throughout this book, photography as a cultural form is shown to be an open field – one that is, simultaneously, a continuation of the active human desire to envision and declare our presence in the world, and a means by which new paradigms of discovery through making are modelled. We look towards contemporary artists to show us how we can take the cultural changes of this moment into account.

The context for this final chapter, to which all of the artists represented invite us to pay close attention, is our present-day networked, commodity-centric culture, where the digital media environment of the Web, social media and mobile imaging technologies are significant controlling factors. We each carry our own anecdotal and subjective daily interactions with contemporary images, and feel ourselves to be implicated in a mercurial climate of image production that is so vast as to be ungraspable; ultimately determined by crowd-sourced behaviours within algorithmic systems rather than by a separate photographic ecology of individual authors, artists and editors.

The most commonly used description of artistic practices that are naturalized within our networked image environment is 'Postinternet'. Such art practices do not have a specific aesthetic or set of technological tools, nor a particular critical stance. Instead, Postinternet in the context of photography is a catch-all term for of artists working across the medium's terrain – from use of analogue darkroom experimentation as a conscious statement within a digital era, to subversion of the standardized applications of pixel-based software, showing it

to be a creative medium in its own right; from explorations of the possibilities of 3-D rendering and an expansion out from the lens-based definition of photography to the use of online images as a source material for contemporary photographic artworks. The artists whose practices are shown here are cognizant of the ways in which commodified systems of visual communication, set well beyond the confines of artistic practice per se, impact upon the meaning and making of photographic works of art and the inseparability of art from its wider visual context.

One artist who stands out as both precedent-setter and honorary peer to Postinternet image-makers is the American artist Barbara Kasten (b. 1936). For those who are working through contemporary post-disciplinary ideas, particularly concerning the 'photographic', and also the 'sculptural' and 'painterly', Kasten's artistic approach is a prescient embodiment of the nimble quest for vantage points that hold equivocal but vital forms of photographic address and experimentation. Kasten's investigations of what photographic materials can do – how they can be manipulated, but also their inherent capacities to automatically render an indexical visualization of action and reaction – stem from her knowledge of and interactions with European avant-garde photography that surfaced in the early twentieth century. For example, László Moholy-Nagy's (1895–1946) abstract, hyper-material photograms, made by crumpling photographic paper before exposure to light, created a groundbreaking play between two- and three-dimensional space and are extraordinary precursors to the interplay of 'image' and 'object' status that is a defining feature of both Kasten's oeuvre since the mid-1970s and much Postinternet photographic practice of the past fifteen years.

There are distinctions to be made between younger contemporary artists and Kasten, given the actual proximity with which she has encountered and internalized the scheme of Modernism and contributed to Postmodernist photography (see Chapter 7). Kasten's engagement with Modernism started in the 1960s while she was a student and part of an artists' network in the newly-credited field of experimental textiles. In the 1970s, art communities in Southern California – the Light and Space art movement, and her network of photographic artists with parallel experimental and conceptual enquiries, combined to outline the framework within which Kasten worked. By the 1980s, Kasten's use of materials, symbols and effects in her work contributed to a cultural shift into Postmodernist design, architecture and art-making. Kasten returned to her studio in 2006, and began a still-ongoing suite of revisions and

expansions to her creative practice that riff on the algorithmic 'image explosion' that creatively militates art-making in our cultural era. Kasten has set interesting precedents for the idea of photography as contemporary art – both as a mediumistic space for unfettered experimentation and a site where representation can be rethought. She shares with her present-day contemporaries a deep curiosity for what will unfold and be discovered through the immeasurable active and non-linear choices made by artists.

This chapter constellates a range of artistic positions that strike their own balance within our fluid image environment – rendering images *as* objects and vice versa, and navigating a field in which distinctions between original and copy blur in the ongoing dynamics of circulation and versioning in which artists now practice. In a seemingly effortless and observational manner, American artist Anne Collier (b. 1970) uses

246 Anne Collier, *8 x 10 (Blue Sky)*, 2008, and *8 x 10 (Grey Sky)*, 2008. This photographic diptych, like much of Collier's work, can be read in a specific and descriptive way – as documents of somewhat anachronistic analogue photographic clichés, 'framed' within the images by Kodak photographic paper boxes. The title of the work is a literal description but also an invitation to affix binary emotional values to the optimism of the colour skyscape and the nostalgia of its black and white counterpart.

photography to create often witty linguistic propositions. 8 x 10 (*Blue Sky) and 8 x 10 (Grey Sky)* are intelligently flat-footed: Collier strips an image down to its leanest visual economy, paying homage to the conceptually driven photography of the 1960s and early 1970s. This photographic diptych, like much of her work, can be read in a specific and descriptive way – as documenting the somewhat anachronistic analogue materials of photography, 'framed' by Kodak photographic paper boxes. The title of the work is a literal description but also an invitation to affix binary emotional values to the optimism of the colour skyscape and the melancholy of its black and white counterpart.

247 Shannon Ebner's (b. 1971) photographic and sculptural work is concerned with language – both in her calling-forth of the spoken and written languages of politics, protest and experimental literature and in her use of photography as a language of visual signs. Often working with black and white photography and monochromatic sculptural forms, Ebner explores how textual and photographic language can articulate political and social structures. There is a strong sense in her work of photography operating as a metaphorical form for things breaking down or functioning through false claims and rhetoric. Ebner constructs encounters that invite us to

247 OPPOSITE Shannon Ebner, *Agitate*, 2010
248 Erin Shirreff, *Relief (no. 1)*, 2015

249 Letha Wilson, *Moon Wave*, 2013

contemplate and acknowledge these emotional and troubling states. Similarly, the work of Marie Angeletti (b. 1984), Viktoria Binschtok (b. 1972), Tris Vonna-Michell (b. 1982) and Clunie Reid has a dynamic, live-action sense of photographic language. Each crafts an unsettling viewpoint while remaining attuned to the instinctive and unpredictable nature of photography's processes and mutable meanings.

The preponderance of objects and forms made from and structured by images within contemporary art is undoubtedly a direct response to the total lack of boundary between an image and the ostensible subject that it represents in virtual space, and the shifts in our perception and experience of photographs because of the impossibility inherent in online viewership of making any real distinction between the effect of an actual object or its representation. Canadian artist Erin Shirreff's (b. 1975) photographic work is a remarkable contemplation of the difference between a physical object and that of its photographic mediation – and the creative possibilities within the confusion of difference. Like her forebear Barbara Kasten, Shirreff's studio practice is improvisational and experimental. For an ongoing body of work, Shirreff constructs three-dimensional models from painted card or simple plaster forms that recall mid-century Modernist sculpture. Set against nondescript backdrops, they are lit and photographed in a manner that renders their scale ambiguous. The act of photography transforms them into sculptures that we encounter as reproductions, playing into the somewhat ironic reality that we learn the history of modern art more often through photographic documentation than through physical experience. Shirreff then conjoins halves of two images with different scales and perspectives in one print, creasing the photographic paper along the centre join to create an effect reminiscent of the arching of a book's open double-page spread, adding yet another layer of mediation to the work and further reinforcing the experience of a photograph as both a material object and the means by which a sculptural object is rendered.

American artist Letha Wilson (b. 1976) tests and pushes her chosen materials of photographic prints, metals and concrete, and upends the photographic relationships between substrates and surfaces. Her sculptural works contradict our expectations of photography and its representation of the landscapes of the American West. In her concrete band, bend, fold and circular tondo works, Wilson pushes her analogue photographs into wet cement, recording the material response of the photographic prints' folds, ripples and torn fragments to the still viscous concrete to become a disrupted yet still legible pictorial form.

These sculptural composites of representation and process become entangled and complicated. In *Moon Wave* (2013), Wilson's vinyl photograph of a night sky and landscape is mounted onto a curved wooden structure to create a wave that responds to and is seemingly held in place by the column that cuts through the architecture of the gallery.

Many contemporary artists are exploring versatile, even ubiquitous ideas of photography as image and object combined. One leading practitioner whose innovative practices have created context for today's Postinternet artists is Isa Genzken (b. 1948). Since the late 1990s, Genzken has used her own and found photographs as a dynamic element within her sculptural installations, with no special privilege accorded to the medium, nor, significantly, any barriers to its equal place within the scheme of her art. Genzken also challenges the slick production values of much contemporary art with her willfully handcrafted, broken and non-functioning objects. Among these are photographs embedded in and roughly taped onto the surfaces of the sculptures, their cheap materiality purposefully evident. The work of American artist Rachel Harrison (b. 1966) in the 1990s has also given many the creative permission to work with the unstable and disruptive capacity of photography in a pan-media art practice. Similarly, in Michael Queenland's (b. 1970) practice of the mid-2000s, photography is explored along with other art materials as a

10

250 Daniel Shea, *Blue Island, II.IV*, 2013

251 Alexandra Leykauf, *Spanische Wand (Spanish Wall)*, 2013

transformative tool for quotidian objects and experiences. He has cast balloons in plaster and bronze, made loaves of bread in porcelain and constructed totem-like wooden structures that combine modern sculptures and their display plinths in single rough and organic forms; his photographs add to his playful subversions of art's formal language. In his installation and book works, American artist Daniel Shea (b. 1985) activates photography's documentary storytelling heritage and its mythological power. Shea is an artist who creates installations, sculptural forms and impactful, experimental artist books that embody his research and field work in the areas of human labour, post-industrialization and capitalism, with the languages and legacies of photography as the central axis point. These malleable forms of photography, dramatizing the idiosyncrasies of human mark-making and visual ordering, are also strongly present in the work of Nando Alvarez-Perez (b. 1988), Becky Beasley (b. 1975), Sarah Conaway (b. 1972), Every Ocean Hughes (F.K.A. Emily Roysdon, b. 1977), Gwenneth Boelens (b. 1980), Victoria Fu (b. 1978), Matt Keegan (b. 1976),

250

252 Soo Kim, *The DMZ (Train station)*, 2016. From the series *The DMZ*. Through a meticulous process of subtraction and abstraction, Kim creates a different image-object from which viewers can consider multiple vantage points and potential narratives.

Basim Magdy (b. 1977), Harold Mendez (b. 1977) and Emmeline de Mooij (b. 1978).

251 In all of German artist Alexandra Leykauf's (b. 1976) work – from artist books to exhibition installations – she creates for the viewer a highly sensitized awareness of the forced point of view that a photographic representation constructs, and the imaginative avenues for us to explore and unpack the assumed character of photography. Using found and intentionally degraded images to test how far a photograph can be reduced and still maintain its representational information and perspective, Leykauf's installations amplify but also break the illusory effect of photographs. In *Spanische Wand* (2012), Leykauf photographed a simple cardboard model with the volume and proportions of the gallery space in which the final work was to be shown. The enlarged black and white prints were adhered to a zig-zagged wooden structure, with its folds contradicting the trompe l'oeil effect of the photograph on its surface and creating an experience of simultaneous distance and immersion.

252 The work of Korean-American artist Soo Kim (b. 1969) similarly dramatizes the oscillation between material and indexical ideas of photography. Kim takes and prints her

photographs before making precise excisions that maintain the visual skeleton of a subject and transform the photographic prints into shyly dimensional objects. Through the purposeful absences in each photograph, a different image is created from which we can make imaginative attempts to reconcile these image-absences. Potential narrative expands beyond the retained, stubborn indexicality of a photograph – a place becomes space, and a city's architectonic memory, energy and contradictions become her photographic palette. *The DMZ* (2016), is a series of double-sided works, held in free-standing sculptural frames or suspended from ceilings that invite the viewer to actually and symbolically see from both sides. Kim captured the highly politicized – and, for the artist, personal – border of North and South Korea at a meticulously maintained train station that was engineered to move people between the North and the South, but has never been opened or used. The cuts in each pair of photographs create visual connections and irreconcilable spaces between the two perspectives on this border junction. Kim's extraction of rectangular sections of the photographs also calls to mind blank boxes of redacted text,

253 Anne de Vries, *Interface – Downstairs*, 2014. De Vries distils elements of contemporary visual culture, particularly corporate and commercial imagery, into image-objects that visualize the influence of digital technologies on our personal and social worlds.

manifesting the difficulty of reading both the space and the divisive, charged situation.

Many Postinternet artists who are shaping the field of photography as contemporary art began their creative lives in the haptic, social era of digital photography. Invariably, these digital-native artists experiment across contexts, with the gallery as just one intended space alongside online platforms and both traditional and digital publishing. This generation of practitioners are distinctly agnostic in their attitudes, drawing from all areas of creative cultures and visual messaging and cognizant of the fluidity with which they can move between forms and the tools of their engagement. One such artist, Anne de Vries (b. 1977), works with photography, sculpture and new media. He imaginatively combines a constellation of references, such as Modernist conventions of sculptural art-making, with visual motifs that reference advertising and amateur photography, utilizing new industry-standard image and object-making technologies. His work distils contemporary visual culture into sculptural experiences that abstract and hold (two highly photographic capacities) the personal and social impact of technologies upon the human psyche.

The overarching narrative of John Houck's (b. 1977) practice can be read as a meditation on the feedback loop of digital and photographic reproduction and the way it can be interrupted by desire. Houck's first wave of critical attention came from

253

254

254 OPPOSITE John Houck, *First Set*, 2015. From the series *Playing and Reality*.
255 Lucas Blalock, *Both Chairs in CW's Living Room*, 2012

Photographicness

256 Artie Vierkant, *Image Objects*, 2011–ongoing. Vierkant selects documentation images of his *Image Objects* gallery exhibitions and overlays them with painterly Photoshop gestures to create the versions that circulate online.
257 OPPOSITE Elad Lassry, *Untitled (Costume) B*, 2013

his 2011 series *Aggregates*. He created a piece of software to generate grids in which he controlled the coordinates of the number of rows, columns and colour combinations, and with another customized code base, produced a single inkjet print of his chosen aggregations of gridded lines and colour. He would then fold the physical print, photograph it, reprint, fold and photograph again, and repeat these hand-crafted combinations until the final version of the print was made, creased once more, and framed. Houck's bringing together of the consequences of algorithmic image-making with the steps of his manual, analogue processes underpinned his practice during the 2010s. *First Set* (2015) is part of his ongoing *Playing and Reality* series and is a seemingly straightforward, unmanipulated photograph – one that is built up of layer upon layer of painting, collaging, and photographing each consequential step of Houck's process. The end result looks

'photoshopped', but is in fact entirely constructed physically, and through the act of re-photographing. It offers a highly personalized simulation of the way memory functions in psychoanalysis and literature through a recursive loop of photographic, painterly and sculptural modalities.

255 Lucas Blalock (b. 1978) draws the default visual settings of digital photography and post-production into the trajectory of contemporary art in ways that have positioned him at the forefront of photographic and Postinternet discourses. He uses software as a material, showing its automated painterly operations as capable of distinctly authored, aesthetic gestures. Photoshop's filters and layers are visibly pronounced in Blalock's photographs, amplifying the alterations and combinations that he renders into remarkably idiosyncratic, articulate and personal pictures using algorithmic settings and tools. Such an approach shows Photoshop as a medium in its own right, and Blalock invites us to read his photographs as paying homage to the enduring capacity of photography to capture and commodify its subjects – but at the same time playing with that very notion. His influential practice opens up the imaginative and genuine possibilities of subjective

creative expression in which photographic and painterly Postinternet actions are combined.

Artie Vierkant's (b. 1986) *Image Objects* (2011–) is a tightly conceived exemplar of the spirit of Postinternet art-making. Vierkant generates an ongoing series of works that he makes to appear online, as printed page reproductions and as gallery wall 'image-object' installations. He renders variations of his digital image files for each context, destabilizing the ideas of photographs-as-objects and photographs-as-documentation, and dismantling the conventional hierarchy of the 'original' artwork and its derivations into documentary dissemination. For his gallery installations Vierkant renders his image files as precision-cut UV prints on aluminium sheets, emphasizing the shallow sculptural character of these hybrid photographic works. Each exhibition is documented, and Vierkant collages and alters the files to create another cache

258 Brea Souders, *Clouds*, 2018. From the series *Film Electric*.

259 Joshua
Citarella,
*Render and
Difference,*
2013

of works. In so doing, he proposes both an alternative method
of representation that circulates on the Web and another
site-specific version of the *Image Objects* project. His approach
is provocative in the way that he monumentalizes and also
re-works the visual language of our screen-based everyday lives
into sculptural objects, and sets up a return of these physical
sculptures into elaborative representations that circulate on
digital platforms and in printed publications.

257 In comparison, Israeli artist Elad Lassry (b. 1977) begins his
interpretations of the behaviours and presence of images from
an almost reversed position. His pan-media practice starts with
a photographic image, as with *Untitled (Costume) B* (2013). For
this Lassry sourced and selected a photographic negative in
an auction lot, from which he made an analogue photographic
print. The process is intentionally laborious, swerving the
easier digital processes that could be used to translate a found
negative into a legible positive image. There is a psychological

charge enacted by Lassry's choice of process for rendering a physical image – one that takes care of and treasures an orphaned photograph and provides an open and imaginative context for its interpretation. This is carried further by the image's partial obfuscation and material protection under the folded casing of silk fabric, which amplifies the perceptual pleasure of attempting to solve the puzzle of the photograph's meaning.

The starting point for Brea Souders's (b. 1978) *Film Electric* (2012–) series is her personal cache of photographic negatives ranging from family and social photographs, documentation and visual note-taking, and her testing-out of artistic and experimental ideas. Initially, Souders began cutting the negatives into pieces as a routine act of archive housekeeping, selecting negatives for destruction and disposal that she knew that she would never use in her artistic practice, and that did not capture a distinct representation of a person, place, object or memory. As Souders cut into the acetate film, the pieces would pick up static electricity and their forms began to bend and coil. Souders created *Film Electric* from this discovery, arranging her image fragments on a clear acetate sheet and photographing them while they were held in the fragile vortices created by the buildup of static electricity.

260 Takaaki Akaishi, *Mountain Range*, 2011. Akaishi's art installations give photography a highly physical presence, creating an overarching material framework for his diverse, elaborately conceived installations.

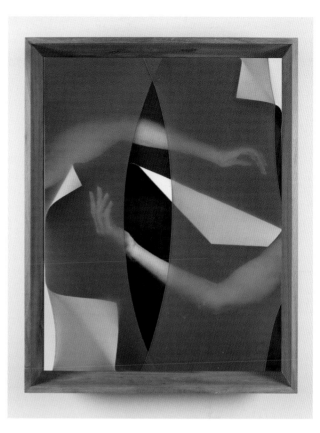

261 Sheree Hovsepian, *The Arc Between Two Deaths*, 2017

The environmental conditions on that day, and the amount and proportions of the negative shards that she arranges, determine the character of each work within the series, creating the overarching effect of *Film Electric* as a metaphor for the dynamic interconnectedness of personal memories, their fragmentary recall and unstable meanings.

Joshua Citarella's (b. 1987) *Render and Difference* (2013) sets up parallel interweaving and dynamic confusion between material, virtual and imaginary photographic presence. Citarella wallpapered an empty stage-like scene and wrapped wooden boards with adhesive vinyl sheets tiled with the results of his online image searches using the term 'clouds'. He added a layer of performance to this theatrical pictorial arena by igniting small chemical explosions within the physical space that add another visual register and type of cloud-formation to the image. Citarella elegantly conflates the modalities of photographic image-capture and image-

259

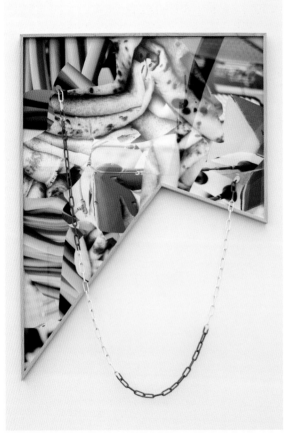

262 Kate Steciw,
Composition 008, 2014
263 OPPOSITE Kate Steciw,
Composition 011, 2014.
Steciw's sculptural,
photographic works
articulate the sociological
and psychological states
of our contemporary
image environment-at-
large and the impact of
its algorithmic dynamics
of automation, repetition
and versioning on us as
viewers.

editing software in *Render and Difference*. This elaborate and clearly intentional work of art holds our attention long enough for us to experience the energetic falling apart of its illusion. Elements of the image float and disrupt the trompe l'oeil effect of a monocular photographic perspective, and we begin to doubt that the clouds embody material existences outside of their immaterial pictorial context.

Another artist whose practice disperses his photographic authorship throughout an elaborate making process is Takaaki 260 Akaishi (b. 1984). In his gallery installations, framed and pinned photographs, mountainous soft sculptures covered in fabrics printed with photographs, backdrops, props and the traces of performative actions all come together. In Akaishi's hands, photography becomes a connecting and binding agent rather than the material fixing of an end result. Such

an approach to photography – where there is a pervasive photographic presence creating the structural connections between a host of materials and processes – also underpins the practice of Sheree Hovsepian (b. 1974). In her exhibition installations, lost-wax cast bronzes become analogous to the indexical quality of analogue black and white prints; her macramé wall hangings intricately declare the consequential steps of the making process, parallel to her tactile arranging of objects and shapes onto light sensitive paper in her wet darkroom in anticipation of how each movement and decision will appear in the photogram image once exposed to a flash of light. In *The Arc Between Two Deaths* (2017), Hovsepian layers gelatin silver prints behind bands of a stretched, semi-transparent fabric that holds the curled edges of the photographs in delicately protruding shapes. Both fabric and the photographs are gently manipulated, like a fragile skin. The photographs depict two female arms and hands and, together with the inference of femininity in the choice of fabric and the curved volumes, they assert the physicality of making photographs and the creative work of women.

Since the late 2000s, American artist Kate Steciw (b. 1979) has been at the forefront of radical creative practices that reconsider the mutability, commodification and temporality of image culture – the terms of which are set beyond the confines of art. She creates caches of stock images drawn from online sources, which, in her recent work, are combined with her own photographic captures without any distinction. The amassed images are raw material that she compiles and amplifies to

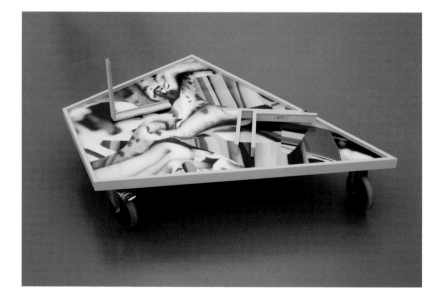

reveal their cipher-like character – as both representations and stand-ins that trigger our collective desires within the virtual space that we now inhabit. Steciw's profound grasp on the 'behaviour' of images and how their state of contingency can be harnessed within the production of art is embedded in the arc of her artistic practice, shown in the ways that she continually rephrases previous investigations, combined with new departures and additions. Her experimentation with commercial techniques – including printing images onto fabrics and metal substrates, laser-cutting geometric acetate layers and irregular image shapes, and overlays of digital gestural flourishes – pushes contemporary, default manifestations of photography into unexpected physical forms. Steciw creates suites of related works where particular images and ideograms (including mass-produced stickers) appear simultaneously in multiple places and on various surfaces, inviting us to adopt a form of viewership where we draw parallels and equivalencies between physical objects and their image stand-ins.

Every aspect of Dutch artist Rachel de Joode's (b. 1979) sculptural, installation and performative works are arranged into playful tension between physical matter, marked by

264 Rachel de Joode, *Stacked Reclining Sculpture*, 2017
265 OPPOSITE Katja Novitskova, *Approximation Mars I*, 2012

de Joode's hand-crafting methods, and the flawless two-dimensionality of screen-based images. Like all of the artists represented in this chapter, de Joode has her own approach to complicating the distinctions between sculptural, painterly and photographic gestures and characteristics. In her exquisitely tactile work, surfaces become structures, images become objects and materials such as clay and vinyl are presented as alternative versions of flesh and skin. Estonian artist Katja Novitskova's (b. 1984) *Approximations* (2012–) are strange, fantastical but strikingly animate depictions of animals, insects and muscular young men. She sources images online, printing her chosen subjects to a mammoth scale and positioning these aluminium-backed and propped image-sculptures within her gallery installations. Both in the direct physical experience of her artworks in exhibition contexts and the clear invitation for viewers to make photographs of her photographic objects – thereby adding further versions of her selected images back into the circulating dynamic of the collective image data cloud – Novitskova forecloses the gap between the corporeality of a living subject and its rendered visual equivalent. The illusory and material pleasure of photography – framed within the context of a dematerializing image environment – is a wonderfully active thread of photography as contemporary art, including artists Heather Cleary (b. 1982), Valerie Green (b. 1981), Anthony Lepore (b. 1977), Phillip Maisel (b. 1981) and Arden Surdam (b. 1988).

265

266 Yuki Kimura, *MPEG-4 H.264 Reflecting in Sizes*, 2019. Kimura's nuanced investigation of the illusory power of photography has been at the fore throughout her practice. She directs viewers' attention towards her image-objects as an array of signs from which we might shape our own imaginary journey.

266 Japanese artist Yuki Kimura's (b. 1971) subtle activation of subjective and multilayered disruptions to the illusory power of photography has been at the fore throughout her practice. Her *Table Stella* (2016) installation consisted of found photographs printed into the top surfaces of tables, onto which ashtrays were positioned. In her use of analogue vestiges of now-defunct habits – in a world of e-cigarettes and immaterial image data files – she directs attention away from original function and towards an alliance of signs. Kimura's installation *MPEG-4 H.264 Reflecting in Sizes* (2019) is made up of three LED monitors of different sizes, displayed horizontally in tabletop formations. The screens simultaneously play a silent eight-minute video, looping eighteen film and animation sequences. On top of the LED screens, Kimura places arrangements of bowl-shaped brandy glasses of varying sizes, which act as a series of lenses or mirrors, becoming 'filled' with both the reflected and refracted video images and the reflections of neighbouring glasses .

267 Since 2006, Canadian artist Owen Kydd's (b. 1985) practice has been underpinned by the technological and ontological shifts in the relationships between still and moving images and the blurring of the boundaries between these traditionally distinct mediums' DNA. In an era of still cameras that record

video, photographic resolution-quality flat screens and the online circulation of GIFs, Kydd describes his artworks as 'durational photographs'. These seamlessly looping, gradual and fixed-shot video works and animations are shown on flat screens and invite us to meditate on how duration has become a determining variable of image-making. Kydd sets up a dynamic for the viewer in which we search the video 'footage' for the photographic moment, anticipating a single frame and decisive observation.

Each of Carter Mull's (b. 1977) bodies of work and phases of his practice share a deep layering of his iterative responses to contemporary visual communication, the media climate from printed newspapers to the televisual, the recalibration of creative industries and, ultimately, how these channels shape human relationality and its material presence. Mull works with photography, printmaking, painting, assemblage, installation, video and design in ways that mimetically flatten the traces of distinctions and hierarchies between materials and mediums,

267 Owen Kydd, *Canvas Leaves, Torso, and Lantern*, 2014. Kydd's 'durational photographs' – four to six-minute video works and animations – are shown on flat screens, and invite viewers to consider the temporality of the photographic moment.

at the same time as demonstrating how a considered studio practice and a focus on the making process can resonate in today's climate in both the terms set by contemporary art and the wider mechanics of image-making industries. Mull's work is critically appreciated in part because it articulates the resonances of analogue thinking in the context of our digital environment. The creative journeys of many of the artists represented in this chapter started with experiences and education in a somewhat separatist idea of photography, even for those who were first forging their photographic ideas in the early years of the twenty-first century, and that version of photography has been the place from which many Postinternet artists have made their creative departures.

Artists including Andrey Bogush (b. 1987) and Anouk Kruithof create installation experiences that animate our symbolic and visceral knowledge of the media environments in which we live and participate. They render objects from images that they gather and then isolate, turning them into amplified cultural artefacts. Bogush treats images and their pixelated data as a surface and a sculptural material where

268 Carter Mull, *Base: No Basics, with Alanna Pearl,* 2014

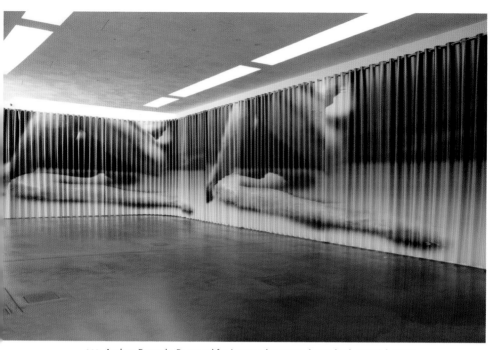

269 Andrey Bogush, *Proposal for image placement (stretched, curtain)*, 2017

the boundaries between an image and its support are richly complicated. Kruithof's *Concealed Matter(s)* (2016–17) is a sculptural body of work that is experienced as a series of painterly abstractions. The images originate from the US Transport Security Agency (TSA) Instagram feed, and are printed on soft, draped sheets of latex, affixed to gallery walls (see also p. 263). Kruithof uses pixel-based software to blur the images she collects to create the surfaces of her image-sculptures.

270 French artist Antoine Catala's (b. 1975) often kinetic and sculptural works constellate the default systems – visual and textual – of contemporary communication. Structuralist in sensibility, Catala is highly effective in holding the viewer's attention, triggering below-surface social anxieties and creating heightened encounters within which we might contemplate the subtext of our relationships with and default responses to the digital and image environment that we have naturalized

271 into our day-to-day lives. The tenor of Asha Schechter's (b. 1978) artworks is both disarming and disorienting, in his use of photographic motifs and three-dimensional renderings that appear to hover in indeterminate physical and pictorial space.

270 Antoine Catala, *Image Families*, 2013

Images become cultural artefacts by being taken out of their
assumed context; their conventions are revealed both by
their isolation and by unexpected juxtapositions within the
somewhat indeterminate spaces of art. The related dynamic of
new perspectives on – and deeper insight into – the behaviour
of images and how they are implicated within our prevailing
ideologies, historical legacies and cultural biases is brilliantly
at play in the work of David Hartt (b. 1967), Timur Si-Qin
(b. 1984) and Stephanie Syjuco (b. 1974).

272 Joiri Minaya's (b. 1990) *#dominicanwomengooglesearch* (2016)
is a remarkable installation piece that offers a corporeal
engagement with the fault-lines in our contemporary climate
of image-making and communication. While we live in an
era where the right to be seen and assert selfhood as an
emancipatory dynamic is radically reshaping human culture,
this predominantly exists in the shadow of the algorithmic
biases of the Web and social media platforms and its systems
of othering. Minaya, who is Dominican American, searched
online for, 'Dominican women' and gathered together the
representations that invariably show partially clothed women
in 'tropical' locations. By searching with English language
terms (as opposed to Spanish, which is the first language of the
Dominican Republic), the preponderance of images functioning
as visual fronts to online 'dating' catalogues for foreign men

during their vacation in DR resorts added further confirmation of the commodification of women of colour online. Minaya enlarged and printed the images directly onto PVC board, isolating out the areas of the 'Dominican women's' unclothed body parts, with men's tropical shirt fabric patterns sourced from vintage stores on each verso, suspended in a 'cloud' of body parts within a gallery environment. Minaya asserts her critical vantage point, calling upon us to experience the profound disconnect between lived experience and self-identity and the colonial gaze that pervades networked image culture through her material subversion of it.

Brandon Lattu's (b. 1970) *Seven Projections* (2010) concludes this final chapter. In 2005, Lattu made regular visits to a doctor's surgery, where he would take a photograph on his camera phone of the display of magazines on the waiting room table in the note-taking way that many of us use our mobile phones on a routine basis. Lattu often makes desktop folders of his casual photographic observations, and he returned to this cache and used it as the source material for

271 Asha Schechter, *Pamplemousse La Croix (Crumpled)*, 2016. Schechter's work unpicks the conventions and behaviour of images by removing them from their assumed context – often to disorientating effect.

272 Joiri Minaya, *#dominicanwomengooglesearch*, 2016.
Installation view at Wave Hill, New York

273 Brandon Lattu, *Seven Projections*, 2010

Seven Projections. Lattu calculated the pyramidal volumes that existed between the vantage points of his cameraphone and the frame of the photographs that he made of the magazine display, rendering the compiled sculptural form of the seven photographic projections through 3-D printing. The photographic sculpture is supported by a metal structure with the proportions of the waiting room table, and a composite image of the photographed magazines hidden on the underside of the table top. Lattu's work manifests the expansive and multivalent manner in which contemporary artists take the idea of photography and abstract it, inviting us beyond the frame and the single, monocular point of view that dominated the twentieth-century idea of the medium. The extraordinary artworks represented in this chapter collectively speak to the ongoing, energetic metabolism of an expanding idea of photography as contemporary art and ushers in a wonderfully exciting future for unexpected versions of this imaginative medium.

Further Reading

Antonsson, Lotta, *I Am A Woman* (Stockholm, 2016)

Baltz, Lewis, *Lewis Baltz* (Göttingen, 2017)

Barney, Tina, *Tina Barney* (Milan, 2017)

Barth, Uta, *Uta Barth – To Draw with Light* (New York, 2012)

Batchen, Geoffrey, *Each Wild Idea: Writing Photography History* (Cambridge, MA, 2001)

Boomoon, *Stargazing at Sokcho* (Tucson, 2006)

Brandt, Matthew, *Lakes and Reservoirs* (Bologna, 2014)

Broomberg, Adam and Oliver Chanarin, *Spirit is a Bone* (London, 2016)

Brotherus, Elina, *Carpe Fucking Diem* (Heidelberg, 2015)

Calle, Sophie, *True Stories: Sixth Edition* (Arles, 2018)

Carucci, Elinor, *Midlife: Photographs by Elinor Carucci* (New York, 2019)

Chetrit, Talia, *Showcaller* (London, 2019)

Crewdson, Gregory, *Twilight* (New York, 2002)

Dean, Tacita, *Landscape, Portrait, Still Life* (London, 2018)

Demand, Thomas, *The Complete Papers* (London, 2018)

DiCorcia, Philip-Lorca, *Philip-Lorca diCorcia* (Bielefeld, 2013)

Dijkstra, Rineke, *A Retrospective* (New York, 2012)

Douglas, Stan, *Stan Douglas* (Munich, 2014)

Drucker, Zackary and Rhys Ernst, *Relationship* (Munich, 2016)

Dugan, Jess T. and Vanessa Fabbre, *To Survive on This Shore: Photographs and Interviews with Transgender and Gender Nonconforming Older Adults* (Heidelberg, 2018)

Dumas, Charlotte, *Work Horse* (Los Angeles, 2015)

Epstein, Mitch, *American Power* (Göttingen, 2009)

Ethridge, Roe, *Neighbors* (London, 2016)

Evans, Jason, *NYPLT* (London, 2012)

Fischli, Peter and David Weiss, *Equilibres* (Cologne, 2006)

Fox, Anna, *Anna Fox* (Brighton, 2007)

Frazier, LaToya Ruby, *The Notion of Family* (New York, 2016)

Fulford, Jason, *Hotel Oracle* (New York, 2014)

Genzken, Isa, *Isa Genzken* (London, 2006)

Goldin, Nan, *The Ballad of Sexual Dependency* (New York, 2012)

Gonzalez-Torres, Felix, *Felix Gonzales-Torres* (Göttingen, 2006)

Graham, Paul, *The Whiteness of the Whale* (London, 2015)

Grannan, Katy, *The Westerns* (San Francisco, 2007)

Greene, Myra, *My White Friends* (Heidelberg, 2012)

Gursky, Andreas, *Andreas Gursky* (Göttingen, 2018)

Haifeng, Ni, *Ni Haifeng: No Man's Land* (Amsterdam, 2004)

Halpern, Gregory, *Zzyzx* (London, 2016)

Hang, Ren, *Ren Hang* (Cologne, 2016)

Hanzlová, Jitka, *Female* (Munich, 2000)

Harris, Lyle Ashton, *Today I Shall Judge Nothing That Occurs: Selections from the Ektachrome Archive* (New York, 2017)

Hernandez, Anthony, *Anthony Hernandez* (San Francisco, 2016)

Hewitt, Leslie, *Leslie Hewitt* (New York, 2019)

Höfer, Candida, *Libraries* (Munich, 2019)

Horn, Roni, *Roni Horn* (London, 2000)

Janssen, Cuny, *There Was a Child Went Forth* (Amsterdam, 2017)

Jones, Sarah, *Sarah Jones* (London, 2013)

Kasten, Barbara, *Stages* (Zurich, 2015)

Kawauchi, Rinko, *Utatane* (Japan, 2001)

Lassry, Elad, *Elad Lassry* (New York, 2014)

Lawson, Deana, *Deana Lawson* (New York, 2018)

Lehr, John, *The Island Position* (London, 2019)

Leonard, Zoe, *Survey* (Munich, 2018)

Leong, Sze Tsung, *Horizons* (Stuttgart, 2014)

Lipper, Susan, *Trip* (New York, 1999)

Lucas, Sarah, *Au Naturel* (London, 2018)

Manchot, Melanie, *Open Ended Now* (Paris 2018)

McGinley, Ryan, *Whistle for the Wind* (Milan, 2012)

McMurdo, Wendy, *Wendy McMurdo* (Salamanca, 1998)

Markosian, Diana, *Santa Barbara* (New York, 2020)

Meiselas, Susan, *Kurdistan: In the Shadow of History* (Chicago, 2008)

Misrach, Richard and Guillermo Galindo, *Border Cantos* (New York, 2016)

Mosse, Richard, *The Castle* (London, 2019)

Muholi, Zanele, *Zanele Muholi* (London, 2020)

Nieweg, Simone, *Nature Man-Made*
(Munich, 2012)
Norfolk, Simon, *Afghanistan: Chronotopia*
(Stockport, 2002)
Novitskova, Katja, *If Only You Could See What I've
Seen with Your Eyes* (New York, 2017)
Opie, Catherine, *Catherine Opie* (London, 2020)
Ou, Arthur, *The World Is All That Is the Case*
(Amsterdam, 2019)
Paglen, Trevor, *Trevor Paglen* (London, 2018)
Pickering, Sarah, *Explosions, Fires, and Public
Order* (New York, 2010)
Potter, Kristine, *Manifest* (Oakland, 2018)
Richardson, Clare, *Harlemville* (Göttingen, 2003)
Riddy, John, *Photographs* (Göttingen, 2019)
Riepenhoff, Meghann, *Littoral Drift + Ecotone*
(Santa Fe, 2018)
Ristelhueber, Sophie, *Fait: Books on Books No. 3*
(New York, 2008)
Rødland, Torbjørn, *Confabulations* (London, 2016)
Ruff, Thomas, *Photographs 1979-2011*
(Munich, 2012)
Ruiz, Stefan, *Factory of Dreams* (New York, 2012)
Salvesen, Britt, *New Topographics* (Göttingen, 2009)
Schorr, Collier, *8 Women* (London, 2014)
Sealy, Mark, *Decolonising the Camera:
Photography in Racial Time* (London, 2019)
Sekula, Allan, *Photography Against the Grain:
Essays and Photo Works, 1973–1983* (Halifax,
1984; repr. London, 2016)
Sepuya, Paul Mpagi, *Paul Mpagi Sepuya* (New
York, 2020)
Shafran, Nigel, *Dark Rooms* (London, 2016)
Shahbazi, Shirana, *First Things First* (New
York, 2017)
Sheikh, Fazal, *Portraits* (Göttingen, 2011)
Sherman, Cindy, *The Complete Untitled Film Stills*
(New York, 2003)
Shonibare, Yinka, *Yinka Shonibare MBE* (Munich,
2014)
Simon, Taryn, *An American Index of the Hidden
and Familiar* (Göttingen, 2007)
Soth, Alec, *Sleeping by the Mississippi*
(London, 2017)
Starkey, Hannah, *Photographs 1997–2017*
(London, 2018)
Sultan, Larry, *Pictures From Home*
(London, 2017)
Tagg, John, *The Burden of Representation: Essays
on Photographies and Histories* (Basingstoke,
1988; repr. London, 2007)
Thomas, Hank Willis, *All Things Being Equal* (New
York, 2018)
Tillmans, Wolfgang, *Wolfgang Tillmans* (Cologne,
2011)

Umbrico, Penelope, *Photographs* (New York, 2011)
Wall, Jeff, *Jeff Wall* (New York, 2007)
Waterhouse, Patrick, *Restricted Images: Made with
the Warlpiri of Central Australia* (London, 2018)
Wearing, Gillian, *Gillian Wearing* (London, 2012)
Welling, James, *Monograph* (New York, 2013)
Wells, Liz, *Photography: A Critical Introduction*
(London, 2015)
Winant, Carmen, *My Birth* (Ithaca and
London, 2018)

List of Illustrations

Safetyville. Courtesy Casey Kaplan, New York, and ACME, Los Angeles

69 Thomas Demand, *Salon (Parlour)*, 1997. Courtesy the artist and Victoria Miro Gallery, London, and 303 Gallery, New York. © DACS 2020

70 Anne Hardy, *Flutter*, 2017. Courtesy Maureen Paley, London. © Anne Hardy

71 Celine van Balen, *Muazez*, 1998. From the series *Muslim girls*. Courtesy Van Zoetendaal, Amsterdam

72 Lewis Baltz, *Power Supply No. 1*, 1989–92. From the series *Sites of Technology*. Courtesy Galerie Thomas Zander, Cologne. © Lewis Baltz

73 Taryn Simon, *Avian Quarantine Facility, The New York Animal Import Center, Newburgh, New York*, 2007. From the series *An American Index of the Hidden and Unfamiliar*. Courtesy the artist. © Taryn Simon

74 Andreas Gursky, *Chicago, Board of Trade II*, 1999. © Andreas Gursky/Courtesy Sprüth Magers Berlin London/DACS 2020

75 Sze Tsung Nicolás Leong, *Chunshu, Xuanwu District, Beijing*, 2004. From the series *History Images*. Courtesy the artist and Yossi Milo Gallery, New York. © Sze Tsung Nicolás Leong

76 Ed Burtynsky, *Oil Fields #13, Taft, California*, 2002. From the series *Oil Fields*. © Edward Burtynsky, Toronto

77 Jacqueline Hassink, *Mr. Robert Benmosche, Chief Executive Officer, Metropolitan Life Insurance, New York, NY, April 20, 2000*, 2000. Courtesy the artist

78 Candida Höfer, *Bibliotheca PHE Madrid I*, 2000. Courtesy Candida Höfer/VG Bild-Kunst © 2004

79 Naoya Hatakeyama, *Untitled / Osaka*, 1999. Courtesy Taka Ishii Gallery, Tokyo. © Naoya Hatakeyama

80 Mitch Epstein, *Poca High School and Amos Coal Power Plant, West Virginia*, 2004. From the series *American Power*. © Black River Productions, Ltd/Mitch Epstein. Courtesy Sikkema Jenkins & Co., New York. Used with permission. All rights reserved

81 Dan Holdsworth, *Untitled (A machine for living)*, 1999. Courtesy Entwistle, London

82 Takashi Homma, *Shonan International Village, Kanagawa*, 1995–98. From the series *Tokyo Suburbia*. Courtesy Taka Ishii Gallery, Tokyo

83 Simone Nieweg, *Grünkohlfeld, Düsseldorf – Kaarst*, 1999. Courtesy Gallery Luisotti, Los Angeles. © Simone Nieweg

84 John Riddy, *Maputo (Train) 2002*, 2002. Courtesy the artist and Frith Street Gallery, London

85 Thomas Struth, *Pergamon Museum 1, Berlin*, 2001. Courtesy the artist and Marian Goodman Gallery, New York

86 Jem Southam, *Painter's Pool*, 2003. Courtesy Hirschl Contemporary Art, London. © Jem Southam

87 Yoshiko Seino, *Tokyo*, 1997. From the series *Emotional Imprintings*. Courtesy Osiris, Tokyo. © Yoshiko Seino

88 Richard Misrach, *Wall, Near Los Indios, Texas*, 2015. From the series *Border Cantos*. Courtesy Fraenkel Gallery, San Francisco, Pace/MacGill Gallery, New York, and Marc Selwyn Fine Art, Los Angeles. © Richard Misrach

89 Boomoon, *Untitled (East China Sea)*, 1996. © Boomoon

90 Clare Richardson, *Untitled IX*, 2002. From the series *Sylvan*. Courtesy Jay Jopling/White Cube, London. © The artist

91 Lukas Jasansky and Martin Polak, *Untitled*, 1999–2000. From the series *Czech Landscape*. Courtesy Lukas Jasansky, Martin Polak and Galerie Jirisvestka, Prague

92 Thomas Struth, *Paradise 9 (Xi Shuang Banna Provinz Yunnan), China*, 1999. Courtesy the artist and Marian Goodman Gallery, New York

93 Charlotte Dumas, *Ringo, Arlington VA*, 2012. From the series *ANIMA*. Courtesy Andriesse-Eyck Gallery, Amsterdam

94 Hiroshi Sugimoto, *Anne Boleyn*, 1999. Courtesy Jay Jopling/White Cube, London. © The artist

95 Thomas Ruff, *Portrait (A. Volkmann)*, 1998. Galerie Nelson, Paris/Ruff. © DACS 2020

96 Joel Sternfeld, *A Woman with a Wreath, New York, New York, December 1998*, 1998. Courtesy the artist and Luhring Augustine, New York

97 Jitka Hanzlová, *Indian Woman, NY Chelsea*, 1999. From the series *Female*. Courtesy Jitka Hanzlová

98 Mette Tronvoll, *Stella and Katsue, Maiden Lane*, 2001. From the series *New Portraits*. Galerie Max Hetzler, Berlin

99 Melanie Manchot, *Cathedral, 6.23pm*, 2004. From the series *Groups and Locations*. Courtesy Galerie m, Bochum, Germany and Parafin, London

100 Albrecht Tübke, *Celebration*, 2003. Courtesy the artist

101 Rineke Dijkstra, *Julie, Den Haag, Netherlands, February 29, 1994*, 1994. From the series *Mothers*. Courtesy the artist and Marian Goodman Gallery, New York

102 Rineke Dijkstra, *Tecla, Amsterdam, Netherlands, May 16, 1994*, 1994. From the series *Mothers*. Courtesy the artist and Marian Goodman Gallery, New York

142 Ryan McGinley, *Gloria*, 2003. Courtesy the artist
143 Ren Hang, *Untitled 51*, 2012. Courtesy the Estate of Ren Hang and Blindspot Gallery, Hong Kong
144 Elle Pérez, *Nicole*, 2018. Courtesy the artist and 47 Canal, New York
145 Hiromix, from *Hiromix*, 1998. Edited by Patrick Remy Studio. © Hiromix 1998 and © 1998 Steidl Publishers, Göttingen
146 Ka Xiaoxi, *Mr. Sea Turtle*, 2015. From the series *Never Say Goodbye to Planet Booze*. Courtesy the artist
147 Yang Yong, *Fancy in Tunnel*, 2003. Courtesy the artist
148 Elina Brotherus, *Le Nez de Monsieur Cheval*, 1999. From the series *Suite Françaises 2*. Courtesy the artist and gb agency, Paris
150 Annelies Strba, *In the Mirror*, 1997. From the installation *Shades of Time*. Courtesy the artist and Frith Street Gallery, London
149 Elinor Carucci, *My Mother and I*, 2000. From the book *Closer*. Courtesy Ricco/Maresca Gallery
151 LaToya Ruby Frazier, *Me and Mom's Boyfriend Mr. Art*, 2005. From the series *The Notion of Family*. Courtesy the artist and Gavin Brown's enterprise, New York/Rome
152 Guanyu Xu, *Space of Mutation*, 2018. From the series *Temporarily Censored Home*. Courtesy the artist
153 Alessandra Sanguinetti, *Vida mia*, 2002. Courtesy Alessandra Sanguinetti
154 Tina Barney, *Philip & Philip*, 1996. Courtesy Janet Borden, Inc., New York
155 Bharat Sikka, *Untitled*, 2017. From the series *The Sapper*. Courtesy of the artist
156 Ruth Erdt, *Pablo*, 2001. From the series *The Gang*. © Ruth Erdt
157 Shirana Shahbazi, *Shadi-01-2000*, 2000. Courtesy Galerie Bob van Orsouw, Zurich
158 Richard Billingham, *Untitled*, 1994. Courtesy Anthony Reynolds Gallery, London. © The artist
159 Lieko Shiga, *Spiral Shore*, 2010. From the series *Rasen Kaigan*. Courtesy the artist
160 Sophie Ristelhueber, *Iraq*, 2001. Courtesy the artist
161 Zarina Bhimji, *Memories Were Trapped Inside the Asphalt*, 1998–2003. Courtesy Lisson Gallery, London and Luhring Augustine, New York. © Zarina Bhimji. All Rights Reserved, DACS 2020
162 Anthony Haughey, *Minefield, Bosnia*, 1999. From the series *Disputed Territory*. © Anthony Haughey 1999
163 Ziyah Gafic, *Quest for ID*, 2001. Ziyah Gafic/Grazia Neri Agency, Milan

164 Paul Seawright, *Valley*, 2002. Courtesy Maureen Paley, London. © Paul Seawright
165 Luc Delahaye, *Kabul Road*, 2001. © Luc Delahaye/Magnum Photos/Ricci Maresca, New York
166 Simon Norfolk, *Destroyed Radio Installations, Kabul, December 2001*, 2001. From the series *Afghanistan: Chronotopia*. Simon Norfolk, courtesy Galerie Martin Kudler, Cologne, Germany
167 Allan Sekula, *Conclusion of Search for the Disabled and Drifting Sailboat 'Happy Ending'*, 1993–2000. From the series *Fish Story*. Courtesy the artist and Christopher Grimes Gallery, Santa Monica
168 Paul Graham, *Untitled 2001 (California)*, 2001, and *Untitled 2002 (Augusta) #60*, 2002. From the series *American Night*. Courtesy Anthony Reynolds Gallery, London. © The artist
169 Richard Mosse, *Moria in Snow I, Lesbos*, 2017. From the series *Heat Maps*. Courtesy the artist and Jack Shainman Gallery, New York. © Richard Mosse
170 Trevor Paglen, *National Reconnaissance Office Ground Station (ADF-SW) Jornada del Muerto, New Mexico Distance ~16 Miles*, 2012. Courtesy the artist, Metro Pictures, New York, Altman Siegel, San Francisco
171 Oliver Chanarin and Adam Broomberg, *The Revolutionary, Spirit is a Bone*, 2012. Courtesy Lisson Gallery, London
172 Fazal Sheikh, *Halima Abdullai Hassan and her grandson Mohammed, eight years after Mohammed was treated at the Mandera feeding centre, Somali refugee camp, Dagahaley, Kenya*, 2000. Courtesy Pace/MacGill Gallery, New York. © Fazal Sheikh
173 Chan Chao, *Young Buddhist Monk, June 1997*, 2000. From the series *Burma: Something Went Wrong*. Courtesy the artist, and Numark Gallery, Washington
174 Jess T Dugan, *Sky, 64, Palm Springs, CA, 2016*, 2016. From *To Survive on This Shore: Photographs and Interviews with Transgender and Gender Nonconforming Older Adults*. Courtesy the artist and Catherine Edelman Gallery, Chicago
175 Deidre O'Callaghan, *BBC 1, March 2001*. From the book *Hide That Can*, Trolley 2002. © Deidre O'Callaghan
176 Trine Søndergaard, *Untitled, image #24*, 1997. From the series *Now that you are mine*. Trine Søndergaard/*Now that you are mine*/Steidl 2002
177 Boris Mikhailov, *Untitled*, 1997–98. From the series *Case History*. Courtesy Boris and Victoria Mikhailov
178 Roger Ballen, *Eugene on the phone*, 2000. Courtesy Michael Hoppen Gallery, London. © Roger Ballen

179 Kristine Potter, *Topher by the River*, 2012. From the series *Manifest*, 2012–2015. Courtesy the artist
180 Jim Goldberg, *Saleem, Athens*, 2004. From the series *Open See*, 2003–2009. Courtesy of the artist, Pace/MacGill Gallery, New York, and Casemore Kirkeby Gallery, San Francisco. © Jim Goldberg
181 Patrick Waterhouse, *Hip-Hop Gospel and Tanami. Restricted with Athena Nangala Granites*, 2016. From the series *Restricted Images: Made with the Warlpiri of Central Australia*. Courtesy Patrick Waterhouse/Warlukurlangu Artists
182 Carolyn Drake, *Untitled*, 2014. From the series *Internat*, 2006–2017. Courtesy Carolyn Drake
183 John Edmonds, *America, The Beautiful*, 2017. From the series *Du-Rags*. Courtesy the artist
184 Jamie Hawkesworth, *Preston Bus Station*, 2013. Courtesy the artist
185 Star Montana, *Sarah*, 2016. From the series *I Dream of Los Angeles*. Courtesy the artist
186 Zanele Muholi, *Nhlanhla Mofokeng, Katlehong, Johannesburg*, 2012. Courtesy the artist, Yancey Richardson, New York, and Stevenson, Cape Town/Johannesburg. © Zanele Muholi
187 Vik Muniz, *Action Photo 1*, 1997. From the series *Pictures of Chocolate*. Courtesy Brent Sikkema, New York
188 Cindy Sherman, *Untitled #48*, 1979. Courtesy the artist and Metro Pictures, New York
189 Cindy Sherman, *Untitled #400*, 2000. Courtesy the artist and Metro Pictures, New York
190 Yasumasa Morimura, *Self- portrait (Actress) after Vivien Leigh 4*, 1996. Courtesy the artist and Luhring Augustine Gallery, New York
191 Rashid Johnson, *Self-Portrait with my hair parted like Frederick Douglass*, 2003. Courtesy the artist
192 Vibeke Tandberg, *Line #1 – 5*, 1999. Courtesy c/o Atle Gerhardsen, Berlin. © DACS 2020
193 Nikki S. Lee, *The Hispanic Project (2)*, 1998. Courtesy Leslie Tonkonow Artworks + Projects, New York. © Nikki S Lee
194 Trish Morrissey, *July 22nd, 1972*, 2003. From the series Seven Years. Courtesy the artist. © Trish Morrissey
195 Collier Schorr, *Jens F (114, 115)*, 2002. Courtesy 303 Gallery, New York
196 Zoe Leonard and Cheryl Dunye, *The Fae Richards Photo Archive*, 1993–96. Created for Cheryl Dunye's film *The Watermelon Woman*, 1996. Courtesy Paula Cooper Gallery, New York
197 The Atlas Group/Walid Ra'ad, *Civilizationally We Do Not Dig Holes to Bury Ourselves (CDH: A876)*, 1958–2003. Courtesy Anthony Reynolds Gallery, London. © The artist

198 Tracey Moffatt, *Laudanum*, 1998. Courtesy the artist and Roslyn Oxley9 Gallery, Sydney
199 Aleksandra Mir, *First Woman on the Moon*, 1999. Event produced by Casco Projects, Utrecht, on location in Wijk aan Zee, Netherlands
200 Hans-Peter Feldmann, page from *Voyeur*, 1997. Voyeur produced by Hans-Peter Feldmann in collaboration with Stefan Schneider, under the direction of Dennis Ruggieri, for Ofac Art Contemporain, La Flèche, France. © 1997 the Authors, © 1997 Verlag der Buchhandlung Walther König, Cologne, in cooperation with 3 Möven Verlag. Hans-Peter Feldmann © DACS 2020
201 Tacita Dean, *Ein Sklave des Kapitals*, 2000. From the series The Russian Ending. Courtesy the artist and Frith Street Gallery, London and Marian Goodman Gallery, New York/Paris
202 Richard Prince, *Untitled (Girlfriend)*, 1993. Courtesy Barbara Gladstone, New York
203 Joachim Schmid, *No. 460, Rio de Janeiro, December 1996*, 1996. From the series Pictures from the Street. Courtesy the artist
204 Nadir Nadirov in collaboration with Susan Meiselas, *Family Narrative*, 1996. © Nadir Nadirov in collaboration with Susan Meiselas, published in *Kurdistan In the Shadow of History* (Random House, 1997)
205 Batia Suter, *Wave, floor version #1*, 2012. Installation at Le Prairies, Biennial for Contemporary Art, Rennes, France. © Batia Suter
206 Lotta Antonsson, *Arrangements I – V*, 2010–2012. Courtesy the artist
207 Lyle Ashton Harris, *Blow up IV (Sevilla)*, 2006. MUSAC Collection, Contemporary Art Museum of Castilla and León. Courtesy the artist and CRG Gallery, New York
208 Carmen Winant, *My Birth*, 2018. Installation view of *Being: New Photography 2018* at The Museum of Modern Art, New York, March 18– August 19, 2018. The Museum of Modern Art, New York/Scala, Florence. Photo Kurt Heumiller
209 Sherrie Levine, *After Walker Evans*, 1981. © Sherrie Levine. Courtesy Paula Cooper Gallery, New York. © Walker Evans Archive. The Metropolitan Museum of Art, New York
210 Susan Lipper, *untitled*, 1993–98. From the series *trip*. Courtesy the artist
211 Seung Woo Back, *Utopia #001*, 2008. From the series *Utopia*. Courtesy the artist
212 Florian Maier-Aichen, *The Best General View*, 2007. Courtesy the artist and Blum & Poe, Los Angeles
213 Markéta Othová, *Something I Can't Remember*, 2000. Courtesy Markéta Othová
214 Christopher Williams, *Kodak Three Point*

Reflection Guide, © 1968 Eastman Kodak Company, 1968. (Corn) Douglas M. Parker Studio, Glendale, California, April 17, 2003, 2003. Courtesy David Zwirner, New York. © Christopher Williams
215 Alec Soth, *Sugar's, Davenport, IA*, 2002. From the series *Sleeping by the Mississippi*. Courtesy Yossi Milo Gallery, New York
216 Katy Grannan, *Joshi, Mystic Lake, Medford, MA*, 2004. From the series *Sugar Camp Road*. Courtesy Artemis, Greenberg, Van Doren Gallery, New York and Salon 94, New York
217 Roe Ethridge, *Lip Stickers*, 2018. Courtesy the artist and Andrew Kreps Gallery, New York
218 Torbjørn Rødland, *Nudist no. 6*, 1999. Courtesy Air de Paris and David Kordansky Gallery, Los Angeles
219 James Welling, *Crescendo B89*, 1980. Courtesy David Zwirner, New York
220 Arthur Ou, *Primer*, 2018–19. Brennan and Griffin, New York
221 Ellen Carey, *Dings & Shadows*, 2013. Private Collection, New York
222 Ellen Carey, *Self-Portrait*, 1987. The Yale University Art Gallery, New Haven. Gift of Robinson A. Grover, B.A. 1958, M.S.L. 19775, and Nancy D. Grover
223 Hannah Whitaker, *Reach 2*, 2017. Courtesy the artist, Marinaro, New York, Galerie Christophe Gaillard, Paris and M+B, Los Angeles
224 Jessica Eaton, *cfaal 2213*, 2018. From the series *Cfaal (Cubes for Albers and Lewitt)*. Courtesy the artist
225 Liz Deschenes, *Moiré #2*, 2007. Courtesy Miguel Abreu Gallery, New York
226 Phil Chang, *Replacement Ink for Epson Printers (Magenta and Red 172201) on Epson Premium Luster Paper*, 2014. Courtesy the artist and M+B, Los Angeles
227 Marten Elder, *noc 9*, 2013. Courtesy the artist
228 Matthew Porter, *This Is Tomorrow*, 2013. Courtesy M+B, Los Angeles
229 Jason Evans, *Untitled* from *NYLPT*, 2005–12. Courtesy the artist
230 Eileen Quinlan, *Yellow Goya*, 2007. Courtesy the artist and Miguel Abreu Gallery, New York
231 Taisuke Koyama, *Light Field 031*, 2015. © Taisuke Koyama
232 Penelope Umbrico, News, 2018. From the series *Broken Sets and Bad Display (eBay)*, 2009 – ongoing. Courtesy the artist, David Smith Gallery, Denver, and Bruce Silverstein Gallery, New York
233 Cornelia Parker, *Grooves in a Record that belonged to Hitler (Nutcracker Suite)*, 1996. Courtesy the artist and Frith Street Gallery, London

234 Walead Beshty, *3 Sided Picture (Magenta/Red/Blue), December 23, 2006, Los Angeles, CA, Kodak, Supra*, 2007. Collection of FRAC Nord - Pas de Calais, Dunkirk
235 Mariah Robertson, *001*, 2016. Courtesy the artist and M+B, Los Angeles
236 Sara Cwynar, *Tracy (Gold Circle)*, 2017. From the series *Rose Gold*. Courtesy the artist, Foxy Production, New York, and Cooper Cole, Toronto
237 Sara VanDerBeek, *Eclipse 1*, 2008. Courtesy the artist and D'Amelio Terras, New York
238 Matt Lipps, *Frontiers*, 2013–14. From the series *Library*. Courtesy the artist, Marc Selwyn Fine Art, Los Angeles, Jessica Silverman Gallery, San Francisco and Josh Lilley Gallery, London
239 Daniel Gordon, *Simple Fruit*, 2016. Courtesy the artist and James Fuentes Gallery, New York
240 Myra Greene, *Character Recognition, plate #57*, 2006-7. Courtesy Myra Greene
241 Adam Fuss, From the series *My Ghost*, 2000. Courtesy the artist and Cheim & Reid, New York
242 Susan Derges, *River, 23 November, 1998*, 1998. From the series *River Taw*. Collection Charles Heilbronn, New York
243 Matthew Brandt, *Rainbow Lake WY 1*, 2013. From the series *Lakes and Reservoirs*. Courtesy the artist
244 Meghann Riepenhoff, *Littoral Drift #844 (Point White Beach, Bainbridge Island, WA 11.28.17, Five Waves)*, 2017. Courtesy Meghann Riepenhoff and Yossi Milo Gallery, New York
245 Barbara Kasten, *Progression Eight*, 2018. From the series *Progression*. Courtesy Bortolami, New York, Kadel Willborn Gallery, Dusseldorf, Thomas Dane and the artist © Barbara Kasten
246 Anne Collier, *8 x 10 (Blue Sky)*, 2008, and *8 x 10 (Grey Sky)*, 2008. Courtesy the artist and Marc Foxx, Los Angeles
247 Shannon Ebner, *Agitate*, 2010. Courtesy the artist and LAXART
248 Erin Shirreff, *Relief (no. 1)*, 2015. Courtesy Sikkema Jenkins & Co., New York. © Erin Shirreff
249 Letha Wilson, *Moon Wave*, 2013. Installation photo Steven Probert. Courtesy the artist
250 Daniel Shea, *Blue Island, II.IV*, 2013. Courtesy the artist
251 Alexandra Leykauf, *Spanische Wand (Spanish Wall)*, 2013. Courtesy Alexandra Leykauf and MOREpublishers
252 Soo Kim, *The DMZ (Train station)*, 2016. From the series The DMZ. Courtesy the artist
253 Anne de Vries, *Interface - Downstairs*, 2014. From the series Interface. Courtesy the artist
254 John Houck, *First Set*, 2015. From the series *Playing and Reality*. Courtesy the artist, Jessica

Index

The World of Art series is a comprehensive,
accessible, indispensable companion to the history
of art and its latest developments, covering themes,
artists and movements that span centuries and
the gamut of visual culture around the globe.

You may also like:

Contemporary Painting
Suzanne Hudson

**Central and Eastern
European Art Since 1950**
Maja and Reuben Fowkes

Digital Art
Christiane Paul

Movements in Art Since 1945
Edward Lucie-Smith

**Realism in 20th-Century
Painting**
Brendan Prendeville

World of Art

For more information about
Thames & Hudson, and the World of Art
series, visit **thamesandhudsonusa.com**